FUNDAMENTALS OF
English
Grammar

FIFTH EDITION
WORKBOOK
VOLUME A

Betty S. Azar
Stacy A. Hagen
Geneva Tesh

Fundamentals of English Grammar, Fifth Edition
Workbook Volume A

Pearson Education, 221 River Street, Hoboken, NJ 07030

Azar Associates: Sue Van Etten, Manager

Staff credits: The people who made up the *Fundamentals of English Grammar, Fifth Edition,*
Workbook team, representing content development, design, project management, publishing,
and rights management, are Pietro Alongi, Sheila Ameri, Warren Fischbach, Sarah Henrich,
Niki Lee, Amy McCormick, Robert Ruvo, Paula Van Ells, and Joseph Vella.

Production Editor: Jennifer McAliney

Text composition: Aptara

Photo Credits: Page 5: Microgen/Shutterstock; 9: Harvepino/Shutterstock; 15: Poznyakov/
Shutterstock; 16: Papobchote Akkahbutr/123RF; 28 (top): VectorZilla/Shutterstock; 28 (cell phones):
Pom Pom/Shutterstock; 29: Ljupco Smokovski/Shutterstock; 34: Arvind Singh Negi/Red Reef
Design Studio/Pearson India Education Services Pvt. Ltd; 38: Tankist276/123RF; 48 (racoon):
Blueringmedia/123RF; 48 (mow grass): Tim Carillet/Shutterstock; 52 (whitewater rafting): LHF
Graphics/Shutterstock; 52 (scuba diving): Zhenyakot/Shutterstock; 67: Arvind Singh Negi/Red Reef
Design Studio/Pearson India Education Services Pvt. Ltd; 73: Beta757/Shutterstock; 112: Robuart/
Shutterstock; 116: Flat vectors/Shutterstock.

Printed in the United States of America

ISBN 10: 0-13-515947-4
ISBN 13: 978-0-13-515947-7

Contents

Preface

The *Fundamentals of English Grammar Workbook* is a place for lower-intermediate and intermediate students to explore and practice English grammar on their own. It is a place where they can test and fine-tune their understanding of English structures and improve their ability to use English meaningfully and correctly. All of the exercises have been designed for independent study, but this book is also a resource for teachers who need exercise material for additional classwork, homework, testing, or individualized instruction.

The *Workbook* is keyed to the explanatory grammar charts found in *Fundamentals of English Grammar, Fifth Edition*, a classroom teaching text for English language learners, and in the accompanying *Chartbook*, a grammar reference with no exercises.

The answers to the practices can be found in the *Answer Key* in the back of the *Workbook*. Its pages are perforated so that they can be detached to make a separate booklet. However, if teachers want to use the *Workbook* as a classroom teaching text, the *Answer Key* can be removed at the beginning of the term.

Two special *Workbook* sections called *Phrasal Verbs* and *Preposition Combinations*, not available in the main text, are included in the *Appendices*. These sections provide reference charts and a variety of exercises for independent practice.

CHAPTER 1 Present Time

PRACTICE 1 ▸ Simple present and present progressive. (Chart 1-1)
Choose the correct completions.

1. I sit / am sitting at my desk right now.

2. I sit / am sitting at this desk every day.

3. I do / am doing grammar homework every day.

4. I do / am doing grammar homework now.

5. I look / am looking at Sentence 5 now.

6. Now I choose / am choosing the correct verb for this sentence.

7. Henry doesn't do / isn't doing homework right now.

8. He checks / is checking his messages.

9. He checks / is checking his messages 30 or 40 times a day.

10. He posts / is posting pictures to his social media accounts every day.

11. He usually posts / is posting pictures of his cat.

12. Right now he looks / is looking at his friends' posts.

PRACTICE 2 ▸ Forms of the simple present. (Chart 1-2)
Complete each sentence with the correct form of the verb **speak**.

Part I: STATEMENT

1. I _____*speak*_____ English.

2. They _____ English.

3. He _____ English.

4. You _____ English.

5. She _____ English.

Part II: NEGATIVE

6. I _____*do not / don't speak*_____ English.

7. They _____ English.

8. She _____ English.

9. You _____ English.

10. He _____ English.

Part III: QUESTION

11. _____*Do*_____ you _____*speak*_____ English?

12. _____ they _____ English?

13. _____ he _____ English?

14. _____ we _____ English?

15. _____ she _____ English?

PRACTICE 3 ▸ Forms of the simple present. (Chart 1-2)

Complete the sentences with the appropriate verbs from the box. Add **-s** / **-es** as necessary. Use each verb only once.

coach	cook	manage	program	write
collect	drive	✓play	run	

1. Leo is a piano player. He _____*plays*_____ the piano in a restaurant on weekends.

2. Akira is an apartment manager. He _____ three apartment buildings.

3. My grandparents are coin collectors. They _____ coins from different countries.

4. My sister is a computer programmer. She _____ computers for a large corporation.

5. James and Ted are marathon runners. They _____ in marathon races.

6. Gino is the cook in the governor's house. He _____ for the governor's family.

7. Two of my friends are coaches. They _____ high school basketball teams.

8. Alex is a truck driver. He _____ a huge truck across the country.

9. I am a travel writer. I _____ a weekly blog.

PRACTICE 4 ▸ The simple present. (Chart 1-2)

Sentence *A* is incorrect. In Sentence *B,* write the negative of that statement, and then write the correct fact. Use the affirmative and negative forms of the verb in Sentence *A*.

1. A. The needle of a compass points south.

 B. No. The needle of a compass _____*doesn't point*_____ south. It _____*points*_____ north.

2. A. February comes before January.

 B. No. February _____ before January. It _____ after January.

3. A. It snows in warm weather.

 B. No. It _____ in warm weather. It _____ in cold weather.

4. A. Bananas grow in cold climates.

 B. No. Bananas _____ in cold climates. Bananas _____ in warm climates.

5. A. Lightning follows thunder.

 B. No. Lightning _____ thunder. Thunder _____ lightning.

6. A. Cats bark.

 B. No. Cats _____. Dogs _____.

7. A. The earth revolves around the moon.

 B. No. The earth _____ around the moon. The

 moon _____ around the earth.

8. A. Butterflies turn into caterpillars.

 B. No. Butterflies _____ into caterpillars.

 Caterpillars _____ into butterflies.

PRACTICE 5 ▸ The simple present. (Chart 1-2)

Complete the sentences with **do, does,** or **Ø**.

1. Polly and Scott _____ not work in an office.

2. They _____ own a small construction company.

3. The company _____ not build houses.

4. The company _____ repairs houses.

5. Polly and Scott _____ not do the same work.

6. They _____ do different kinds of work.

7. Polly _____ enjoys painting, but Scott _____ not like painting.

8. He _____ prefers to fix things.

9. They _____ spend 8 to 10 hours at work on most days.

10. They _____ not work at night or on weekends.

11. _____ they plan to work together for a long time? Yes, they're married.

PRACTICE 6 ▸ Forms of the present progressive. (Chart 1-2)

Complete the sentences with the correct form of the verb **speak**.

Part I: STATEMENT

1. I _____ *am speaking* _____ English right now.

2. They _____ English right now.

3. She _____ English right now.

4. You _____ English right now.

5. He _____ English right now.

Part II: NEGATIVE

6. I _____ *am not speaking* _____ English right now.

7. They _____ English right now.

8. She _____ English right now.

9. You _____ English right now.

10. He _____ English right now.

11. _____*Are*_____ you _____*speaking*_____ English right now?

12. _____ he _____ English right now?

13. _____ they _____ English right now?

14. _____ we _____ English right now?

15. _____ she _____ English right now?

PRACTICE 7 ▶ The present progressive. (Charts 1-1 and 1-2)

Complete the paragraph with the simple present or present progressive form of the verbs in parentheses.

I'm looking around the classroom now. We (*wait*) _____ for our
<div align="right">1</div>
professor. He usually (*arrive*) _____ at class early, but he is very late
<div align="right">2</div>
this morning. Lilly (*play*) _____ a game on her phone. Ali (*sleep*)
<div align="right">3</div>
_____ at his desk. He (*works*) _____ late every
<div align="right">4</div> <div align="right">5</div>
night. He often (*fall*) _____ asleep in class. Kenzo and Gabi (*watch*)
<div align="right">6</div>
_____ a video on Gabi's tablet. They (*laugh*) _____
<div align="right">7</div> <div align="right">8</div>
really hard. Kenzo (*make*) _____ funny videos every day and (*post*)
<div align="right">9</div>
_____ them online. Maya (*file*) _____ her
<div align="right">10</div> <div align="right">11</div>
nails. Tanya and Sasha (*listen*) _____ to music on their headphones. Eva
<div align="right">12</div>
(*draw*) _____ something in her notebook. Finally, our professor (*walk*)
<div align="right">13</div>
_____ through the door. Now the students (*put*) _____
<div align="right">14</div> <div align="right">15</div>
away their devices and (*get*) _____ ready for class.
<div align="right">16</div>

PRACTICE 8 ▶ The simple present and the present progressive. (Charts 1-1 and 1-2)

Choose the correct answers for each group.

Group 1

1. Jack __*c*__. a. working today

2. Jack is _____. b. work in an office

3. Jack does not _____. c. works in a factory

Group 2

1. Nina _____. a. playing tennis now

2. She does not _____. b. play tennis on weekdays

3. She is not _____. c. plays tennis on weekends

Group 3

1. Leah and Hank are _____. a. text each other every night

2. They _____. b. texting each other now

3. Leah _____. c. texts a lot

Group 4

1. My roommate and I do not _____. a. streams shows on his computer
2. My roommate _____. b. watch TV
3. He is not _____. c. streaming a show right now

PRACTICE 9 ▸ Present verbs: questions. (Charts 1-1 and 1-2)
Complete the questions with **Does she** or **Is she**.

1. _____Is she_____ a student?
2. _____Does she_____ have good professors?
3. _____ from Spain?
4. _____ in the classroom?
5. _____ like school?
6. _____ a math major?
7. _____ studying math?
8. _____ study every day?
9. _____ live on campus?
10. _____ do homework every night?
11. _____ doing homework right now?

PRACTICE 10 ▸ Present verbs: questions. (Charts 1-1 and 1-2)
Complete the questions with **Do you** or **Are you**.

1. _____Are you_____ working right now?
2. _____Do you_____ like your job?
3. _____ take the train to work?
4. _____ sitting at your desk?
5. _____ come to the office every day?
6. _____ like your job?
7. _____ on the phone?
8. _____ in a meeting?
9. _____ work overtime often?
10. _____ working overtime now?

PRACTICE 11 ▸ The simple present and the present progressive. (Charts 1-1 and 1-2)
Choose the correct answers.

1. Riley _____ at a swimming pool every summer.

 a. work b. works c. is working

2. He _____ a lifeguard.

 a. is b. are c. does

3. Lifeguards _____ the safety of swimmers at a swimming pool.

 a. supervise b. supervises c. are supervising

4. Riley _____ all day today.

 a. working b. work c. is working

5. It _____ a beautiful, sunny day.

 a. is b. do c. does

6. Right now, Riley _____ in a lifeguard chair at the pool.

 a. sit b. sits c. is sitting

7. He _____ a group of kids in the water.

 a. watches b. is watching c. is

8. The kids _____ very strong swimmers.

 a. aren't b. isn't c. don't

9. His job _____ easy.

 a. isn't b. aren't c. not

10. But he _____ it.

 a. like b. likes c. is like.

PRACTICE 12 ▶ Singular/plural. (Chart 1-3)

Is the word ending in *-s* a singular verb or a plural noun? Check (✓) the box.

	Singular Verb	Plural Noun
1. Flowers need water.		✓
2. The flower smells good.	✓	
3. Elephants live a long time.		
4. An elephant never forgets.		
5. My brother works for an airline.		
6. Pilots travel all over the world.		
7. Golfers play golf.		
8. A pianist plays the piano.		
9. A mail carrier brings the mail each day.		
10. Delivery trucks carry large packages.		

PRACTICE 13 ▶ Final -s / -es. (Chart 1-3)

Add *-s* where necessary. Write Ø if no *-s* is needed.

1. A kangaroo hop___*s*___.

2. The mother kangaroo___*Ø*___ carries her baby in a pouch.

3. Kangaroo_____ live in Australia.

4. This apple taste_____ delicious. It come_____ from a farm near here.

5. Apple_____ are healthy. They contain_____ vitamins.

6. Every Sunday, my grandma bake_____ something. Usually she cut_____ up some apples and put_____ them in a pie_____.

7. Mauricio is a mechanic_____. He repair_____ cars.

8. Lili work_____ at a fast-food restaurant_____. She serve_____ food to customer_____.

9. Harry and Janice go_____ to different restaurant_____ every weekend.

PRACTICE 14 ▸ Spelling of final -s / -es. (Chart 1-4)
Complete the second sentence with the correct form of the verb in **bold**.

1. I **eat** potatoes. Emma _____ rice.

2. I **teach** English. Henri _____ French.

3. We **study** business. Malek _____ engineering.

4. I **do** the dishes every evening. Alex _____ the laundry.

5. I **pay** bills on my phone. Celine _____ bills on her tablet.

6. We **have** a house. Lara _____ an apartment.

7. We **watch** movies in the evening. Paul _____ the news.

8. We **go** to class in the morning. Hannah _____ to class in the afternoon.

9. We **ride** the bus to school. Jacob _____ his bike.

10. I **fly** home to my country every winter. Marco _____ home every summer.

PRACTICE 15 ▸ Simple present: final -s / -es. (Chart 1-4)
Read Sam's paragraph about his typical day. Then rewrite the paragraph using **he** in place of **I**. You will need to change the verbs.

Sam's Day

 I leave my apartment at 8:00 every morning. I walk to the bus stop and catch the 8:10 bus. It takes me downtown. Then I transfer to another bus, and it takes me to my part-time job. I arrive at work at 8:50. I stay until 1:00, and then I leave for school. I attend classes until 5:00. I usually study in the library and try to finish my homework. Then I go home around 8:00. I have a long day.

Sam ___*leaves*___ his apartment at 8:00 every morning. ___*He walks*___ to the bus stop
 1 2

and _____ the 8:10 bus. It takes him downtown. Then _____ to another
 3 4

bus, and it takes him to his part-time job. _____ at work at 8:50. _____
 5 6

until 1:00, and then _____ for school. _____ classes until 5:00.
 7 8

_____ in the library and _____ to finish his homework.
 9 10

Then _____ home around 8:00. _____ a long day.
 11 12

PRACTICE 16 ▶ Frequency adverbs. (Chart 1-5)

Put the word in *italics* in its usual midsentence position. Write Ø if no word is needed.

1. *usually* Anna _____*usually*_____ goes _____Ø_____ out to eat for lunch.

2. *usually* Anna _____Ø_____ is _____*usually*_____ at a restaurant at lunchtime.

3. *ever* Does _____ she _____ bring _____ her lunch to work?

4. *always* Luke _____ stays _____ home in the evening.

5. *generally* He _____ is _____ at his desk in the evening.

6. *usually* He _____ doesn't _____ go out.

7. *always* But, he _____ doesn't _____ study in the evening.

8. *sometimes* He _____ watches _____ a little TV.

9. *rarely* He _____ stays _____ awake past midnight.

10. *almost never* He _____ is _____ awake past midnight.

11. *occasionally* Does _____ he _____ go out _____ at night?

12. *always* Is _____ he _____ home at night?

PRACTICE 17 ▶ Frequency adverbs. (Chart 1-5)

Use the given information to complete the sentences. Use a frequency adverb for each sentence.

Kim's Week	S	M	T	W	Th	F	S
1. wake up late	X	X	X	X	X	X	X
2. skip breakfast		X	X		X		
3. visit friends	X	X		X		X	X
4. be on time to class		X	X	X	X		
5. go to the gym				X			
6. clean her room	X	X	X	X		X	X
7. do homework			X			X	
8. be in bed early							

1. Kim _____*always wakes*_____ up late.

2. She _____ breakfast.

3. She _____ friends.

4. She _____ on time for class.

5. She _____ the internet.

6. She _____ her room.

7. She _____ homework.

8. She _____ in bed early.

Part I. Read the passage. Then circle the eight remaining verbs in the simple present tense and one verb in the present progressive. <u>Underline</u> the three remaining frequency adverbs.

Powerful Storms

Hurricanes and typhoons (are) powerful storms. They <u>always</u> form over warm oceans. They have strong winds (at least 74 miles or 119 kilometers per hour), a huge amount of rain, low air pressure, and thunder and lightning. Scientists call the storms east of the International Date Line and north of the equator — for example, in Mexico and the United States — hurricanes. Storms west of the International Date Line and south of the equator — for example, in Indonesia and India — are typhoons.

About 100 of these tropical storms usually occur each year. These storms travel from the ocean to the coast and on to land. On land, the wind, rain, and enormous waves often cause terrible destruction. People never like to hear the news that a hurricane or typhoon is coming.

Part II. Answer the questions according to the information in the passage. Circle "T" if the statement is true and "F" if the statement is false.

1. Hurricanes and typhoons have winds of more than 74 miles per hour.	T	F
2. These storms don't have rain.	T	F
3. There is often snow with hurricanes.	T	F
4. Hurricanes are bigger than typhoons.	T	F
5. In India and Indonesia, these big storms are typhoons.	T	F
6. Hurricanes and typhoons begin over land.	T	F
7. Hurricanes and typhoons rarely cause destruction.	T	F
8. People don't like to hear that a hurricane is coming.	T	F

PRACTICE 19 ▸ Verbs not usually in the progressive. (Chart 1-6)
Choose the correct sentence in each pair.

1. (a.) The professor wants an answer to her question.

 b. The professor is wanting an answer to her question.

2. a. A student knows the answer.

 b. A student is knowing the answer.

3. a. Look! An eagle flies overhead.

 b. Look! An eagle is flying overhead.

4. a. It's over that tree. Are you seeing it?

 b. It's over that tree. Do you see it?

5. a. I believe that Tokyo is the largest city in the world.

 b. I am believing that Tokyo is the largest city in the world.

6. a. I think that São Paulo is the largest city in the world.

 b. I am thinking that São Paulo is the largest city in the world.

7. a. What do you think about right now?

 b. What are you thinking about right now?

8. a. I need to call my family.

 b. I am needing to call my family.

9. a. This is fun. I have a good time.

 b. This is fun. I am having a good time.

10. a. I like to meet new people.

 b. I am liking to meet new people.

PRACTICE 20 ▸ Simple present and present progressive. (Charts 1-1 → 1-6)
Complete the sentences with the simple present or present progressive form of the verbs in the box.
Use each verb only once.

belong	need	prefer	shine	✓take
drive	play	rain	✓snow	understand

1. Look outside! It _____is snowing_____. Everything is beautiful and white.

2. My father _____takes_____ the 8:15 train into the city every weekday morning.

3. On Tuesdays and Thursdays, I walk to work for the exercise. Every Monday, Wednesday, and
 Friday, I _____ my car to work.

4. A: Charlie, it's time for dinner.

 B: Please give me five more minutes. I _____ a game online with my friends.

5. I'm drinking black tea today, but I _____ green tea.

6. I'm gaining weight around my waist. These pants are too tight. I _____ a larger pair
 of pants.

7. Thank you for your help in algebra. Now I _____ that lesson.

8. Why are you giving me these headphones? They aren't mine. They _____
 to Colette.

9. I see a rainbow. That's because it _____, and at the same time, the sun

 _____.

PRACTICE 21 ▸ Simple present and present progressive. (Charts 1-1 → 1-6)
Complete the paragraph with the simple present or present progressive form of the verbs in parentheses.

 Rosa is sitting on the train right now. She (take, not, usually) _____usually doesn't take_____ the

train, but today her son (need) _____ her car. She (enjoy) _____

the ride today. There (be, always) _____ so many people to watch. Some people

(eat) _____ breakfast. Others (drink) _____ coffee and (read)

_____ the news. One woman (work) _____ on her tablet.

Another (feed) _____ her baby. Two teenagers (play) _____

games on their phones. Rosa (*know*) _____ that teenagers (*love*)
_____ online games. She (*have*) _____ two teenage daughters,

and they (*play*) _____ games all the time. Rosa (*smile*) _____

and (*relax*) _____ now. The train ride (*take, usually*) _____

longer than driving, but it (*be*) _____ a more enjoyable way for her to travel.

PRACTICE 22 ▸ Present verbs: questions and short answers. (Chart 1-7)

Complete the questions with **Do**, **Does**, **Is**, or **Are**. Then complete both the affirmative and negative short answers.

1. A: _____Are_____ you leaving now?

 B: Yes, _____I am_____. OR No, _____I'm not_____.

2. A: _____Do_____ your neighbors have loud parties?

 B: Yes, _____they do_____. OR No, _____they don't_____.

3. A: _____ you follow the same routine every morning?

 B: Yes, _____. OR No, _____.

4. A: _____ Dr. Jarvis know the name of her new assistant yet?

 B: Yes, _____. OR No, _____.

5. A: _____ Paul and Beth studying math?

 B: Yes, _____. OR No, _____.

6. A: _____ they understand the problem?

 B: Yes, _____. OR No, _____.

7. A: _____ Mike texting and watching TV at the same time?

 B: Yes, _____. OR No, _____.

8. A: _____ you listening to me?

 B: Yes, _____. OR No, _____.

9. A: _____ that building safe?

 B: Yes, _____. OR No, _____.

10. A: _____ you and your co-workers meet outside of work?

 B: Yes, _____. OR No, _____.

PRACTICE 23 ▸ Check your knowledge. (Chapter 1 Review)

Correct the errors.

1. Don ~~does~~ *is* not working now.

2. Florida doesn't has mountains.

3. This train always is late.

4. Does Marta usually goes to bed early?

5. Mr. Chin always come to work on time.

6. Shhh! The concert starting now.

7. The refrigerator no work.

8. Is Catherine has a car?

9. Vanessa and Ben are getting married. They are loving each other.

10. Anna do not understand this subject.

11. Jessica asks sometimes her parents for advice.

12. Does you do your laundry at the laundromat on the corner?

13. When the color blue mix with the color yellow, the result is green.

14. Jim frys two eggs for breakfast every morning.

15. We are studing English.

PRACTICE 24 ▸ Present time. (Chapter 1 Review)
Choose the correct completions.

Kim: Hi, Anh. Welcome to the university. I'm Kim, your academic advisor. I help / helping new students register for classes.

Anh: Hi, Kim. Nice to meet you.

Kim: Let's see. You need / are needing to take four classes every semester. What's your major?

Anh: I am / do studying business.

Kim: Great. I'm making / make a note of that in your records now. But for this first semester you only need general requirements.

Anh: Do / Are you mean classes like math and science?

Kim: Exactly. I see you come from Vietnam. Do you speak / Are you speaking Vietnamese?

Anh: Yes, I do / am.

Kim: Good. Then you don't / aren't need a foreign language class. You need / needs English Composition and College Algebra. All students need / needs those classes, as well as a science class. Do you want / wanting biology, chemistry, geology, astronomy, or physics?

Ahn: I don't / am not know. What do you recommend?

Kim: Students often choose / choose often Biology or Chemistry for the first semester. Those are both good introductory courses.

Anh: OK. Biology, then.

Kim: Great. Do you want to take an extra class this semester?

Anh: No, I'm not / I don't. Four is enough for my first semester.

Kim: Then we only need / needs one more class to complete your schedule. I usually advise / advise usually students to take history their first semester. How do / does that sound?

Anh: Perfect.

Kim: All right, you're ready. You have / are having English composition, algebra, biology, and history. Have a great semester!

Anh: Thanks for your help.

Complete the crossword puzzle. Use the clues to find the correct words.

Across

1. Mike _____ not have a job. He is unemployed.

2. Most birds _____.

4. Shhh! The movie is _____ now.

6. Textbooks are expensive. My textbook _____ more than my shoes.

Down

1. Sam doesn't _____ to work. He walks. He doesn't own a car.

2. Kim is a pilot. He _____ all over the world.

3. Every year, the university closes for the New Year holiday. Classes _____ again early in January.

5. The baby _____ not sleeping now.

2

Past Time

PRACTICE 1 ▸ Expressing past time: regular verbs. (Chart 2-1)

Write the question and negative forms of the sentences.

1. It started early. _Did it start early?_ _It didn't start early._

2. Ben walked home. _____ _____

3. Hana worked all day. _____ _____

4. Dad planted roses. _____ _____

5. Mom liked the game. _____ _____

6. Kim cooked dinner. _____ _____

7. Nate played tennis. _____ _____

8. They arrived late. _____ _____

9. Sam invited Ava. _____ _____

10. We finished our work. _____ _____

PRACTICE 2 ▸ Simple present and simple past. (Chapter 1 and Chart 2-1)

Complete the chart.

Statement	Question	Negative
1. You work every day.	_Do you work every day?_	You don't work every day.
2. You worked yesterday.	_____?	_____.
3. _____ every day.	_____?	She doesn't work every day.
4. She worked yesterday.	_____?	_____.
5. _____ every day.	Do they work every day?	_____.
6. They worked yesterday.	_____?	_____.
7. _____ every day.	_____?	He doesn't work every day.
8. He worked yesterday.	_____?	_____.

PRACTICE 3 ▸ Expressing past time. (Chart 2-1)

Rewrite the sentences in the past. Use the simple past of the verb in **bold**.

1. Joe **arrives** to class late.

 Joe arrived to class late.

2. We **watch** a lot of movies.

 _____.

3. The kids **play** soccer.

 _____.

4. Sarah **lives** in Canada.

 _____.

5. Amy **listens** to loud music.

 _____.

6. Alex **doesn't work**.

 _____.

7. I **don't walk** to school.

 _____.

8. **Do** you **travel** often?

 _____.

9. **Does** your teacher **help** you with your homework?

 _____.

10. **Does** Ben **play** the piano?

 _____.

PRACTICE 4 ▸ Expressing past time: *yes / no* **questions.** (Charts 2-1 and 2-2)

Complete the questions with *Was, Were,* or *Did*.

1. _____ you go out last night?

2. _____ you go to a party?

3. _____ it fun?

4. _____ it a birthday party?

5. _____ you eat birthday cake?

6. _____ many of your friends there?

7. _____ you meet new people?

8. _____ you have a good time?

9. _____ you stay out late?

10. _____ you tired when you got home?

11. _____ it hard to wake up early this morning?

12. _____ you sleep late today?

PRACTICE 5 ▸ Expressing past time: *yes / no* questions. (Charts 2-1 and 2-2)
Write past tense questions using the *italicized* words and **Did, Was,** or **Were**.

1. *he, study* _____Did he study_____?
2. *he, sick* _____Was he sick_____?
3. *she, sad* _____?
4. *they, eat* _____?
5. *they, hungry* _____?
6. *you, go* _____?
7. *she, understand* _____?
8. *he, forget* _____?

PRACTICE 6 ▸ Expressing past time: *yes / no* questions. (Chart 2-1 and 2-2)
Circle the correct verb form in Sentence A. Then write the correct verb form in Sentence B.
Add **not** as necessary.

1. A: (Was) / Were / Did Albert Einstein alive in this century?

 B: No, he ___wasn't___.

2. A: Was / Were / Did he live in the 20th century?

 B: Yes, he _____.

3. A: Was / Were / Did he a biologist?

 B: No, he _____.

4. A: Was / Is / Did he study physics?

 B: Yes, he _____.

5. A: Was / Is / Did he very intelligent?

 B: Yes, he _____.

6. A: Was / Were / Did he from Europe?

 B: Yes, _____.

7. A: Was / Is / Did he move to China?

 B: No, he _____.

8. A: Are / Was / Did he teach?

 B: Yes, he _____.

9. A: Were / Was / Did his ideas famous?

 B: Yes, they _____.

10. A: Was / Were / Did people around the world know about him?

 B: Yes, they _____.

Einstein

$E = mc^2$

Make a question from the *italicized* words, and give a short answer. Each list has one or two extra words. Some words may be used more than once. Use a capital letter to start the question.

A driver's test

1. *did, pass, you, was*

 A: _____ Did you pass _____ your driver's test yesterday?

 B: Yes, _____ I did _____ .

2. *were, did, you, be*

 A: _____ nervous?

 B: No, _____ .

3. *were, you, did, practice*

 A: _____ a lot before the test?

 B: Yes, _____ .

4. *did, was, the test, be*

 A: _____ difficult?

 B: No, _____ .

5. *you, did, made, make*

 A: _____ any mistakes on the test?

 B: No, _____ .

6. *was, did, the car*

 A: _____ easy to drive?

 B: Yes, _____ .

7. *put, you, did, were*

 A: _____ your new driver's license in your wallet right away?

 B: Yes, _____ !

8. *go, went, you, did*

 A: _____ home right after the test?

 B: No, _____ .

PRACTICE 8 ▶ Spelling of irregular verbs. (Chart 2-3)
Write the past tense of the given verbs.

Part I.

buy b _o_ _u_ _g_ _h_ t

bring br __ __ __ __ t

fight f __ __ __ __ t

think th __ __ __ __ t

teach t __ __ __ __ t

find f __ __ __ d

Part II.

swim sw __ __

drink dr __ __ __

sing s __ __ __

ring r __ __ __

Part III.

blow bl __ __

draw dr __ __

fly fl __ __

grow gr __ __

know kn __ __

throw thr __ __

Part IV.

write wr __ __ __

freeze fr __ __ __

ride r __ __ __

sell s __ __ __

steal st __ __ __

Part V.

hit h __ __

hurt h __ __ __

read r __ __ __

shut sh __ __

cost c __ __ __

put p __ __

quit qu __ __

Part VI.

pay p __ __ d

say s __ __ d

PRACTICE 9 ▶ Word search puzzle. (Chart 2-3)
Circle the irregular past tense of these verbs in the puzzle: **bring, buy, go, grow, say, take**.
The words may be horizontal, vertical, or diagonal.

K	R	T	W	K	C	T
N	G	H	D	E	H	J
S	C	G	C	G	N	N
A	J	U	U	L	L	T
I	Z	O	T	O	O	K
D	B	R	L	R	K	T
M	P	B	G	R	E	W

PRACTICE 10 ▶ Common irregular verbs. (Chart 2-3)
Complete each sentence with the past tense form of the verb.

Everyday...

1. I wake up early.
2. She brings her books to class.
3. We come to class on time.
4. They do their homework.
5. He and I take the bus.
6. Some students forget their homework.

Yesterday...

I _____woke up_____ early.

She _____ her books to class.

We _____ to class on time.

They _____ their homework.

He and I _____ the bus.

Some students _____ their homework.

7. You know the answers. You _____ the answers.

8. I write in my journal. I _____ in my journal

9. Ms. Chow drives to work. Ms. Chow _____ to work.

10. They see their friends. They _____ their friends.

PRACTICE 11 ▸ Common irregular verbs. (Chart 2-3)
Complete the sentences with the past form of the verbs in **bold**.

1. A: You seem a little tired. Did you **go** to bed late last night?

 B: Yes, I did. I ____went____ to bed late because I had a lot of homework.

2. A: Sarah is emptying her backpack. She looks really nervous. Did she **lose** something?

 B: Yes, she did. She _____ her phone.

3. A: How was your shopping trip? Did you **buy** anything?

 B: Yes. I _____ some shoes and a shirt.

4. A: Did you **find** your keys?

 B: Yes, I did. I _____ them on my desk.

5. A: Did you **eat** lunch in the cafeteria?

 B: No, I didn't. I _____ at home today.

6. A: Did you **read** all your messages?

 B: Yes, I did. I _____ them on the bus this morning.

7. A: Did you **hear** about the hurricane?

 B: Yes. I _____ about it on the news last night.

8. A: Did Zoe **leave**?

 B: Yes, she did. She _____ an hour ago.

9. A: Your hair looks different. Did you **get** a haircut?

 B: Not recently. I _____ a haircut about two months ago.

10. A: Did you **speak** English in high school?

 B: No. I _____ Spanish and French.

PRACTICE 12 ▸ Expressing the past. (Charts 2-1 → 2-3)
Complete the conversation with the correct form of the verbs in parentheses.

A: ___Were you___ (*you, be*) OK yesterday? You ___seemed___ (*seem*) upset.
$\quad\quad$ 1 $\quad\quad\quad\quad\quad\quad\quad\quad\quad\quad\quad\quad$ 2

B: I _____ (*have*) a terrible day! First, I _____ (*miss*) my bus because
$\quad\quad$ 3 $\quad\quad\quad\quad\quad\quad\quad\quad\quad\quad\quad\quad$ 4

\quad I _____ (*oversleep*).
$\quad\quad$ 5

A: _____ (*you, set*) an alarm?
　　　　　6

B: Yes, _____ (*do*). I _____ (*set*) the alarm on my phone, but the alarm
　　　　　7　　　　　　　　　　　　8

　　_____ (*not, work*) because the battery died.
　　　　　9

A: But you _____ (*not, be*) late for school yesterday. I _____ (*see*) you
　　　　　　10　　　　　　　　　　　　　　　　　　　　　　　11

　　before class.

B: That's right. I _____ (*take*) a taxi. It _____ (*cost*) a fortune!
　　　　　　　　　12　　　　　　　　　　　　　　　13

　　I _____ (*get*) to school on time, but I _____ (*leave*) my backpack in
　　　　　14　　　　　　　　　　　　　　　　　　　15

　　the taxi.

A: Oh no! _____ (*call*) the driver?
　　　　　　16

B: No, _____ (*do, not*). I _____ (*not, have*) the driver's name or phone
　　　　　17　　　　　　　　　　　　　　18

　　number. And I _____ (*forget*) the name of the taxi company.
　　　　　　　　　19

A: That's terrible! What was in your backpack?

B: Just two books and a notebook. I _____ (*not, lose*) my phone or wallet because they
　　　　　　　　　　　　　　　　　　20

　　were in my pocket.

A: Well, that's good. I hope you have a better day today!

PRACTICE 13 ▸ Spelling of *-ing* and *-ed* forms. (Chart 2-5)
Complete the chart.

End of verb	Double the consonant?	Simple form	*-ing*	*-ed*
-e	*No*	live race	*living*	*lived*
Two Consonants		work start		
Two Vowels + One Consonant		shout wait		
One Vowel + One Consonant		ONE-SYLLABLE VERBS: pat shop		
		TWO-SYLLABLE VERBS: STRESS ON FIRST SYLLABLE listen happen		
		TWO-SYLLABLE VERBS: STRESS ON SECOND SYLLABLE occur refer		
-y		play reply study		
-ie		die tie		

PRACTICE 14 ▸ Spelling of *-ing* forms. (Chart 2-5)

Add *-ing* to the verbs and write them in the correct columns.

begin	✓ hit	learn	take
come	hop	rain	win
cut	hope	study	write

Double the consonant. *(stop → stopping)*	Drop the *-e*. *(live → living)*	Just add *-ing*. *(visit → visiting)*
hitting		

PRACTICE 15 ▸ Spelling of *-ing* forms. (Chart 2-5)

Complete each word with one "*t*" or two "*t*"s to spell the *-ing* verb form correctly. Then write the simple form of the verb for each sentence.

Simple Form

1. I'm wai__*t*__ing for a phone call. 1. _____*wait*_____
2. I'm pe__*tt*__ing my dog. 2. _____*pet*_____
3. I'm bi_____ing my nails because I'm nervous. 3. _____
4. I'm si_____ing in a comfortable chair. 4. _____
5. I'm wri_____ing in my book. 5. _____
6. I'm figh_____ing the urge to have some ice cream. 6. _____
7. I'm wai_____ing to see if I'm really hungry. 7. _____
8. I'm ge_____ing up from my chair now. 8. _____
9. I'm star_____ing to walk to the refrigerator. 9. _____
10. I'm permi_____ing myself to have some ice cream. 10. _____
11. I'm lif_____ing the spoon to my mouth. 11. _____
12. I'm ea_____ing the ice cream now. 12. _____
13. I'm tas_____ing it. It tastes good. 13. _____
14. I'm also cu_____ing a piece of cake. 14. _____
15. I'm mee_____ing my sister at the airport tomorrow. 15. _____
16. She's visi_____ing me for a few days. I'll save some cake and ice cream for her. 16. _____

PRACTICE 16 ▸ Spelling of *-ing* and *-ed* forms. (Chart 2-5)

Complete the chart with the missing verb forms.

Simple Form	-ed	-ing
1. stop	*stopped*	stopping
2. pick		picking
3.	arrived	arriving
4. cry	cried	
5.	walked	
6. play		
7. practice		practicing
8. refer	referred	
9. study		
10. hop		hopping
11. hope		
12. plan		
13.		smiling
14. help		
15. listen		

PRACTICE 17 ▸ Spelling of *-ing* and *-ed* forms. (Chapter 1 and Chart 2-5)

Part I. Write the present progressive (*-ing*) form of each verb.

A TV sportscaster is reporting from the Boston Marathon, the oldest yearly marathon race in the world.

Good morning, ladies and gentlemen. Our coverage of the 2018 Boston Marathon (*begin*)
_____is beginning_____ right now, here on Channel 5. We (*report*) _____ live from
 1 2
Boston. Nearly 30,000 men and women (*run*) _____ in this year's marathon.
 3
Citizens from 85 countries (*compete*) _____ in the 26-mile (42-km) course and (*race*)
 4
_____ through the city of Boston. There they go… the race (*start*) _____
 5 6
now. Some of the runners (*get*) _____ off to a slow start and (*try*) _____
 7 8
to save their strength, but others (*speed*) _____ ahead. The wind is cold, and it (*rain*)
 9
_____ very hard, but the runners (*not, stop*) _____!
 10 11

Part II. Complete the rest of the report. Write the simple past form of the verbs in parentheses.

Here we are at the finish line at the end of the Boston Marathon. It was a great race!

As usual, fans all along the course (*cheer*) _____*cheered*_____ for the runners. They (*shout*)

_____ words of encouragement to them and clearly (*enjoy*) _____ the
　　　　　　2　　　　　　　　　　　　　　　　　　　　　　　　　　　　　　　　　3

famous event.

What a great day for Yuki Kawauchi from Japan! He (*race*) _____ from start to
　　　　　　　　　　　　　　　　　　　　　　　　　　　　　　　　　　　4

finish in 2 hours, 15 minutes, and 54 seconds, and won in the men's division. Kawauchi (*surprise*)

_____ everyone when he (*pass*) _____ Geoffrey Kirui in the last few miles
　　　　　5　　　　　　　　　　　　　　　　　　　　　6

of the race. The women's race was also an exciting event. Desiree Linden was the winner of the women's

division. This was the first win by an American woman in 33 years. She (*finish*)_____
　　　7

in 2 hours, 39 minutes, and 54 seconds. Linden (*admit*) _____ that she almost quit
　　　　　　　　　　　　　　　　　　　　　　　　　　　8

the race because of the bad weather, but instead she (*slow*) _____ down and (*continue*)
　　　　　　　　　　　　　　　　　　　　　　　　　　　　　　9

_____ .
　　　10

Tatyana McFadden made history this year in the wheelchair division when she (*achieve*)

_____ her 22nd World Marathon Major victory, the most wins by any athlete. McFadden
　　　11

(*cross*) _____ the finish line in 2 hours, 4 minutes, and 39 seconds.
　　　　　12

The weather was terrible this year! The athletes (*struggle*) _____ through strong
　　　　　　　　　　　　　　　　　　　　　　　　　　　　　　　　　13

winds and heavy rain. Medical staff (*treat*) _____ nearly 3,000 runners. Several athletes
　　　　　　　　　　　　　　　　　　　　14

(*drop*) _____ out of the race. But 95% of the runners (*manage*) _____ to
　　　　　15　　　　　　　　　　　　　　　　　　　　　　　　　　　　　　　16

finish the race. People are passionate about the Boston Marathon!

PRACTICE 18 ▸ Present and past negatives. (Chapter 1 and Charts 2-1 → 2-5)
All the sentences contain inaccurate information. Make true statements by:
(1) making a negative statement, and
(2) making an affirmative statement using accurate information.

1. a. George flew to school yesterday.

　b. No, he _____*didn't fly*_____ to school yesterday. He _____*rode*_____ his bike.

2. a. Lemons are sweet.

　b. No, lemons _____ sweet. They _____ sour.

3. a. You were a baby in the year 2010.

 b. No, I _____ a baby in 2010. I _____ ten years old in 2010.

4. a. Buddha came from China.

 b. No, Buddha _____ from China. Buddha _____ from Nepal.

5. a. Coffee comes from cocoa beans.

 b. No, coffee _____ from cocoa beans. It _____ from coffee beans.

6. a. You slept outdoors last night.

 b. No, I _____ outdoors last night. I _____ indoors.

7. a. Ice is hot.

 b. No, ice _____ hot. It _____ cold.

8. a. Dinosaurs disappeared a hundred years ago.

 b. No, dinosaurs _____ a hundred years ago. They _____ millions of years ago.

9. a. Our bodies make Vitamin C from sunshine.

 b. No, our bodies _____ Vitamin C from sunshine. They _____ Vitamin D from sunshine.

PRACTICE 19 ▶ Review: simple present, present progressive, and simple past forms.
(Chapter 1 and Charts 2-1 → 2-5)
Complete the chart with the correct forms of the verbs in **bold**.

Every Day	Now	Yesterday
1. He **is** here.	He ___*is*___ here.	He ___*was*___ here.
2. I ___*think*___ about you.	I **am thinking** about you.	I ___*thought*___ about you.
3. We **play** tennis.	We _____ tennis.	We _____ tennis.
4. I _____ juice.	I _____ juice.	I **drank** juice.
5. He _____.	He **is teaching**.	He _____.
6. She _____.	She _____.	She **swam**.
7. You **sleep** late.	You _____ late.	You _____ late.
8. He _____.	He **is reading**.	He _____.
9. They _____ hard.	They _____ hard.	They **tried** hard.
10. We **eat** dinner.	We _____ dinner.	We _____ dinner.

PRACTICE 20 ▶ Past progressive. (Chart 2-6)
Complete the sentences with the past progressive form of the verbs in **bold**.

1. I **am living** in New York right now. This time last year I _____*was living*_____ in New York.

2. What **did** you **do** after you got home? What _____ you _____ between 10 and 11 PM?

3. The kids **are playing** soccer right now. The kids _____ soccer all weekend.

4. Ethan **studies** all the time. He _____ for hours last night.

5. **Did** it **rain** yesterday? _____ it _____ at this time yesterday?

6. **Does** Harper **work** at a restaurant? _____ she _____ there last night?

7. I **am** not **feeling well** today, and I _____ well yesterday.

8. Sebastian **isn't listening** to the teacher right now. He _____ to the teacher during class yesterday.

PRACTICE 21 ▸ Past progressive. (Chart 2-6)

Complete the sentences by using the past progressive form of the verbs in the box. Use each verb only once.

✓hide	look	play	read	ring	sit	talk	watch

1. Jack's wife arranged a surprise birthday party for him. When Jack got home, several people ____*were hiding*____ behind the couch or behind doors. All the lights were out, and when Jack turned them on, everyone shouted "Surprise!"

2. Dan's alarm clock started ringing when the sun rose at 6:30. Dan woke up at 6:45. When Dan woke up, his alarm clock _____.

3. I _____ a movie when my best friend called.

4. While we _____, I dropped my phone and cracked the screen.

5. The bus driver looked at all the passengers on her bus and noticed how quiet they were. Some people _____ games on their phone. Some _____ the news or their messages. Many passengers _____ quietly in their seats and _____ out the windows of the bus.

PRACTICE 22 ▸ Simple past and past progressive. (Chart 2-7)

Complete the sentences. Use the simple past form for one clause and the past progressive form for the other.

Activity in Progress	Nadia	George	Bill
play soccer	break her glasses	score a goal	hurt his foot
hike	find some money	see a bear	pick up a snake
dance	trip and fall	meet his future wife	get dizzy

1. While Nadia ____*was playing*____ soccer, she ____*broke*____ her glasses.

2. George ____*scored*____ a goal while he ____*was playing*____ soccer.

3. Bill _____ his foot while he _____ soccer.

4. While Nadia _____, she _____ some money.

5. George _____ a bear while he _____.

6. Bill _____ a snake while he _____.

7. Nadia _____ and _____ while she _____.

8. While George _____, he _____ his future wife.

9. While Bill _____, he _____ dizzy.

PRACTICE 23 ▸ Simple past and past progressive. (Chart 2-7)

Choose the correct answers.

1. When the professor walked into the classroom, __*d*__. Conversation filled the room.

2. When the professor walked to the front of the class, _____. Then they picked up their pens to take notes.

3. While the professor was giving his lecture, _____. They wanted to remember everything he said.

4. When it was time to board Flight 177, _____.

5. While the professor was speaking, _____. Everyone left the room immediately.

6. When we finally got on the plane, _____.

7. While we were flying over the ocean at night, _____.

8. When we finally landed in the morning, _____.

a. the fire alarm went off

b. the students took notes

c. the students stopped talking

d. students were talking to each other

e. the passengers stood up quickly and took their luggage down from the overhead racks.

f. many of the passengers tried to sleep in their small airplane seats.

g. we lined up at the gate and showed the airline staff our boarding passes.

h. we sat down and fastened our seat belts.

PRACTICE 24 ▸ Simple past and past progressive. (Chart 2-7)

Choose the correct completions.

1. It began to rain while Amanda and I (were walking)/ walked to school this morning.

2. While I was washing / washed the dishes last night, I was dropping / dropped a plate. The plate was breaking / broke.

3. I was seeing / saw Ted at the student cafeteria at lunchtime yesterday. He was eating / ate a sandwich and talking / talked with some friends. I was joining / joined them.

4. Robert didn't answer the phone when Sara called. He was singing / sang his favorite song in the shower and wasn't hearing / didn't hear the phone ring.

5. A: There was a power outage in our part of town last night. Were your lights going out / Did your lights go out, too?

 B: Yes, they did. It was terrible! I was taking / took a shower when the lights went out. My wife was finding / found a flashlight and rescued me from the bathroom. We couldn't cook dinner, so we were eating / ate sandwiches instead. I tried to do some work, but it was too dark, so I was going / went to bed and was sleeping / slept.

PRACTICE 25 ▸ Expressing past time: using time clauses. (Chart 2-8)
Decide what happens first and what happens second. Number the clauses "1" and "2". Then combine the clauses and write a complete sentence.

1. The fire alarm went off. Everyone left the building.
 1 *2*

 When ___the fire alarm went off, everyone left the building___.

2. They left the building. They stood outside in the rain.

 After _____, _____.

3. Everyone started to dance. The music began.

 As soon as _____, _____.

4. The music ended. They danced.

 _____ until _____.

5. The fans cheered. The soccer player scored a goal.

 When _____, _____.

6. Everyone left the stadium. The game was over.

 _____ as soon as _____.

7. Mateo finished his homework. He went to bed.

 Before _____, _____.

8. He woke up. He had some coffee.

 _____ when _____.

PRACTICE 26 ▸ Expressing past habit: *used to*. (Chart 2-9)
Complete the sentences. Use ***used to*** and the given information. Some verbs may be negative.

1. When James was young, he hated school. Now he likes it.

 James ___used to hate school___, but now he likes it.

2. Leah was a secretary for many years, but now she owns her own business.

 Leah _____, but now she owns her own business.

3. Before Adam got married, he played tennis five times a week.

 Adam _____ five times a week.

4. When we raised our own chickens, we had fresh eggs every morning.

We _____ every morning when we raised our own chickens.

5. When Ben was a child, he often crawled under his bed and put his hands over his ears when he heard thunder.

Ben _____ and _____ when he heard thunder.

6. When I lived in my hometown, I went to the beach every weekend. Now I rarely go to the beach.

I _____ every weekend, but now I don't.

7. Joshua has a new job. He wears a suit every day. When he was a student, he always wore jeans.

Joshua _____ every day, but now he wears a suit.

8. When I was young, I wasn't allergic to peanuts. Now I'm allergic to peanuts and can't eat them.

I _____ to peanuts, but now I am.

PRACTICE 27 ▶ Past verbs. (Chapter 2 Review)

Part I. Read the passage about the first cell phone. Circle all the verbs that refer to the present time. <u>Underline</u> all the verbs that refer to the past time.

The First Cell Phone

The first cell phone call was in 1973. A man named Martin Cooper made the first call.

He was working for the Motorola communications company. When Cooper placed the call,

he was walking down a street in New York. People stared at him and wondered about his behavior.

This was before cordless phones, so it looked very strange. It took another ten years before

Motorola had a phone to sell to the public. That phone weighed about a pound (.45 kilogram), and it was very expensive. Now, as you know, cell phones are small enough to put in a pocket, and millions of people around the world have them.

Part II. Read the passage again and then read the statements. Circle "T" if the statement is true and "F" if the statement is false.

1. A customer for Motorola made the first cell phone call. T F

2. Many people looked at Cooper when he was talking on the phone. T F

3. In the 1970s, cordless phones were very popular. T F

4. A year after the first call, Motorola sold phones to the public. T F

Correct the verb errors.

 didn't visit
1. We ~~don't visited~~ my cousins last weekend.

2. They are walked to school yesterday.

3. I was understand all the teacher's questions yesterday.

4. Matt and I was texting when my phone died.

5. When Flora hear the news, she didn't knew what to say.

6. David and Carol go to Italy last month.

7. I didn't drove a car when I am a teenager.

8. Carmen no used to eat fish, but now she does.

9. Did Ms. Piper at school yesterday?

10. Were you seeing that red light? You didn't stopped!

11. I used to living in a big city when I was a child. Now I live in a small town.

12. We maked a pizza for dinner last night.

13. Sophie was breaking her right foot last year. After that, she hoped on her left foot for three weeks.

14. Where did you used to live before you move here?

15. Sorry I miss your call last night. I went to bed as soon as I get home.

Complete the paragraph with the simple past or the past progressive form of the verbs in parentheses.

 Late yesterday afternoon while I (*prepare*) _____was preparing_____ dinner and my son Noah (*play*)

_____, the doorbell (*ring*) _____. The water on the stove (*boil*)
 2 3

_____, so I quickly (*turn*) _____ off the stove and (*answer*)
 4 5

_____ the door. When I (*open*) _____ it, I (*see*) _____ a
 6 7 8

delivery man. He (*hold*) _____ a package. He (*ask*) _____ me
 9 10

to sign for it. At that moment, Noah (*scream*) _____. He cried, "Mommy,
 11

I (*fall*) _____ and (*hurt*) _____ my knee!" I (*slam*)
 12 13

_____ the door shut and (*run*) _____ to Noah to help
 14 15

him. Then I (*hear*) _____ the doorbell again. I remembered that the
 16

delivery man (*wait*) _____ for me to sign for the package! I (*open*)
 17

_____ the door, (*take*) _____ the package, (*thank*)
 18 19

_____ the delivery man, and (*sign*) _____ the receipt.
 20 21

Choose the correct answers.

1. At 3:30 this afternoon, I _____ on the TV.

 a. turned b. was turning c. turning

2. After that, I _____ any more work.

 a. not do b. didn't do c. didn't

3. At 7:34 last night, we _____ dinner when the power went out.

 a. had b. were having c. have

4. We _____ to eat in the dark, so we lit some candles.

 a. didn't want b. didn't wanted c. weren't wanting

5. _____ to the meeting yesterday? What happened?

 a. Do you went b. Did you went c. Did you go

6. _____ Harvey told that funny joke, everyone laughed.

 a. As soon b. Until c. When

7. Kirk was texting and driving at the same time. He was not paying attention to the road _____ he was driving.

 a. after b. while c. until

8. _____ I heard about Kate's new baby, I texted all her friends to share the good news right away.

 a. While b. As soon as c. Before

9. When Grandma was a child, she _____ three miles to school every day.

 a. was walking b. used to walking c. used to walk

10. It _____ when we left our office. The streets were all wet.

 a. rains b. was raining c. rain

11. After the teacher explained the grammar point, all the students _____ it very well.

 a. understood b. were understanding c. used to understand

12. Jim _____ the keys on the table and left the room.

 a. put b. putting c. was putting

13. Alex _____ when I called her last night.

 a. was slept b. sleeps c. was sleeping

14. Emily was still cooking when I _____ at her house for dinner.

 a. was arriving b. arrive c. arrived

15. I didn't _____ my homework until after midnight.

 a. finishing b. finish c. finished

Future Time

PRACTICE 1 ▸ Expressing future time: *be going to* and *will.* (Chart 3-1)

Check (✓) the sentences that refer to future time. <u>Underline</u> the future verb.

✓	1.	Nora <u>is going to be</u> an architect.
_____	2.	She loves modern buildings.
_____	3.	She's studying in Italy now.
_____	4.	She studied in England last year.
_____	5.	She worked part-time at an architecture firm in London.
_____	6.	She will finish her classes next year.
_____	7.	She will design buildings.
_____	8.	She is looking for a job while she is in school.
_____	9.	She likes big cities.
_____	10.	She is going to live in a big city.
_____	11.	She does good work.
_____	12.	She'll be an excellent architect.

PRACTICE 2 ▸ Forms with *be going to.* (Charts 3-2)

Complete the sentences with the correct forms of **be going to**.

1. I (*leave*) _____ *am going to leave* _____ next Monday.

2. Mr. Rose (*leave*) _____ next Monday.

3. Mr. Liu (*not, leave*) _____ next Monday.

4. What about you? (*leave*) _____ you _____ next Monday?

5. Claire (*be*) _____ here next week.

6. Alex and Olga (*be*) _____ here next week.

7. I (*be, not*) _____ here next week.

8. What about Tom? (*be*) _____ he _____ here next week?

9. It (*rain*) _____ tomorrow.

10. It (*not, snow*) _____ tomorrow.

11. What about next weekend? (*rain*) _____ it _____ next weekend?

Complete the chart with the correct forms of the verbs.

be going to		**will**	
I ___am going to___ leave.		I ___will___ leave.	
You _____ leave.		You _____ leave.	
Mr. Rose _____ leave.		He _____ leave.	
We _____ leave.		We _____ leave.	
Our parents _____ leave.		They _____ leave.	
The boys (*not*) _____ leave.		They (*not*) _____ leave.	
Ann (*not*) _____ leave.		She (*not*) _____ leave.	
I (*not*) _____ leave.		I (*not*) _____ leave.	

Read the passage. Change all the verbs with *be going to* to *will*.

A 50th Wedding Anniversary Celebration

 will
 The Smiths ~~are going to~~ celebrate their 50th wedding anniversary on December 1st of this

year. Their children are planning a party for them at a local hotel. Their family and friends are

going to join them for the celebration.

 Mr. and Mrs. Smith have three children and five grandchildren. The Smiths know that two

of their children are going to be at the party, but their youngest daughter is far away in Africa. She

is doing medical research there. They believe she is going to be in Africa at the time of the party.

 The Smiths don't know it, but their youngest daughter is going to come home. She is

planning to surprise them. It is going to be a wonderful surprise for them! They are going to be

very happy to see her. The whole family is going to enjoy being together for this special occasion.

Use the information in *italics* to complete the questions. Write the question forms for both *will* and *be going to*.

1. Nick is thinking about *starting* an online business. His friends are wondering:

 ___Will Nick start___ an online business?

 ___Is Nick going to start___ an online business?

2. Mr. Jones is thinking about *giving* a test. His students are wondering:

 _____ a test?

 _____ a test?

3. Jacob is thinking about *quitting* his job. His co-workers are wondering:

 _____ his job?

 _____ his job?

4. Mr. and Mrs. Kono are thinking about *adopting* a child. Their friends are wondering:

_____ a child?

_____ a child?

5. The Johnsons are thinking about *moving*. Their friends are wondering:

_____?

_____?

6. Dr. Johnson is thinking about *retiring*. Her patients are wondering:

_____?

_____?

PRACTICE 6 ▸ Forms with *will*. (Chart 3-3)

Put the words in *italics* in the correct order to complete the sentence or question. Capitalize the first letter if necessary.

1. *will, be, tomorrow*

 Today is Tuesday. _____*Tomorrow will be*_____ Wednesday.

2. *have, we, will*

 We often have tests. _____ a test tomorrow?

3. *have, will, we*

 No, but _____ a test next week.

4. *will, be, the test*

 Our tests are sometimes difficult. _____ difficult?

5. *not, be, will*

 No. The test _____ difficult.

6. *pass, I, will*

 I'm nervous. _____ the test?

7. *will, pass, you*

 Yes. _____ the test.

8. *pass, will, not*

 Jack never studies. He _____ the test.

PRACTICE 7 ▸ Present, past, and future. (Chapters 1 → 3)

Complete the sentences with the given verbs in parentheses. For "a." use the simple present. For "b." use the simple past. For "c." use the future with **be going to**, and for "d." use the future with **will**.

1. (*arrive*) a. Joe _____*arrives*_____ on time **every day**.

 b. Joe _____*arrived*_____ on time **yesterday**.

 c. Joe ___*is going to arrive*___ on time **tomorrow**.

 d. Joe _____*will arrive*_____ on time **tomorrow**.

2. (*eat*) a. Annie _____ breakfast **every day**.

 b. Annie _____ breakfast **yesterday**.

 c. Annie _____ breakfast **tomorrow**.

 d. Annie _____ breakfast **tomorrow**.

3. (*arrive, not*) a. Mike _____ on time **every day**.

b. Mike _____ on time **yesterday**.

c. Mike _____ on time **tomorrow**.

d. Mike _____ on time **tomorrow**.

4. (*eat*) a. _____ you _____ breakfast **every day?**

b. _____ you _____ breakfast **yesterday?**

c. _____ you _____ breakfast **tomorrow?**

d. _____ you _____ breakfast **tomorrow?**

5. (*eat, not*) a. I _____ breakfast **every day**.

b. I _____ breakfast **yesterday**.

c. I _____ breakfast **tomorrow**.

d. I _____ breakfast **tomorrow**.

PRACTICE 8 ▸ Forms with *will* and contractions. (Chart 3-3)

Complete each paragraph with contractions of *will* and the correct verbs in *italics*.

1. *begin, enjoy, teach*

 Howard and I are going to take a painting class. I think we _____*'ll enjoy*_____ it very much. It

 _____ next month. The teacher of the class is John Mack. He's very good with beginners

 like us. He _____ us everything we need to know.

2. *be, call*

 I can't talk right now, Tina. Our friends are coming for dinner, and they _____ here in

 half an hour. I _____ you back tomorrow.

3. *drive, ride, start*

 Our daughter is four years old. She _____ school in the fall. Two other kids from our

 neighborhood are the same age. When school begins, they _____ to school together in a

 carpool.* The parents will drive them on different days. I _____ them on Mondays and

 Thursdays.

*carpool = a group of people who travel together to work, school, etc., in one car

PRACTICE 9 ▸ Forms with *will* and *be going to*. (Charts 3-2 and 3-3)

Complete the conversations with *will* or *be going to*. Note: Pronouns are <u>not</u> contracted with helping verbs in short answers. CORRECT: *Yes, I will.* INCORRECT: *Yes, I'll.*

1. A: (*you, help*) _____<u>Will you / Are you going to help</u>_____ me tomorrow?

 B: Yes, _____<u>I will / I am</u>_____. OR No, _____<u>I won't / I'm not</u>_____.

2. A: (*Paul, have*) _____ have lunch with us?

 B: Yes, _____. OR No, _____.

3. A: (*Jane, graduate*) _____ this spring?

 B: Yes, _____. OR No, _____.

4. A: (*her parents, be*) _____ at the ceremony?

 B: Yes, _____. OR No, _____.

5. A: (*you, answer*) _____ your texts messages?

 B: Yes, _____. OR No, _____.

6. A: (*Jill, text*) _____ you again tomorrow?

 B: Yes, _____. OR No, _____.

PRACTICE 10 ▸ *Be going to* vs. *will*. (Chart 3-5)

Decide whether the sentence with *will* or *be going to* expresses a prediction, a prior plan, or a decision at the moment of speaking.

1. The weather will be nice tomorrow.

 a. prediction b. prior plan c. decision at the moment of speaking

2. The weather is going to be nice tomorrow.

 a. prediction b. prior plan c. decision at the moment of speaking

3. Shelly isn't answering her phone. I'll try again later this afternoon.

 a. prediction b. prior plan c. decision at the moment of speaking

4. We're going to see my favorite band in concert. We bought tickets two months ago.

 a. prediction b. prior plan c. decision at the moment of speaking

5. Our team is going to win the game.

 a. prediction b. prior plan c. decision at the moment of speaking

6. Our team will win the game.

 a. prediction b. prior plan c. decision at the moment of speaking

7. You can't find your phone? Wait. I'll call your number.

 a. prediction b. prior plan c. decision at the moment of speaking

8. Uh-oh! My phone battery is very low. It's going to run out of power in a few minutes.

 a. prediction b. prior plan c. decision at the moment of speaking

9. You're sick? Stay home. I'll get you anything you need.

 a. prediction b. prior plan c. decision at the moment of speaking

10. Jenny and I have a lunch date. We're going to meet at Gusto Café at noon.

 a. prediction b. prior plan c. decision at the moment of speaking

11. I'm sorry. I can't have dinner with you tonight. I'm going to help Harry with his science project. He's building a rocket!

 a. prediction b. prior plan c. decision at the moment of speaking

PRACTICE 11 ▸ *Be going to* vs. *will.* (Chart 3-5)

Part I. Complete each conversation with the correct form of ***be going to*** and a verb from the box. Use each verb only once.

get	move	stream	✓work

At the office
1. A: It's 5:00. Are you leaving the office soon?
 B: No, I ___'m going to work___ late tonight.

At home
2. A: It's almost 8:00. Don't you want to watch the game?
 B: The game is tomorrow night. I _____ this movie instead.

At a party
3. A: Do you still live on Tenth Avenue?
 B: Yes, we do, but only for a few more days. We _____ on Saturday. We just bought a small house about ten miles north of the city.

Conversation between friends
4. A: The flu is really bad this year. I'm worried about it.
 B: Me too. I _____ my flu shot this afternoon. I made an appointment with my doctor for it.

Part II. Complete each conversation with the correct form of ***will*** and a verb from the box. Use each verb only once. You may use contractions.

✓answer	ask	clean	pay

At the office
1. A: No one is at the front desk, and the phone's ringing.
 B: I ___'ll answer___ it.

At a store
2. A: I'd like to return this jacket.
 B: We usually don't allow returns on sale items, but I _____ the manager.

At a restaurant
3. A: Let's split the check.
 B: No, no. You paid last time. I _____ this time.

At home
4. A: Oops. I just spilled my coffee.
 B: No problem. I _____ it up.

PRACTICE 12 ▸ Be going to vs. will. (Chart 3-5)

Complete the sentences with either **be going to** or **will**. Use contractions.

1. SITUATION: Speaker B is planning to listen to the news at six.

 A: Why did you turn on the radio?

 B: I ____'m going to_____ listen to the news at six.

2. SITUATION: Speaker B didn't have a plan to show the other person how to solve the math problem, but she is happy to do it.

 A: I can't figure out this math problem. Do you know how to do it?

 B: Yes. Give me your pencil. I _____ show you how to solve it.

3. SITUATION: Speaker B has made a plan. He is planning to lie down because he doesn't feel well.

 A: What's the matter?

 B: I don't feel well. I _____ lie down for a little while. If anyone calls, tell them I'll call them later.

 A: Okay. I hope you feel better.

4. SITUATION: Speaker B did not plan to take the other person home. He offers to do it only after the other person talks about missing his bus.

 A: Oh, no! I wasn't watching the time. I missed my bus.

 B: That's okay. I _____ give you a ride home.

 A: Hey, thanks!

5. SITUATION: Speaker B has already made her plans about what to wear. Then Speaker B volunteers to help.

 A: I can't figure out what to wear to the dinner tonight. It's informal, isn't it?

 B: Yes. I _____ wear a pair of nice jeans.

 A: Maybe I should wear my jeans too. But I think they're dirty.

 B: I _____ wash them for you. I'm planning to do a load of laundry in a few minutes.

 A: Really? Thanks! That'll help a lot.

PRACTICE 13 ▸ Be going to vs. will. (Chart 3-5)

Choose the correct completions.*

1. A: Anya is on the phone. She would like an appointment with you soon.

 B: Okay. Let's see. I have some time tomorrow. I am going to / will see her tomorrow.

2. A: How about joining us for dinner on Friday evening?

 B: We would love to, but we can't. We are going to / will fly to Florida on Friday.

3. A: Would you like tickets to the rock concert on Saturday night? We have two extra tickets.

 B: Thanks, but we already have tickets. We are going to / will go to that concert too.

4. A: Why are you leaving the office so early?

 B: I am going to / will see my dentist. I have a terrible toothache.

*Usually **be going to** and **will** are interchangeable: you can use either one of them with little difference in meaning. Sometimes, however, they are NOT interchangeable. In Practice 13, only one of them is correct, not both. See Chart 3-5 in the Student Book.

5. A: My friend's cat had eight kittens, Mom! Can we have one?

 B: A new kitten? Well, I don't know…

 A: Please, Mom. They're so cute! And my friend can't keep them all.

 B: Well, okay. We are going to /
 will take one.

 A: Yay! Thanks, Mom!

6. A: Where are you going?

 B: I have an eye appointment.
 I am going to / will get new glasses.

 A: Oh, good luck!

7. A: Do you need help with those packages?

 B: Well…

 A: Don't worry. I am going to / will carry them for you.

 B: Thank you!

PRACTICE 14 ▸ *Will probably.* (Chart 3-6)

Complete the sentences.

Part I. Use a pronoun + *will / won't*. Use *probably*.

1. I went to the library last night, and _____I'll probably go_____ there tonight too.

2. Camila didn't come to class today, and _____she probably won't come_____ to class tomorrow either.

3. Liam went to bed early last night, and _____ to bed early tonight too.

4. Jack didn't finish his homework today, and _____ it tomorrow either.

5. The students had a quiz today, and _____ one tomorrow too.

Part II. Use a pronoun + *be going to / not be going to*. Use *probably*.

6. I streamed a show last night, and _____I'm probably going to stream_____ a show tonight too.

7. I wasn't at home last night, and _____ at home tonight either.

8. My friends didn't come over last night, and _____ over tonight either.

9. Alice didn't ride her bike to school today, and _____ it to school tomorrow either.

10. It's cold today, and _____ cold tomorrow too.

PRACTICE 15 ▸ Certainty about the future. (Chart 3-6)

How certain is the speaker? Check (✓) the correct box.

	100% Certain	About 90% Certain	About 50% Certain
1. You'll probably hear from our office tomorrow.		✓	
2. Alan may not finish his work on time.			
3. Eva may call later.			
4. Carlos is probably going to buy a new car.			
5. Maybe Sanji is going to study architecture.			
6. You will find the key in my top drawer.			
7. Amira is going to drive to California.			
8. Eric is probably going to fail this class.			
9. Maybe Sam will be here later.			
10. The plane will probably arrive on time.			
11. The judge may not agree with you.			
12. I probably won't be here tomorrow.			

PRACTICE 16 ▸ Certainty about the future. (Chart 3-6)

Answer each question. Use the words in parentheses and pay special attention to word order.

Joel and Lily's Wedding

1. A: Are Joel and Lily going to have a simple wedding? (*probably*)

 B: Yes. They _____*are probably going to have*_____ a simple wedding.

2. A: Are they going to invite a lot of people? (*probably not*)

 B: No. They _____ a lot of people.

3. A: Will they have the wedding reception in Lily's garden? (*may*) Or will they have it at a hotel? (*maybe*)

 B: They're not sure. They _____ the ceremony in Lily's garden.

 _____ they _____ it at a hotel.

4. A: Is Lily going to rent her wedding dress? (*may*)

 B: She's trying to save money, so she's thinking about it. She _____ her wedding dress.

5. A: Will she decide that she wants her own wedding dress? (*probably*)

 B: She _____ that she wants her own wedding dress.

6. A: Will Joel feel very relaxed on his wedding day? (*may not*) Will he be nervous? (*may*)

 B: Joel _____ very relaxed on his wedding day. He _____ a little nervous.

7. A: Are they going to go on a honeymoon? (*will*)

 B: Yes. They _____ on a honeymoon immediately after the wedding, but they haven't told anyone where they are going to go.

8. A: Will they go far away for their honeymoon? (*probably not*)

 B: They _____ far. They have only a few days before they need to be back at work.

Underline the time clauses.

1. Before Bill met Maggie, he was lonely.

2. He was an unhappy man until he met Maggie.

3. When he met Maggie, he fell in love.

4. He became a happy person after he met her.

5. After they dated for a year, he asked her to marry him.

6. As soon as Bill gets a better job, they will set a date for the wedding.

7. They will get married before they buy a house.

8. They will buy a house when they have enough money.

9. After they get married, they will live together happily.

10. They will live together happily until they die.

Combine the ideas of the two given sentences into one sentence by using a time clause. Use the word in parentheses to introduce the time clause.

1. *First:* I'm going to finish my homework.
 Then: I'm going to go to bed.
 (after) ___*After I finish*___ my homework, ___*I'm going to go*___ to bed.

2. *First:* I'll finish my homework.
 Then: I'm going to go to bed.
 (until) _____ to bed _____ my homework.

3. *First:* Layla will finish her homework.
 Then: She will watch a movie tonight.*
 (before) _____ a movie tonight, _____ her homework.

4. *First:* Jim will get home tonight.
 Then: He's going to read the news.
 (after) _____ the news _____ home tonight.

5. *First:* I'll call John tomorrow.
 Then: I'll ask him to my party.
 (when) _____ John tomorrow, _____ him to my party.

6. *First:* Ms. Torres will stay at her office tonight.
 Then: She will finish her report.
 (until) _____ at her office tonight _____ her report.

7. *First:* I will get home tonight.
 Then: I'm going to take a hot bath.
 (as soon as) _____ home tonight, _____ a hot bath.

*The noun usually comes before the pronoun when you combine clauses:
*After **Ann** eats dinner, **she** is going to study.*
***Ann** is going to study after **she** eats dinner.*

PRACTICE 19 ▸ If-clauses. (Chart 3-7)

Complete each sentence by using an **if-clause** with the given ideas. Use a comma if necessary.*

1. Maybe it will rain tomorrow.

 _____*If it rains tomorrow,*_____ I'm going to go to a movie.

2. Maybe it will be hot tomorrow.

 _____ I'm going to go swimming.

3. Maybe Adam will have enough time.

 Adam will finish his essay tonight _____.

4. Maybe I won't exercise at the gym tomorrow.

 _____ I'll run in my neighborhood.

5. Perhaps I'll get a raise soon.

 We will take a nice vacation trip next summer _____.

6. Maybe Jia won't study for her test.

 _____ she'll get a bad grade.

7. Maybe I will have enough money.

 I'm going to go to Hawaii for my vacation _____.

8. Maybe I won't study tonight.

 _____ I probably won't pass the chemistry exam.

9. Maybe we won't have class tomorrow.

 I'm going to sleep late _____.

10. Perhaps John won't play soccer this weekend.

 _____ he will help you move this weekend.

PRACTICE 20 ▸ Future time clauses and *if*-clauses. (Chart 3-7)

Choose the correct completions. Pay attention to the words in **bold**.

Sam and I are going to leave on a road trip tomorrow. We'll pack our suitcases and put everything in the car **before** we go / will go to bed tonight. We'll leave tomorrow morning very early, **as soon as** the sun will come / comes up. We'll drive for a couple of hours on the highway **while** we will talk / talk and listen / will listen to our favorite music. **When** we will see / see a nice rest area, we'll stop for coffee. **After** we walk / will walk around the rest area a little bit, we'll get back in the car and drive a little longer. We'll stay on that highway **until** we come / will come to Highway 44. Then we'll turn off and drive on scenic country roads. **If** Sam will get / gets tired, I'll drive. Then **when** I drive / will drive, he'll probably take a little nap. We'll keep going **until** it will get / gets dark.

*Notice the punctuation in the example. A comma is used when the **if**-clause comes before the main clause. No comma is used when the **if**-clause follows the main clause.

PRACTICE 21 ▸ Future time clauses. (Chart 3-7)

Choose the correct answers.

Facts:

• Water boils at 100 degrees Celsius (100° C) or 212 degrees Fahrenheit (212° F).
• Water freezes★ at 0 degrees Celsius (0° C) or 32 degrees Fahrenheit (32° F).
• Spring follows winter.

1. The plants will die from the cold if _____.
2. If freezing weather from the north arrives tonight, _____.
3. Water boils when _____.
4. When you put water in a pot and turn the stove on high, soon _____.
5. The flowers will bloom when _____.
6. After this long winter finally ends, _____.
7. If you leave ice cream at room temperature, _____.

a. the temperature reaches 212° F
b. spring comes
c. spring will come
d. it will melt★★
e. the temperature falls below 0° C
f. the water will boil
g. the temperature will fall below 0° C

PRACTICE 22 ▸ Future time clauses and *if*-clauses. (Chart 3-7)

Combine the given ideas into one sentence by using the word in *italics* to make an adverb clause. Omit the words in parentheses from your new sentence. <u>Underline</u> the adverb clause.

1. *when* a. Mei is going to buy an apartment (then).

 b. Mei is going to have enough money (first).

 _____ *When Mei has enough money* _____, she is going to buy an apartment. OR

 Mei is going to buy an apartment _____ *when she has enough money* _____.

2. *before* a. I'm going to clean up my apartment (first).

 b. My friends are going to come over (later).

3. *when* a. The storm will be over (in an hour or two).

 b. I'm going to do some errands (then).

4. *if* a. (Maybe) you won't update your skills.

 b. (As a result), you will have trouble finding a job.

5. *as soon as* a. Joe is going to meet us at the coffee shop.

 b. He is going to finish his report (soon).

★*freeze* = change from liquid to solid
★★*melt* = change from solid to liquid

6. *after* a. Lesley will wash and dry the dishes.

 b. (Then) she will put them away.

7. *if* a. They may not leave at seven.

 b. (As a result), they won't get to the theater on time.

PRACTICE 23 ▸ Review: past and future. (Chapter 2 and Charts 3-1 → 3-7)

Read Part I. Use the information in Part I to complete Part II with the correct verb forms. Use *will* (not *be going to*) for future time in Part II. Use the simple present form for present time.

Part I.

 Yesterday morning was an ordinary morning. I got up at 6:30. I took a shower and brushed my teeth. Then I put on my jeans and a sweater. I went to the kitchen and turned on the coffee maker. While I was waiting for my coffee to brew, I took my dog for a walk around the neighborhood. My neighbor's cat was playing in our front yard. My dog started barking loudly at the cat. When my dog barked, the cat ran away.

 As soon as I got back to the kitchen, I poured myself a cup of coffee and read the news on my tablet. While I was reading the news, my teenage daughter came downstairs. We talked about her plans for the day. We had breakfast together, and I made a lunch for her to take to school. After we said good-bye, I finished my coffee.

 Then I went to my office. It is in my home. My office has a desk, a computer, a printer, and a lot of bookshelves. I worked all morning. While I was working, my phone rang many times. I talked to a lot of people. At 11:30, I went to the kitchen and made a sandwich for lunch. As I said, it was an ordinary morning.

Part II.

 Tomorrow morning _____*will be*_____ an ordinary morning. I _____*'ll get*_____ up at
 1 2

6:30. I _____*'ll wash*_____ my face and _____*brush*_____ my teeth. Then I _____
 3 4 5

probably _____ on my jeans and a sweater. I _____ to the kitchen and
 6 7

_____ the coffee maker. While I _____ for my coffee to brew,
 8 9

I _____ my dog for a walk. If my neighbor's cat is playing in the front yard, my dog
 10

_____ barking loudly. When my dog _____, the cat _____
 11 12 13

away.

 As soon as I _____ back to the kitchen, I _____ myself a
 14 15

cup of coffee and _____ the news. While I'm reading, my teenage daughter
 16

_____ downstairs. We _____ about her plans for the day. We
 17 18

_____ breakfast together, and I _____ a lunch for her to take to school.
 19 20

After we _____ good-bye, I _____ my coffee.
 21 22

Then I _____ to my office. It _____ in my home. My office
 23 24
_____ a desk, a computer, a printer, and a lot of bookshelves. I _____ all
 25 26
morning. While I'm working, my phone _____ many times. I _____ to
 27 28
many people. At 11:30, I _____ to the kitchen and _____ a sandwich for
 29 30
lunch. As I said, it _____ an ordinary morning.
 31

PRACTICE 24 ▸ Using *be going to* and the present progressive to express future time. (Chart 3-8)

Rewrite the sentences with **be going to** and the present progressive.

1. I'm planning to stay home tonight.

 ____*I'm going to stay*____ home tonight.

 _____*I'm staying*_____ home tonight.

2. My parents are planning to travel across the country by train this summer.

 _____ across the country by train this summer.

 _____ across the country by train this summer.

3. My boyfriend and I are planning to get married in June.

 _____ married in June.

 _____ married in June.

4. Xavier is planning to start graduate school next year.

 _____ graduate school next year.

 _____ graduate school next year.

5. My manager is planning to go to New Zealand next month.

 _____ to New Zealand next month.

 _____ to New Zealand next month.

6. My neighbors are planning to build their dream home this spring.

 _____ their dream home this spring.

 _____ their dream home this spring.

PRACTICE 25 ▸ Using the present progressive to express future time. (Chart 3-8)

Complete the sentences with the present progressive. Use each verb in the box only once. Note the future time expressions in **bold**.

come	give	graduate	have	leave	meet	take	✓travel

1. Katey ____*is traveling*____ to Caracas **next month** to attend a conference.

2. Cameron _____ the office **early today**. He just made an appointment with the dentist for 3:00 P.M. He has a terrible toothache.

3. The president _____ a speech **at noon today**.

4. We _____ a party **tomorrow**. Would you like to come?

5. Amanda likes to take her two children with her on trips whenever she can, but she _____ not _____ them with her to El Paso, Texas, **next week**. It's strictly a business trip.

6. A: Your apartment is so neat! Are you expecting guests?

 B: Yes. My parents _____ **tomorrow** for a short visit.

7. A: Do you have any plans for lunch today?

 B: I _____ Shannon at the Island Café **in an hour**. Want to join us?

8. A: Will you be at Ada and Alberto's tenth anniversary party **next Friday**?

 B: No, unfortunately. I also have a very important event on that day. I _____ from college, finally!

PRACTICE 26 ▶ Using the present progressive to express future time. (Chart 3-8)
Decide whether each sentence refers to a plan for the future or a prediction.

1. A big storm is going to hit the coast tomorrow.

 a. a plan for the future b. a prediction

2. We are going to leave for a safer location later today.

 a. a plan for the future b. a prediction

3. Ralph is going to go to medical school after he graduates from college.

 a. a plan for the future b. a prediction

4. Ralph is smart and serious. I am sure he is going to be an excellent doctor.

 a. a plan for the future b. a prediction

5. This car is going to run out of gas very soon! The indicator is on empty.

 a. a plan for the future b. a prediction

6. We're going to stop to get gas at the next gas station.

 a. a plan for the future b. a prediction

7. This little seed is going to be a large tree one day.

 a. a plan for the future b. a prediction

8. We are going to plant vegetables in our garden tomorrow.

 a. a plan for the future b. a prediction

PRACTICE 27 ▶ Using the present progressive to express future time. (Chart 3-8)
Check (✓) the correct sentence. Both sentences may be correct.

1. _____ a. It is going to snow tomorrow.
 _____ b. It is snowing tomorrow.

2. _____ a. I'm going to attend a conference in April.
 _____ b. I'm attending a conference in April.

3. _____ a. Irv is going to come for dinner tomorrow night.
 _____ b. Irv is coming for dinner tomorrow night.

4. _____ a. A new restaurant is going to open next month.
 _____ b. A new restaurant is opening next month.

5. _____ a. This old building is going to fall down pretty soon.
 _____ b. This old building is falling down pretty soon.

6. _____ a. Jackie and I are going to take her uncle out to dinner tonight.

 _____ b. Jackie and I are taking her uncle out to dinner tonight.

7. _____ a. You're going to feel better after you take that medicine.

 _____ b. You're feeling better after you take that medicine.

8. _____ a. The plane is going to leave on time.

 _____ b. The plane is leaving on time.

9. _____ a. Take an umbrella. If you don't, you're going to get wet.

 _____ b. Take an umbrella. If you don't, you're getting wet.

10. _____ a. I ordered a new phone. It's going to arrive next week.

 _____ b. I ordered a new phone. It's arriving next week.

PRACTICE 28 ▶ Using the simple present to express future time. (Chart 3-9)

Complete the sentences using the verbs from the box. Use the simple present to express future time.

arrive	close	end	get	leave	start
begin	depart	finish	in	open	

1. A: What time _____does_____ class _____begin / start_____ tomorrow morning?

 B: It _____begins / starts_____ at eight o'clock sharp.

2. A: The coffee shop _____ at 7:00 tomorrow morning. I'll meet you there at 7:15.

 B: Okay. I'll be there.

3. A: What time are you going to go to the airport tonight?

 B: Tom's plane _____ around 7:15, but I think I'll go a little early. It might arrive a

 little ahead of schedule.

4. A: What's the hurry?

 B: I've got to take a shower, change clothes, and get to the stadium fast. The game

 _____ in forty-five minutes, and I don't want to miss the beginning.

5. A: What time _____ the dry cleaners _____ this evening? If I don't

 get there in time, I'll have nothing to wear to the party tonight.

 B: It _____ at 6:00. I can pick up your dry cleaning for you.

 A: Hey, thanks! That'll really help!

6. A: What time should we go to the theater tomorrow night?

 B: The doors _____ at 6:00 P.M., but we don't need to be there that early. The show

 _____ at 8:00. If we _____ at the theater by 7:15, we'll be there in

 plenty of time. The show _____ around 10:30, so we can be back home by a little

 after 11:00.

7. A: I've enjoyed my visit with you, but tomorrow I have to go back home.

 B: What time _____ your flight _____ tomorrow?

 A: It _____ at 12:34 P.M. I want to be at the airport an hour early, so we should

 leave here around 10:30, if that's okay with you.

 B: Sure. What time _____ your flight _____ in Mexico City?

 A: It's about a three-hour flight. I'll get in around 4:30 Mexico City time.

PRACTICE 29 ▸ Using *be about to*. (Chart 3-10)

Choose the correct answers.

What does it usually mean if...

1. the sky is very gray and cloudy? _____
2. Jack is leaving his house with his keys in his hand? _____
3. the teacher is picking up a marker? _____
4. it is 6:59 A.M. and your alarm clock is set for 7:00 A.M.? _____
5. it is 7:58 P.M. and the president is going to give a speech at 8:00 P.M.? _____
6. Tim is holding a fork in his hand and looking at a plate of warm pasta? _____
7. Bob is standing up inside a canoe? _____
8. the plane is slowly coming toward the runway and its wheels are down? _____

a. It means that he is about to write on the board.
b. It means that he is about to speak.
c. It means that he is about to eat.
d. It means that it is about to rain.
e. It means that it is about to land.
f. It means that he is about to get into his car.
g. It means that he is about to fall out.
h. It means that it is about to ring.

PRACTICE 30 ▸ Parallel verbs. (Chart 3-11)

Complete the sentences with the correct form of the verbs in parentheses.

1. My classmates are going to meet at Danny's and (*study*) _____*study*_____ together tonight.
2. Tomorrow the sun will rise at 6:34 and (*set*) _____ at 8:59.
3. Last night, I was listening to music and (*do*) _____ my homework when Kim stopped by.
4. Next weekend, Nick is going to meet his friends downtown and (*go*) _____ to a soccer game.
5. My phone slipped out of my hand and (*fall*) _____ to the floor.
6. Alex is (*send*) _____ a text and (*wait*) _____ for a response.
7. Every morning, Ms. Carter (*take*) _____ her dog for a walk and (*get*) _____ a cup of coffee at Charlie's café.
8. Before I (*go*) _____ to your manager and (*tell*) _____ her about your mistake, I want to give you an opportunity to explain it to her yourself.
9. Next month, I (*take*) _____ my vacation and (*forget*) _____ about work.
10. Kathy thinks I was the cause of her problems, but I wasn't. Someday she (*discover*) _____ the truth and (*apologize*) _____ to me.

PRACTICE 31 ▸ Check your knowledge. (Chapter 3 Review)

Correct the errors.

1. My friends will to join us after work.

2. Maybe the party ends soon.

3. On Friday, our school close early so teachers can go to a workshop.

4. It's raining tomorrow.

5. Our company is going to sells computer equipment to schools.

6. Give Grandpa a hug. He's about to leaving.

7. Mr. Scott is going to retire and moving to a warmer climate.

8. If your soccer team will win the championship tomorrow, we'll have a big celebration for you.

9. I bought this cloth because I will make some curtains for my bedroom.

10. I moving to London when I will finish my education here.

11. Are you going go to the meeting?

12. I opened the door and walk to the front of the room.

13. When will you going to move into your new apartment?

14. Maybe I celebrate my 30th birthday with my friends at a restaurant.

PRACTICE 32 ▸ Verb tense review. (Chapters 1 → 3)
Complete the sentences with the correct form of the verbs in parentheses.

Part I.

Right now it's almost midnight. I'm still at my computer. I (work) _____am working_____ late
 1
tonight because I (need) _____ to finish this report before tomorrow. Before
 2
I (go) _____ to bed tonight, I (finish) _____ the report and (send)
 3 4
_____ some messages.
 5

Part II.

I (stay) _____ up very late last night too. While I (read)
 6
_____ a book, I (hear) _____ a noise outside.
 7 8

a raccoon

When I (go) _____ outside to find out about the noise, I (see, not)
 9
_____ anything in the dark. But when I (go) _____ outside
 10 11
early this morning, I (find) _____ garbage all over my lawn. A raccoon
 12
probably (make) _____ the mess.
 13

mowing the grass

Part III.

Jack (watch) _____ a football game right now. He (watch, always) _____
 14 15
football on Sunday afternoons. As soon as the game (be) _____ over, he (mow)
 16
_____ the grass in the back yard.
 17

Part IV.

It's cold today. Right now I (make) _____ potato soup. It (cook) _____ on
 18 19
the stove. When I (be) _____ a kid, my mother (make, use to) _____ potato
 20 21
soup for me when the weather (get) _____ cold.
 22

Part V.

We (go) _____ 23 _____ to New York next week. When we (be) _____ 24 _____ in New York next week, we (see) _____ 25 _____ a couple of plays on Broadway. Last week we (buy) _____ 26 _____ tickets online for two plays. We (buy, always) _____ 27 _____ the tickets online before we (leave) _____ 28 _____ on a trip. We (stay, usually) _____ 29 _____ at a small hotel near the theater district. But, when we (be) _____ 30 _____ in New York next week, we (stay, not) _____ 31 _____ at that hotel. When we (try) _____ 32 _____ to make reservations last week, the hotel (be) _____ 33 _____ full. We (stay, may) _____ 34 _____ with friends in the city, or maybe we (stay) _____ 35 _____ with our cousins in the suburbs.

Part VI.

Mark is crazy about video games. He (play) _____ 36 _____ video games morning, noon, and night. Sometimes he (skip) _____ 37 _____ class to play them. Right now, he (do, not) _____ 38 _____ very well in school. If he (study, not) _____ 39 _____ harder and (go) _____ 40 _____ to class every day, he (fail) _____ 41 _____ his classes.

Part VII.

I had a dream last night. In the dream, I (see) _____ 42 _____ the man who stole my backpack from my car last Friday. I (run) _____ 43 _____ after him, (catch) _____ 44 _____ him, and (knock) _____ 45 _____ him down. A passerby (call) _____ 46 _____ the police. I sat on the man while I (wait) _____ 47 _____ for them to come. After the police (get) _____ 48 _____ there and (understand) _____ 49 _____ the situation, they (put) _____ 50 _____ handcuffs on him and (take) _____ 51 _____ him to jail. Then the dream (end) _____ 52 _____ and I (wake) _____ 53 _____ up.

Part VIII.

My neighbor, Hannah, (love) _____ 54 _____ animals. She (have) _____ 55 _____ six cats. She (get) _____ 56 _____ a dog last month. At first, the cats (like, not) _____ 57 _____ the new dog, but now they get along very well. I (take) _____ 58 _____ care of Hannah's animals this week while she is on vacation. I (have, not) _____ 59 _____ any pets of my own. My apartment (be) _____ 60 _____ too small for a pet. Maybe I (get) _____ 61 _____ a pet some day when I (move) _____ 62 _____ to a bigger apartment.

PRACTICE 33 ▸ Crossword puzzle.

Complete the puzzle. Use the clues to find the correct words.

Across

3. We won't go to the beach if it _____.

7. We'll call you as soon as we _____ at the airport.

8. _____ I will pass this course. I just don't know!

Down

1. Carl _____ won't get the job. He really doesn't have the right skills for it.

2. If Ted needs a ride, tell him that I _____ pick him up at 6:30.

4. Maria is going to have a cup of coffee before she _____ work.

5. The schools are _____ to be closed on Monday because it's a holiday.

6. Please turn off your cell phones. The concert is about to _____.

8. Helen _____ come to the movie with us. She's not sure.

CHAPTER 4

Present Perfect and Past Perfect

PRACTICE 1 ▶ Past participles. (Chart 4-1)
Circle the past participle in each group.

1. finish (finished) finishing
2. stopped stopping stops
3. puts put putting
4. knew knowing known
5. be been were
6. wanting wanted wants
7. saying said say
8. having have had
9. gone go went
10. took taken taking

PRACTICE 2 ▶ Review: irregular verbs. (Chart 4-1)
Write each verb in the correct group.

bring	feed	keep	quit	sink	teach
buy	fight	let	✓ring	sit	think
catch	find	meet	set	stand	upset
cut	have	pay	shut	stick	weep
drink	✓hurt	put	sing	swim	✓win

I. Simple form, simple past, and past participle are the same.

Simple Form	Simple Past	Past Participle	Simple Form	Simple Past	Past Participle
hurt	_hurt_	_hurt_	_____	_____	_____
_____	_____	_____	_____	_____	_____
_____	_____	_____	_____	_____	_____
_____	_____	_____	_____	_____	_____

II. The vowel changes: i → a → u.

Simple Form	Simple Past	Past Participle
ring	_rang_	_rung_
_____	_____	_____
_____	_____	_____
_____	_____	_____
_____	_____	_____

III. Simple past and past participle are the same.

Simple Form	Simple Past	Past Participle
win	*won*	*won*
_____	_____	_____
_____	_____	_____
_____	_____	_____
_____	_____	_____
_____	_____	_____
_____	_____	_____
_____	_____	_____
_____	_____	_____
_____	_____	_____
_____	_____	_____
_____	_____	_____
_____	_____	_____
_____	_____	_____
_____	_____	_____
_____	_____	_____

PRACTICE 3 ▸ Present perfect: unspecified time with *ever* and *never*. (Chart 4-2)
Complete the conversations. Use the present perfect form of the verbs in parentheses.

1. A: (*you, eat, ever*) ___*you ever eaten*___ a snake?

 B: No, ___*I haven't*___. I (*eat, never*) ___*have never eaten*___ a snake.

2. A: (*you, go, ever*) _____ white water rafting?

 B: No, I _____. I (*go, never*) _____ whitewater
 rafting.

whitewater rafting

3. A: (*you, be, ever*) _____ on a cruise?

 B: No, I _____. I (*be, never*) _____ on a cruise.

4. A: Your teacher loves movies. (*she, show, ever*) _____ movies in class?

 B: No, she _____. She (*show, never*) _____ *movies* in class.

5. A: (*I, tell, ever*) _____ you about my trip to Morocco?

 B: No, you _____. You (*tell, never*) _____ me about your trip.

6. A: Your kids are good swimmers. (*they, try, ever*) _____ scuba diving?

 B: No, they _____. They (*try, never*) _____ scuba diving.

scuba diving

Complete the conversations with the given verbs and any words in parentheses. Use the present perfect.

1. eat A: (*you, ever*) <u>Have you ever eaten</u> pepperoni pizza?

 B: Yes, I <u> have </u>. I <u> have eaten </u> pepperoni pizza many times.

 OR

 No, I <u> haven't </u>. I (*never*) <u> have never eaten </u> pepperoni pizza.

2. talk A: (*you, ever*) _____ to a famous person?

 B: Yes, I _____. I _____ to a lot of famous people.

 OR

 No, I _____. I (*never*) _____ to a famous person.

3. rent A: (*Erica, ever*) _____ a car?

 B: Yes, she _____. She _____ a car many times.

 OR

 No, she _____. She (*never*) _____ a car.

4. see A: (*you, ever*) _____ a shooting star?

 B: Yes, I _____. I _____ a lot of shooting stars.

 OR

 No, I _____. I (*never*) _____ a shooting star.

5. catch A: (*Joe, ever*) _____ a big fish?

 B: Yes, he _____. He _____ lots of big fish.

 OR

 No, he _____. He (*never*) _____ a big fish.

6. have A: (*you, ever*) _____ a bad sunburn?

 B: Yes, I _____. I _____ a bad sunburn several times.

 OR

 No, I _____. I (*never*) _____ a bad sunburn.

7. meet A: (*I, ever*) _____ you before?

 B: Yes, you _____. You _____ me before.

 OR

 No, you _____. You (*never*) _____ me before.

8. be A: (*the boys, ever*) _____ to a baseball game before?

 B: Yes, they _____. They _____ to a few baseball games.

 OR

 No, they _____. They (*never*) _____ to a baseball game.

PRACTICE 5 ▸ Present perfect: unspecified time with *already* and *yet*. (Chart 4-3)

Choose the correct answers. Both answers may be correct for some sentences.

1. Registration hasn't ended _____. There is still time to register for classes before the semester begins.

 a. already b. yet

2. Winter arrived early this year. It has snowed twice _____, and summer isn't even over!

 a. already b. yet

3. Have you finished your homework _____?

 a. already b. yet

4. Kate has _____ returned from a year in Tokyo.

 a. already b. yet

5. I'm not quite ready to leave. I haven't finished packing my suitcase _____.

 a. already b. yet

6. Have you seen the new Indian movie _____?

 a. already b. yet

7. Malcolm doesn't need to take another science course. He has _____ taken the required number of science classes.

 a. already b. yet

8. You're late! Class has _____ started. But you're also lucky. The teacher hasn't taken attendance _____.

 a. already … yet b. yet … already

PRACTICE 6 ▸ Present perfect: unspecified time with *already* and *yet*. (Chart 4-3)

Complete the sentences with the words in the lists. There is one extra word in each list.

1. *has, school, started, not, yet, already*

 Our daughter is only two years old, so she __has not started school yet.__ She is too young.

2. *has, learned, already, yet, the alphabet*

 Our daughter is only two years old, but she _____

 _____. Isn't she smart?

3. *already, corrected, has, yet, our tests*

 Our teacher works very quickly. She _____

 _____. She corrected them all in one hour!

4. *returned, the tests, not, has, already, yet*

 Our teacher corrected the tests last night, but she left them at home. She

 _____. She'll return them tomorrow.

5. *not, already, yet, dinner, cooked, has*

 Anita _____ because she got home from work late.

6. *cooked, already, yet, has, dinner*

 Anita _____. She got home early, and she wants to go to bed early.

Complete the sentences with the appropriate verbs from the box. Include any words that are in parentheses. Use the present perfect form of the verb. Use a negative form if appropriate.

change	invite	meet	pick	return	talk
give	live	✓move	retire	spend	travel

I (*recently*) __have recently moved__ into a new apartment. I (*all my neighbors / yet*)
_____, but I have met some of them. They are interesting people.

My neighbor in 3G is a private pilot. He (*just*) _____ from the South Pole, and before that he was in Africa. He _____ all over the world.

My neighbor in 4F is a doctor, but she doesn't look like a doctor to me. She has a lot of tattoos, and she had blue hair when I first moved in. She (*already*) _____ the color of her hair. Now it's purple.

The young man across the hall has a lot of parties. He (*already*) _____ several parties this week, but he (*me, yet*) _____. Maybe he will invite me to a party one of these days.

My next-door neighbors are musicians. They were with the City Symphony Orchestra for more than 20 years, but they (*recently*) _____. Now they are looking forward to traveling and spending more time with their family.

The neighbors on the other side are mysterious. I _____ to them yet. Whenever they come or go from their apartment, they rush by without talking to anyone.

A young woman in the building is my new best friend. She owns a small advertising business. We (*already*) _____ many fun evenings together.

Complete the second sentence with the present perfect form of the verb in **bold** in the first sentence.

1. Mr. Woods **teaches** chemistry at Central High School. He _____ there for 17 years.

2. Martin **sells** cars. He began selling cars in 2015. Martin _____ cars since 2015.

3. John **loves** Mary. He _____ her since they were teenagers.

4. I **have** a pain in my side. I _____ this pain for about two weeks.

5. You **know** my cousin Rita, don't you? You _____ her since you were in college, right?

6. Clara and Tom are going to **play** tennis on Saturday morning. They _____ tennis together on Saturday mornings for years.

7. I am going to **get up** early again tomorrow so that I can do yoga. I _____ up early to do yoga every day for the past month.

8. My cousins **go** to their house in the mountains every summer. They _____ to their summer home ever since I can remember.

9. Alaska and Hawaii **are** the newest states of the United States. They became states in 1950. They _____ states for more than 60 years.

10. Brazil **is** an independent country. Brazil _____ an independent country since 1822.

PRACTICE 9 ▸ Present perfect with *since* and *for*. (Chart 4-4)
Complete the sentences with *since* or *for*.

1. David has worked for the power company _____*since*_____ 1999.

2. His brother has worked for the power company _____*for*_____ five years.

3. I have known Peter Gowan _____ September.

4. I've known his sister _____ three months.

5. Jonas has been in a wheelchair _____ a year.

6. He's had a bad back _____ he was in a car accident.

7. My vision has improved _____ I got new reading glasses.

8. I've had a toothache _____ yesterday morning.

9. The shoe store on the corner has been there _____ 1920.

10. It has been there _____ almost a hundred years.

PRACTICE 10 ▸ Present perfect with *since* and *for*. (Chart 4-4)
Rewrite the sentences using *since* or *for*.

1. I was in this class a month ago, and I am in this class now.
 I have been in this class for a month.

2. I knew my teacher in September, and I know her now.

3. Sam wanted a dog two years ago, and he wants one now.

4. Sara needed a new car last year, and she still needs one.

5. Our professor was sick a week ago, and she is still sick.

6. My parents live in Canada. They moved there in December.

7. I know Dr. Brown. I met her in 2009.

8. Tom works at a fast-food restaurant. He got the job three weeks ago.

PRACTICE 11 ▶ Present perfect: review. (Charts 4-1 → 4-4)

Complete the questions and statements with the given verbs and any words in parentheses.

BRYAN: Welcome to our show, Ms. Starr.

LARA: Thank you. I'm glad to be here. By the way, please call me Lara.

BRYAN: Okay, Lara. Well, first, how long (*be*) ___*have you been*___ in movies?
 1

LARA: For many years — since I was a teenager.

BRYAN: Really? How many movies (*make, you*) _____ so far?
 2

LARA: I've made about twenty movies.

BRYAN: (*enjoy, you, always*) _____ your work, ever since you began in your teens?
 3

LARA: Yes, I _____. I have always loved my work.
 4

BRYAN: Lara, you travel a lot in your work, right?

LARA: Oh, yes. I travel very often.

BRYAN: Where (*travel, you*) _____ to recently?
 5

LARA: I (*be*) _____ to Europe and Africa so far this year.
 6

BRYAN: Do you miss your friends and family when you are away? (*you, ever, want*)

_____ a more normal life?
 7

LARA: Well, I miss my friends and family, but I (*never, wish*) _____ for a regular life.
 8
I've always been very happy in my work.

BRYAN: (*think, you, ever*) _____ about getting married?
 9

LARA: Well, no, I _____. Maybe that's because I (*not, meet*)
 10

_____ any really nice guys recently. Maybe I will meet someone nice, and
 11

maybe I won't. Either way, it's okay with me.

PRACTICE 12 ▶ Present perfect: review. (Charts 4-1 → 4-4)

Complete the sentences with the appropriate verbs from the box. Use the present perfect tense.

begin	drink	meet	✓put
buy	find	pay	win

1. I ___*have*___ just ___*put*___ the dinner in the oven. It will be ready in twenty minutes.

2. Stuart is very thirsty from playing tennis in the hot sun. He _____ three glasses of water already, and he is asking for more.

3. Hurry, Sal. The game _____ already _____. We can clean up the kitchen later.

4. Our basketball team _____ every game so far this season. What a great team!

5. I _____ the president twice. He said, "It's good to meet you. Thank you for your support."

6. Two police officers _____ just _____ the missing boy, and they are taking him home to his family.

7. This bill is a mistake. I _____ already _____ this bill.

8. The new self-driving car is a big success. Thousands of people _____ one, and many more customers are waiting to buy one.

PRACTICE 13 ▶ Simple past vs. present perfect. (Chart 4-5)
Write "F" if the activity or situation is finished and "C" if it continues to the present.

1. ___C___ My grandfather has worked since he was in high school.

2. ___F___ My grandmother worked for 20 years.

3. ___F___ I finished my work two hours ago.

4. ___F___ I have already finished my work, so I'm leaving the office.

5. _____ My father has been sick since yesterday.

6. _____ Jane was sick last Monday.

7. _____ Tom has already left. He's not here.

8. _____ Tom left five minutes ago.

9. _____ I have known Max Shell since we were children.

10. _____ The baby has had a fever since midnight. I think I'll call the doctor.

11. _____ The baby had a fever all night, but he's better now.

12. _____ I had the flu last year.

13. _____ Susie has had the flu since last Friday.

14. _____ Claude has slept outside under the stars several times this summer.

PRACTICE 14 ▶ Present perfect and simple past with time words. (Charts 4-1 → 4-5)
Choose (✓) all the phrases that correctly complete the sentences.

1. The Petersons took a trip _____.

_____ a. two weeks ago

_____ b. since yesterday

_____ c. yesterday

_____ d. last year

_____ e. several months ago

_____ f. since last month

_____ g. the day before yesterday

_____ h. in March

_____ i. since winter began

2. The Petersons have been out of town _____.

_____ a. the day before yesterday

_____ b. one month ago

_____ c. since Friday

_____ d. last week

_____ e. since winter began

_____ f. since last week

_____ g. in April last year

_____ h. several weeks ago

_____ i. for several weeks

PRACTICE 15 ▶ Simple past vs. present perfect. (Chart 4-5)
Complete the sentences with the letter of the correct verbs in the list.

a. paid	g. have paid
b. sent	h. have sent
c. met	i. have met
d. took	j. have taken
e. watched	k. have watched
f. withdrew	l. have withdrawn

1. I ___c___ many new people at the conference last week. I ___i___ a lot of new people since
 I started going to conferences ten years ago.

2. I _____ a lot of good movies in my lifetime. I _____ an excellent new movie last night.

3. I _____ my rent this morning. I _____ my rent on time for twenty years.

4. I _____ lots of difficult tests since I started college. I _____ a very difficult test yesterday in my World History class.

5. I _____ more than a thousand dollars from my bank account so far this month. Yesterday I _____ three hundred dollars.

6. I _____ several emails to my friends last night. I _____ thousands of emails to my friends in my lifetime.

PRACTICE 16 ▸ Simple past vs. present perfect. (Chart 4-5)
Choose the correct completions. Notice the time expressions.

The Okay Candy Company

(1) The Okay Candy Company is over 100 years old. The Foxworthy family started / has this business in 1910. In the beginning, the company was / has been small and had / has had about 20 employees. Now the company became / has become much larger, and it has more than 2,000 employees. It was / has been a very successful company for many years because of good management.

(2) The current president, Oscar M. Foxworthy, led / has led the company for the last eleven years. The company made / has made a profit every year since he first took / has taken over the company. Last year, for example, the company's profits went / have gone up 4%, and this year profits went / have gone up 4.2% since January. The year didn't end / hasn't ended yet, and people are optimistic about the future of the company.

PRACTICE 17 ▸ Present perfect progressive. (Chart 4-6)
Complete the sentences with the correct form of the present perfect progressive verbs and the appropriate time phrases.

1. I am waiting for the downtown bus. I arrived at the bus stop twenty minutes ago.

 I ___*have been waiting*___ for the bus for _____*twenty minutes*_____.

2. Sandy is playing video games. She started playing two hours ago.

 She _____ video games for _____.

3. Ivo is working at the hospital. He began working at 7:00 this morning, and he hasn't stopped. It is now 10 P.M.

 Ivo _____ at the hospital since _____.

4. Kim is driving. He got in his car six hours ago, and he hasn't stopped.

 Kim _____ for _____.

5. Ruth is writing a novel. She began it three years ago, and she hasn't finished it yet.

 Ruth _____ the novel for _____.

6. Jim and Dan are arguing. They began their argument when Jim brought home a stray cat.

 Jim and Dan _____ since _____.

7. It began to rain two days ago. It is still raining.

 It _____ for _____.

8. Jenny is losing weight. She began her diet on her birthday.

 She _____ weight since _____.

PRACTICE 18 ▸ Present perfect progressive vs. present perfect. (Charts 4-6 and 4-7)
Read the passage about Max. Then answer the questions that follow. Circle "T" if the statement is true and "F" if the statement is false.

A Tiger's Life

 Max has written four books. Three of his books did not sell well. But the fourth book, *A Tiger's Life*, has been very successful. In fact, right now a production company in Hollywood is making a movie of *A Tiger's Life*. Max is taking a break from writing and is a consultant for the movie. He hasn't written anything new for about a year because he has been working on the movie.

1. Max is writing a book now.	T	F
2. All four of his books have been successful.	T	F
3. *A Tiger's Life* has been a success.	T	F
4. A production company has already made a movie of *A Tiger's Life*.	T	F
5. Max began working on the movie about a year ago.	T	F
6. Max has finished working on the movie.	T	F

PRACTICE 19 ▸ Present progressive, present perfect progressive, and the present perfect. (Charts 4-6 and 4-7)
Choose the correct answers.

1. Where have you been? Our manager _____ for you for over an hour!

 a. is looking (b.) has been lookingvw

2. I'm exhausted! I _____ for the last eight hours without a break.

 a. am working b. have been working

3. Shhh! Charlotte _____ now. Let's not make any noise. We don't want to wake her up.

 a. is sleeping b. has been sleeping

4. Annie, go upstairs and wake your brother up. He _____ for over ten hours. He has chores to do.

 a. is sleeping b. has been sleeping

5. Erin has never gone camping. She _____ in a tent.

 a. has never slept b. has never been sleeping

6. This is a great shirt! I _____ it at least a dozen times, and it still looks like new.

 a. have washed b. have been washing

7. Are you still washing the dishes? You _____ dishes for thirty minutes. How long can it take to wash dishes?

 a. have washed b. have been washing

8. We _____ to the Steak House restaurant many times. The food is excellent.

 a. have gone b. have been going

Complete the sentences. Use the present perfect, the present progressive, or the present perfect progressive form of the verbs in parentheses.

1. I can't believe it's 2:00 in the afternoon, and my roommate (sleep) _____ is sleeping _____. He (sleep)
 _ has been sleeping _ for 15 hours!

2. Vanessa (shop) _____ at the mall right now. She (shop)
 _____ for hours. So far, she (buy) _____ two pairs of shoes,
 a dress, and some sunglasses.

3. Ethan (sit) _____ in a café right now. He (already, drink)
 _____ two cups of coffee. He (wait) _____ for his girlfriend
 for the past hour.

4. Max and Maddie (fish) _____ all afternoon, but they (not, catch)
 _____ any fish yet.

5. The kids (not, do) _____ their homework right now. They (play)
 _____ video games for over two hours.

6. My brother and I (taking) _____ a road trip right now. We (drive)
 _____ all day long. We (drive) _____ almost 500 miles so far.

Complete the sentences with the words in parentheses.

BEN: I (need) _____ need _____ to find a job. Where (be) _____
$\quad\overline{1}$ $\qquad\qquad\overline{2}$
a good place for a student to work?

ANNA: (you, work, ever) _____ at a restaurant?
$\qquad\qquad\overline{3}$

BEN: Yes. I (work) _____ at several restaurants. I (have)
$\qquad\overline{4}$
_____ a job as a dishwasher last fall.
$\quad\overline{5}$

ANNA: Where?

BEN: At The Bistro, a little café on First Street.

ANNA: How long (you, work) _____ there?
$\qquad\qquad\overline{6}$

BEN: For two months.

ANNA: I (work) _____ in a lot of restaurants, but I (have, never) _____ a
$\qquad\overline{7}$ $\qquad\qquad\overline{8}$
dishwashing job. How (you, like) _____ your job as a dishwasher?
$\qquad\qquad\overline{9}$

BEN: I (like, not) _____ it very much. It (be) _____ hard work for low pay.
$\qquad\overline{10}$ $\qquad\overline{11}$

ANNA: Where (you, work) _____ right now?
$\qquad\qquad\overline{12}$

BEN: I (have, not) _____ a job right now. I (have, not) _____ a job since
$\qquad\overline{13}$ $\qquad\qquad\overline{14}$
I (quit) _____ the dishwashing one.
$\qquad\overline{15}$

ANNA: (you, look) _____ for a part-time or a full-time job now?
$\qquad\overline{16}$

BEN: A part-time job, maybe twenty hours a week.

ANNA: I (*go*) _____ to Al's Place tomorrow to see about a job. The restaurant (*look*)
 17

_____ for help. Why don't you come along with me?
 18

BEN: Thanks. I (*do*) _____ that. I (*look, never*) _____ for a job at Al's
 19 20

Place before. Maybe the pay (*be*) _____ better than at The Bistro.
 21

ANNA: I (*know, not*) _____. We (*find*) _____ out when we (*go*)
 22 23

_____ there tomorrow.
 24

PRACTICE 22 ▶ Past perfect. (Chart 4-8)

For each item, write "1" before the action that happened first. Write "2" before the action that happened second.

1. Larry called Jane last night, but she had gone out for the evening.

 __2__ Larry called Jane.

 __1__ Jane went out.

2. I opened the door because someone had knocked on it. But no one was there.

 _____ I opened the door.

 _____ Someone knocked on the door.

3. My sister was happy because her boyfriend had called.

 _____ Her boyfriend called.

 _____ My sister was happy.

4. Our dog stood excitedly at the front door. He had seen me as I was putting on my coat to go out for a walk.

 _____ He saw me putting on my coat.

 _____ Our dog stood at the front door.

5. Ken had heard my joke a hundred times before. But he laughed anyway.

 _____ Ken laughed at my joke.

 _____ Ken heard the joke many times.

6. Don opened his car door with a wire hanger. He had lost his keys.

 _____ Don lost his keys.

 _____ Don opened his car door with a wire hanger.

7. My plants died because I had forgotten to water them.

 _____ My plants died.

 _____ I forgot to water the plants.

8. Kelly didn't go to the movie with us last night. She had seen it with her sister.

 _____ Kelly didn't go to the movie with us.

 _____ She saw the movie with her sister.

PRACTICE 23 ▸ Past perfect. (Chart 4-8)

Choose the correct answers.

1. Scott didn't want to go to the movie because _____.
2. Jaden failed his exam because _____.
3. We didn't recognize our teacher at first because _____.
4. Isabel was nervous on the airplane because _____.
5. Leah was exhausted yesterday because _____.
6. My plants died because _____.
7. Sarah bought a new phone because _____.
8. I couldn't find Zac's house because _____.
9. I didn't see Marc because _____.
10. My presentation was awful because _____.

a. I hadn't watered them for weeks.
b. she had never flown before.
c. he'd already seen it before.
d. I hadn't prepared very well.
e. he had given me the wrong directions.
f. he had already left.
g. she had gotten a haircut.
h. she had lost her old one.
i. she hadn't slept the night before.
j. he hadn't studied at all.

PRACTICE 24 ▸ Past perfect. (Chart 4-8)

Part I. Read the passage and underline the past perfect verbs and the modifying adverbs *always* and *never*. Then complete the sentences that follow the passage. Use the past perfect form in your completions.

A New Life for Alan

(1) Alan Green got married for the first time at age 49. His new life is very different because he has had to change many old habits. For example, before his marriage, he had always watched TV during dinner, but his wife likes to talk at dinnertime, so now the TV is off.

(2) Until he got married, he had always listened to jazz. He had never liked any other kind of music. But his wife likes pop, rock, and hip-hop music. Now Alan listens to all different kinds of music.

(3) When he was a bachelor, Alan was a slob. He had always left his dirty socks on the floor. Now he picks them up and puts them in the laundry basket. He had never put the cap back on the toothpaste, but now he does. He had always left his dirty dishes in the sink for days. Now he washes his dishes right away.

(4) Alan had never shared the TV remote control with anyone before he got married. He still likes to have control of the TV remote, but he doesn't say anything when his wife uses it.

Part II. Complete the sentences.

1. Until Alan got married, he ___had always watched___ TV during dinner.
2. Before he got married, he _____ to jazz.
3. Until he met his wife, Alan _____ any other music except jazz.
4. Until he began married life, he _____ his dirty socks on the floor.
5. Before his marriage, he _____ the toothpaste cap back on.
6. Until he had a wife who also liked to use the TV remote control, he _____ the remote with anyone.

Choose the correct answers.

1. Sacha is sleeping _____.

2. I have called Martin _____ this evening, but he hasn't answered the phone.

3. I'll call Martin one more time _____.

4. Where's Hal? I hope he hasn't gone home _____.

5. My family has lived in this house _____.

6. How many people have lived on earth _____?

a. since the world began

b. for twenty-one years

c. at this moment

d. yet

e. after I finish my homework

f. five times

Choose the correct completions.

1. A: Did you enjoy / Have you enjoyed the concert last night?

 B: Oh, yes. I have enjoyed / enjoyed it very much.

2. A: Did you see / Have you seen John yesterday?

 B: Yes, I did. It was / has been good to see him again. I haven't seen / hadn't seen him in a long time.

3. A: Hi, Jim! It's good to see you again. I haven't seen / didn't see you in weeks.

 B: Hi, Susie! It was / is good to see you again, too. I haven't seen / don't see you since the end of last semester. How's everything going?

4. A: Did you get / Have you gotten to class on time yesterday morning?

 B: No. When I get / got there, class has already begun / had already begun.

5. A: I called Ava, but I couldn't talk to her.

 B: Why not?

 A: She had already gone / has already gone to bed, and her sister didn't want to wake her up for a phone call.

6. A: You're a wonderful artist. I love your paintings of the valley.

 B: Thank you. I have painted / was painting the same valley many times because it has such interesting light at different times of the day.

 A: How many pictures of the valley have you painted / are you painting so far?

 B: Oh, more than twenty.

Correct the errors.

have been
1. Where were you? I ~~am~~ waiting for you for an hour.

2. Anna have been a soccer fan since a long time.

3. Since I have been a child, I have liked to solve puzzles.

4. Have you ever want to travel around the world?

5. The family is at the hospital since they hear about the accident.

6. My sister is only 30 years old, but her hair has began to turn gray.

7. Jake has been working as a volunteer at the children's hospital since several years.

8. Steve has worn his black suit only once since he has bought it.

9. My cousin is studying for medical school exams since last month.

10. I hadn't gotten my test results from the doctor yet. I'll find out soon.

11. Our meeting has already ended when Michelle got here.

PRACTICE 28 ▶ Word search puzzle.

Circle the irregular past participles of these verbs in the puzzle: ***become, break, find, go, know, see, take, understand.*** Use the clues below the puzzle to help you. The words may be horizontal, vertical, or diagonal. The first letter of each word is highlighted in gray.

1. Traffic in this city has _____ very bad recently.

2. I have _____ this bus every morning since I started my new job.

3. How long have you _____ Ali's family?

4. This is a terrible washing machine. It has _____ again.

5. I love that movie. I have _____ it seven times.

6. Is Beth still here? Or has she _____ home already?

7. Hal lost his keys. He hasn't _____ them yet.

8. I am not good at math. I have never _____ those complicated math problems.

PRACTICE 1 ▸ Yes / no questions. (Chart 5-1)
Make questions using the information in "B's" response.

			helping verb	subject	main verb	rest of sentence
1.	**SIMPLE PRESENT**	A:	*Do*	*you*	*like*	*coffee?*
		B:	Yes, I like coffee.			

			helping verb	subject	main verb	rest of sentence
2.	**SIMPLE PRESENT**	A:	_____	_____	_____	_____
		B:	Yes, Tom likes coffee.			

			helping verb	subject	main verb	rest of sentence
3.	**PRESENT PROGRESSIVE**	A:	_____	_____	_____	_____
		B:	Yes, Pietro is watching a movie.			

			helping verb	subject	main verb	rest of sentence
4.	**PRESENT PROGRESSIVE**	A:	_____	_____	_____	_____
		B:	Yes, I'm having lunch with Raja.			

			helping verb	subject	main verb	rest of sentence
5.	**SIMPLE PAST**	A:	_____	_____	_____	_____
		B:	Yes, Rafael walked to school.			

			helping verb	subject	main verb	rest of sentence
6.	**PAST PROGRESSIVE**	A:	_____	_____	_____	_____
		B:	Yes, Clarita was taking a nap.			

			helping verb	subject	main verb	rest of sentence
7.	**SIMPLE FUTURE**	A:	_____	_____	_____	_____
		B:	Yes, Ted will come to the meeting.			

			form of *be*	subject	rest of sentence
8.	**MAIN VERB:** *BE* **SIMPLE PRESENT**	A:	_____	_____	_____
		B:	Yes, Ingrid is a good artist.		

			form of *be*	subject	rest of sentence
9.	**MAIN VERB:** *BE* **SIMPLE PAST**	A:	_____	_____	_____
		B:	Yes, I was at the wedding.		

Choose the correct completions.

1. A: Is / Does this your new tablet?
 B: Yes, it is / does.

2. A: It's so small. Is / Does it difficult to read text on that small screen?
 B: No, it isn't / doesn't.

3. A: Is / Does it have a good camera?
 B: Yes, it has / does.

4. A: Do / Are you carry it with you all day?
 B: Yes, I am / do.

5. A: Have / Do you had it for a long time?
 B: No, I haven't / don't.

6. A: Was / Did it cost a lot?
 B: No, it wasn't / didn't.

7. A: Are / Do you going to take it on your trip to Africa?
 B: Yes, I am / do.

8. A: Are / Will you post to social media from Africa?
 B: Yes, I am / will.

9. A: Do / Are you like to travel?
 B: Yes, I do / like.

10. A: Did / Were you travel a lot last year?
 B: Yes, I did / travel.

PRACTICE 3 ▸ Yes / no questions and short answers. (Chart 5-1)
Complete the conversations. Use the correct forms of **be**, **do**, **have**, or **will**.

1. A: _____*Do*_____ you travel very often?
 B: No, I _____*don't*_____.

2. A: _____*Are*_____ the Andes Mountains in North America?
 B: No, they _____*aren't*_____.

3. A: _____ Africa the largest continent?
 B: No, it _____. Asia is.

4. A: _____ rivers flow toward the oceans?
 B: Yes, they _____.

5. A: _____ penguins live in the Arctic?
 B: No, they _____. They live in Antarctica.

6. A: _____ a penguin swim under water?
 B: Yes, it _____.

7. A: _____ the Nile the longest river in the world?
 B: Yes, it _____.

8. A: _____ there snow in Hawaii?

 B: No, there _____. It's too warm for snow.

9. A: _____ 2029 be a leap year?

 B: No, it _____. A leap year is a year that you can divide by 4, like 2016, 2020, 2024, and 2028.

PRACTICE 4 ▶ *Yes / no* questions. (Chart 5-1)

The chart describes the exam schedule of four students. Complete the conversations using the information in the chart.

	Last week	This week	Next week
Jane		math	psychology
George	Spanish		business
Anna		biology	chemistry
John	history		

1. A: _____*Does Jane*_____ have an exam this week?

 B: Yes, _____*she does.*_____ (Jane has an exam this week.)

2. A: _____ have an exam this week?

 B: No, _____. (George doesn't have an exam this week.)

3. A: _____ have exams this week?

 B: Yes, _____. (Jane and Anna have exams this week.)

4. A: _____ have an exam last week?

 B: No, _____. (Jane didn't have an exam last week.)

5. A: _____ have an exam last week?

 B: Yes, _____. (George had an exam last week.)

6. A: _____ have exams last week?

 B: No, _____. (Jane and Anna didn't have exams last week.)

7. A: _____ have exams last week?

 B: Yes, _____. (George and John had exams last week.)

8. A: _____ have an exam next week?

 B: Yes, _____. (Jane will have an exam next week.)

9. A: _____ have an exam next week?

 B: Yes, _____. (George and Anna will have an exam next week.)

10. A: _____ have an exam next week?

 B: No, _____. (John will not have an exam next week.)

Read the interview and choose the correct answers.

1. ANA LOPEZ: Hello! I'm looking for the biochemistry department. There's no number on the door. Is this the right place?

 PROFESSOR HIATT: Yes, it _____.

 a. does b. has c. is

2. PROF: And you must be the student who called for an interview! Are you Ana Lopez?

 ANA: Yes, I _____.

 a. do b. am c. have

3. PROF: I'm Professor Hiatt. It's nice to meet you. Welcome to the biochemistry department.

 ANA: Thank you. I'm very glad to meet you.

 PROF: Well, first of all, we want an assistant who really likes to work on research projects in the lab. Do you like that kind of work?

 Ana: Yes, I _____. I like it very much.

 a. do b. am c. have

4. PROF: Good. Have you had a lot of experience in a biochemistry lab?

 ANA: Yes, I _____. I worked as the student assistant in high school. And I also worked at a small chemical company for two summers.

 a. do b. am c. have

5. PROF: Did you work on any research projects at that company?

 ANA: Yes, I _____. I assisted two chemists in medical research.

 a. did b. have c. do

6. PROF: Now, are you taking a lot of classes this semester?

 ANA: Yes, I _____. I'm taking biology, statistics, and two chemistry courses.

 a. do b. am c. will

7. PROF: Those are difficult classes. Will you have time to study and work here in the lab too?

 ANA: Yes, I _____.

 a. do b. will c. have

Choose the correct completions.

1. Phil works **someplace**.
 Where works he / does he work ?

2. He works **sometimes**.
 When does he work / works he ?

3. Marta is making **something**.
 What she is making / is she making ?

4. She said **something**.
 What did she say / she said ?

5. Jean and Don visited **someone**.

 Who ~~they did visit /~~ did they visit ?

6. They visited her **for a reason**.

 Why did they visit her ~~/ they visited her~~ ?

PRACTICE 7 ▸ Yes / no and information questions. (Charts 5-1 and 5-2)
Complete the sentences with words from the list.

Does	Is	When	Where

1. _____ Mateo work in a restaurant?
2. _____ does Mateo work? Downtown?
3. _____ Mateo working today?
4. _____ does Mateo have a day off? On Saturday?

Are	When	Where	Will

5. _____ Mike and Kate get married next year?
6. _____ will Mike and Kate get married? Soon?
7. _____ they going to have a honeymoon?
8. _____ are they going to go on their honeymoon? Hawaii?

Did	Is	When	Where

9. _____ Iris in class now?
10. _____ is Iris?
11. _____ she come to class yesterday?
12. _____ will Iris come back to class?

PRACTICE 8 ▸ Where, When, What time, Why, How come, What ... for. (Chart 5-2)
Choose the correct answers.

1. _____ do oranges come from?

 Florida.

2. _____ is the sky blue?

 Because the sun reflects the light in a certain way.

3. _____ did the 21st century begin?

 In the year 2000.

4. _____ is the flight going to arrive?

 At 5:30.

5. _____ you left early?

 I went to the dentist.

6. _____ did you go to the dentist for?

 I had a bad toothache.

a. What
b. What time
c. When
d. Where
e. Why
f. How come

Rewrite the sentences beginning with the given words.

1. What are you going downtown for?

 a. How come _____?

 b. Why _____?

2. Why did Paul leave early?

 a. What _____?

 b. How come _____?

3. How come your clothes are on the floor?

 a. Why _____?

 b. What _____?

4. What does Mira need more money for?

 a. How come _____?

 b. Why _____?

Make information questions. Use **Where**, **Why**, **When**, or **What time**. Use the information in parentheses in your question.

1. A: _____ *Why are you waiting* _____ to see your advisor?

 B: Because I need his signature on this application. (I'm waiting to see my advisor because I need his signature on this application.)

2. A: _____ her new job?

 B: Next Monday morning. (Rachel starts her new job next Monday morning.)

3. A: _____ the business meeting?

 B: Because I fell asleep after dinner and didn't wake up until 9:00. (I missed the meeting because I fell asleep after dinner and didn't wake up until 9:00.)

4. A: _____ for home?

 B: Next Saturday. (I'm leaving for home next Saturday.)

5. A: _____ to finish this project?

 B: Next month. (I expect to finish this project next month.)

6. A: _____ today?

 B: At the cafeteria. (I ate lunch at the cafeteria today.)

7. A: _____ lunch?

 B: At 12:15. (I ate lunch at 12:15.)

8. A: _____ at the cafeteria?

 B: Because the food is good. (I eat lunch at the cafeteria because the food is good.)

9. A: _____?

 B: From Osaka to Tokyo. (The bullet train goes from Osaka to Tokyo.)

10. A: _____
 from New York to Los Angeles?

 B: One day in the future, I think! (They will build a bullet train from New York to Los Angeles one day in the future.)

11. A: _____ English?

 B: In Germany. (I studied English in Germany.)

12. A: _____ English in Germany?

 B: Because I had a scholarship to study in Germany. (I studied English in Germany because I had a scholarship to study in Germany.)

PRACTICE 11 ▸ Yes / no and information questions. (Charts 5-1 → 5-3)
Make questions using the information in "B's" response. Write Ø if no word is needed.

	(question word)	helping verb	subject	main verb	rest of sentence
1. A:	Ø	Did	you	hear	the news?

 B: Yes, I did. (I heard the news.)

	(question word)	helping verb	subject	main verb	rest of sentence
2. A:	When	did	you	hear	the news?

 B: Yesterday. (I heard the news yesterday.)

	(question word)	helping verb	subject	main verb	rest of sentence
3. A:					

 B: Yes, he is. (Eric is traveling for work.)

	(question word)	helping verb	subject	main verb	rest of sentence
4. A:					

 B: In South America. (Eric is traveling in South America.)

	(question word)	helping verb	subject	main verb	rest of sentence
5. A:					

 B: Yes, it will. (The class will end soon.)

	(question word)	helping verb	subject	main verb	rest of sentence
6. A:					

 B: In December. (The class will end in December.)

	(question word)	helping verb	subject	main verb	rest of sentence

7. A: _____ _____ _____ _____ _____

 B: Yes, she did. (The teacher helped a student.)

	(question word)	helping verb	subject	main verb	rest of sentence

8. A: _____ _____ _____ _____ _____

 B: Mei Lei. (The teacher helped Mei Lei.)

	(question word)	helping verb	subject	main verb	rest of sentence

9. A: _____ _____ _____ _____ _____

 B: Yes, he will. (The chef will cook a special dish tonight.)

	(question word)	helping verb	subject	main verb	rest of sentence

10. A: _____ _____ _____ _____ _____

 B: Chicken. (The chef will cook his special chicken dinner tonight.)

	(question word)	helping verb	subject	main verb	rest of sentence

11. A: _____ _____ _____ _____ _____

 B: Yes, she was. (Emma was late for work today.)

	(question word)	helping verb	subject	main verb	rest of sentence

12. A: _____ _____ _____ _____ _____

 B: Because she overslept. (Emma was late for work because she overslept.)

PRACTICE 12 ▸ Yes / no and information questions. (Charts 5-1 → 5-3)
Read the passage. Then write questions using the words in *italics* and choose the correct answers.
Capitalize the first word of the question.

Apples

 Apple trees first grew in central Asia thousands of years ago. Today
apples grow in cooler climates all over the world. Each spring, apple
trees produce pink flowers. In the summer and fall, the trees produce
apples. Inside each apple there are tiny brown seeds. If you plant these
seeds, some of them will become new apple trees.

1. *did, originate, apple trees, where*

 _____ Where did apple trees originate? _____

 a. Yes, they did. b. In central Asia.

2. *do, where, grow, apple trees*

 _____?

 a. Yes, they do. b. In cooler climates everywhere.

3. *they, do, grow*

_____ in hot climates?

 a. No, they don't. b. In central Asia.

4. *do, apples, the trees, produce*

_____ in the summer and fall?

 a. Yes, they do. b. Apples.

5. *produce, do, they, when*

_____ pink flowers?

 a. Yes, they do. b. In the spring.

6. *what, find, you, do*

_____ inside each apple?

 a. Yes, you do. b. Seeds.

7. *some of the seeds, become, will*

_____ new apple trees?

 a. Yes, they will. b. New apple seeds.

PRACTICE 13 ▸ Who, Who(m), and What. (Chart 5-3)

Write "S" over the word in **bold** if it is the subject of the verb. Write "O" over the word if it is the object of the verb. Then make questions with **Who**, **Who(m)**, and **What**.

 S

1. **Someone** is talking.

 Who is talking _____?

 O

2. We hear **someone**.

 Who(m) do we hear _____?

3. You know **someone** in my class.

_____ in my class?

4. **Someone** was on TV last night.

_____ last night?

5. **Something** happened in that building.

_____ in that building?

6. Jason knows **something**.

_____?

7. Megan is calling **someone**.

 _____?

8. **Someone** answered the phone.

 _____?

9. You said **something**.

 _____?

10. **Something** is important.

 _____?

PRACTICE 14 ▸ *Who, Who(m), and What.* (Chart 5-3)
Complete the questions with **Who**, **Who(m)**, or **What**.

Part I. Looking for the subject.

At an Office Meeting

1. _____ happened at the meeting?

2. _____ was there?

3. _____ spoke about the reorganization of the company?

4. _____ is going on in the finance department?

5. _____ is going to be the next chief financial officer?

6. _____ is the problem with the air-conditioning system?

Part II. Looking for the object.

Planning a Dinner Party

1. _____ are you inviting to dinner?

2. _____ have you called so far?

3. _____ are you going to serve, meat or fish?

4. _____ do you need to buy for the dinner?

5. _____ are you going to make for dessert?

6. _____ do you need me to do?

PRACTICE 15 ▸ *Who, Who(m), and What.* (Chart 5-3)

Make questions with **Who**, **Who(m)**, and **What**.

	QUESTION	ANSWER
1.	Who knows Julio?	Someone knows Julio.
2.	Who(m) does Julio know?	Julio knows someone.
3.		Someone will help us.
4.		I will ask someone.
5.		Eric is talking to someone on the phone.
6.		Someone is knocking on the door.
7.		Something surprised them.
8.		Jack said something.
9.		Emma talked about something.
10.		Reece talked about someone.

PRACTICE 16 ▸ *Who, Who(m), and What.* (Chart 5-3)

Make questions using the information in parentheses.

1. A: _____Who taught_____ you to play chess?

 B: My mother. (My mother taught me to play chess.)

2. A: _____?

 B: A car accident. (Robert saw a car accident.)

3. A: _____ 911?

 B: Robert did. (Robert called 911.)

4. A: _____?

 B: A toy for my brother's kids. (I'm making a toy for my brother's kids.)

5. A: _____ to?

 B: Joe. (That phone belongs to Joe.)

6. A: _____ on the front windshield of your car?

 B: A parking ticket. (A parking ticket is on the front windshield of my car.)

PRACTICE 17 ▸ Asking for the meaning of a word. (Chart 5-3)

Ask for the meaning of the words in *italics*. Complete the conversations in your own words.

1. A: Jenny is going to study *abroad* next year.

 B: What _____does "abroad" mean_____?

 A: It means _____in a foreign country_____.

2. A: My new apartment is *spacious*.

 B: _____?

 A: It means _____.

3. A: The weather this winter has been *mild.*

 B: _____?

 A: It means _____.

4. A: Todd is *hilarious.*

 B: _____?

 A: It means _____.

5. A: James is a *diligent* student.

 B: _____?

 A: It means _____.

PRACTICE 18 ▸ What + a form of do. (Chart 5-4)

Make questions using **What** and a form of **do.** Use the information in parentheses.
Use the same verb tense that is <u>underlined</u> in parentheses.

1. A: _____*What is Alex doing*_____ now?

 B: Streaming a movie. (Alex is <u>streaming</u> a movie.)

2. A: _____ last weekend?

 B: Nothing. We just stayed home. (We <u>did</u> nothing last weekend. We just <u>stayed</u> home.)

3. A: _____?

 B: They explore space. (Astronauts <u>explore</u> space.)

4. A: _____ next Saturday morning?

 B: Play soccer at Waterfall Park. (I'm <u>going to play</u> soccer at Waterfall Park next Saturday morning.)

5. A: _____ when she heard the good news?

 B: She cried with happiness. (Sara <u>cried</u> with happiness when she heard the good news.)

6. A: _____ after she graduates?

 B: She plans to look for a job in hotel management. (Emily <u>is going to look</u> for a job in hotel management after she graduates.)

7. A: _____ after school today?

 B: Let's go to the mall, okay? (I <u>want to go</u> to the mall after school today.)

8. A: _____ for a living?

 B: He's an airplane mechanic. (Nick <u>repairs</u> airplanes for a living.)

PRACTICE 19 ▸ Using which and what. (Chart 5-5)

Choose the correct completions.

1. A: Ali broke his hand playing basketball.

 B: That's terrible. Which / What hand did he break, the right or left?

2. A: I heard the president's speech last night. Did you?

 B: No, I didn't. Which / What did he say about the economy?

3. A: This book is excellent. It's the best book I have ever read.

 B: Really? Which / What is it about?

4. A: Look at those two pandas! They are so cute.

 B: They are. Which / What one is the mother and which / what one is the daughter?

5. A: We have an invitation to the art show on Friday night.

 B: I'd like to go. But I've never been to an art show before. Which / What do people wear to art shows?

6. A: Alec lives on this street, right?

 B: This is the street, but which / what house is it? Do you have the exact address?

7. A: I don't have the address.

 B: Let's call him. Which / What is his phone number?

8. A: Hey, Bernie! I'm surprised to see you here.

 B: Hey, Marty! Which / What are you doing these days?

 A: Me? Not much. But my son just got an offer from the Broilers to play professional soccer on their team.

 B: That's great! Uh … which / what son is that? Is it Jeff?

 A: No. Jeff's in medical school. I'm talking about Alan, my youngest.

PRACTICE 20 ▸ Using *What kind of.* (Chart 5-5)

Make questions with **What kind of** and one of the nouns in the box for each question.

books	clothes	Italian food	✓music
car	government	job	person

1. A: _____ *What kind of music* _____ do you like?

 B: Rock music and rap.

2. A: _____ do you usually wear?

 B: Jeans and a T-shirt.

3. A: _____ do you like best?

 B: Pizza with onions, peppers, garlic, and extra cheese.

4. A: _____ do you like to read?

 B: Science fiction novels.

5. A: _____ are you going to buy?

 B: A hybrid. One that uses a battery and gas.

6. A: _____ does your country have?

 B: It's democratic.

7. A: _____ would you like to have?

 B: I'd like to have one that pays well, is interesting, and allows me to travel a lot.

8. A: _____ would you like to marry?

 B: Someone who is kind-hearted, loving, funny, serious, and steady.

PRACTICE 21 ▸ Using *How*. (Chart 5-6)

Complete the sentences with appropriate words from the box.

busy	fresh	old	soon
expensive	✓ hot	serious	well

1. A: How _____ *hot* _____ does it get in Chicago in the summer?

 B: Very _____ *hot* _____. It can get over 100°.*

2. A: How _____ will dinner be ready? I'm really hungry.

 B: Very _____. Just a few more minutes.

3. A: Look at that beautiful painting! Let's get it.

 B: How _____ is it?

 A: Never mind! It's really _____. We can't afford it.

4. A: How _____ are you today, Ted? Do you have time to read over this report?

 B: Well, I'm pretty _____, but I'll make time to read it.

5. A: How _____ is Toshi about becoming an astronomer?

 B: He's very _____ about it. He already knows more about the stars and planets than his high school teachers.

6. A: How _____ is Julies's daughter?

 B: She's not very _____. She's only two or three.

7. A: Tomatoes for sale! Do you want to buy some tomatoes?

 B: Hmmm. They look pretty good. How _____ are they?

 A: They are really _____. I picked them myself from the field just this morning.

8. A: Do you know Jack Young?

 B: Yes.

 A: Oh? How _____ do you know him?

 B: Very _____. He's one of my closest friends. Why?

 A: He's applied for a job at my store.

PRACTICE 22 ▸ Using *How often / How many times*. (Chart 5-7)

Choose the correct completions.

1. A: How often / How many times are the summer Olympic Games held?

 B: The summer games are held every four years.

2. A: How often / How many times have the Olympic Games been held in Australia? One or two?

 B: Two, I think. In 1956 and in 2000.

3. A: How often / How many times did Michael Phelps compete in the Olympics?

 B: I'm not sure. Maybe four or five.

*100°F = 37.8°C

4. A: How often / How many times do you take vitamin C?

 B: I take it every day. I think it prevents colds.

5. A: How often / How many times do you get a cold?

 B: Rarely. I rarely get a cold.

6. A: How often / How many times a year do you visit your doctor?

 B: Sometimes none! I never see my doctor unless I'm sick.

PRACTICE 23 ▸ Asking about distance. (Chart 5-8)

Make questions with **How far** and **How many**.

1. A: ____How many miles is it from New York to Philadelphia?____

 or

 ____How far is it from New York to Philadelphia?____

 B: 98 miles. (It's 98 miles from New York to Philadelphia.)

2. A: _____?

 or

 _____?

 B: It's a few blocks. (It's a few blocks from the college to the science museum.

3. A: _____?

 or

 _____?

 B: About ten miles. (I live about ten miles from my office.)

4. A: _____?

 or

 _____?

 B: Nearly 400,000 kilometers. (It's nearly 400,000 kilometers from the earth to the moon.)

PRACTICE 24 ▸ Using *How far*, *It + take*, and *How long*. (Charts 5-8 and 5-9)

Read each paragraph and write questions. Include the word in parentheses in your question. Use the correct tenses, according to the paragraph.

1. The Nile River is the longest river in the world. It is about 6,677 kilometers, or 4,150 miles, long.
 It flows from Burundi in eastern Africa to the Mediterranean Sea in northeast Egypt. A slow ship
 takes several days to make the trip.

 A: (*far*) _____ from the beginning, or source, of the Nile
 River to the end of the Nile River?

 B: It's a long way.

 A: (*miles*) _____ from the source of the Nile River to the
 end of the Nile River?

 B: About 4,150.

 A: (*long*) _____ a slow ship to make the trip?

 B: Several days.

2. Mount Everest is 8,850 meters, or 29,035 feet high — the highest mountain in the world. It is in the central Himalaya Mountains, on the border of Tibet and Nepal. Edmund Hillary and his group climbed to the top of the mountain in 1953. It took them seven weeks to get to the top but only three days to come down.

A: (*high*) _____?

B: It's very high. It's more than 29,000 feet high.

A: (*meters*) _____?

B: It's 8,850.

A: (*long*) _____ Edmund Hillary and his group to climb Mount Everest?

B: Seven weeks.

A: (*days*) _____ them to come down from the top of the mountain?

B: Three.

3. The Trans-Siberian Railway is the longest railway in the world. It goes from Moscow to Vladivostok on the Sea of Japan, a distance of 9,311 kilometers, or 5,786 miles. The trip takes seven days.

A: (*long*) _____ the Trans-Siberian Railway?

B: Very long. Over 9,100 kilometers.

A: (*miles*) _____ the Trans-Siberian Railway?

B: It's 5,786.

A: (*days*) _____ to go from Moscow to Vladivostok on the Trans-Siberian Railway?

B: Seven.

PRACTICE 25 ▸ Using *How often, How far,* and *How long.* (Charts 5-7 → 5-9)
Complete the questions with *far, long,* or *often*.

1. A: How _____*far*_____ is it to the nearest police station?

 B: Four blocks.

2. A: How _____ does it take you to get to work?

 B: Forty-five minutes.

3. A: How _____ do you see your family?

 B: Once a week.

4. A: How _____ is it to your office from home?

 B: About twenty miles.

5. A: How _____ is it from here to the airport?

 B: Ten kilometers.

6. A: How _____ does it take to get to the airport?

 B: Fifteen minutes.

7. A: How _____ above sea level is Denver, Colorado?

 B: One mile. That's why it's called the Mile High City.

8. A: How _____ does it take to fly from Chicago to Denver?

 B: About three hours.

9. A: How _____ does the bus come?

 B: Every two hours.

10. A: How _____ is it from here to the bus stop?

 B: About two blocks.

11. A: How _____ does the ride downtown take?

 B: About twenty minutes.

12. A: How _____ do you take the bus?

 B: Every day.

PRACTICE 26 ▸ More questions with *How*. (Chart 5-11)

Make simple present tense questions with **how** and **you** as the subject. Use each verb in the box only once.

feel	like	pronounce	say	spell

1. A: _____?

 B: I spell my name R-I-C-H-A-R-D.

2. A: _____ your eggs?

 B: I like them scrambled, not too hard.

3. A: _____ *I love you* in French?

 B: *Je t'aime.* That's how you say it.

4. A: _____ *Mississippi*?

 B: This is how you pronounce it: say *missus* – like *Mrs.*, and then say *sip* like *sip a drink with a straw*, and then *E* like the letter *E*.

5. A: _____ about losing your job?

 B: Pretty bad, as you would expect.

PRACTICE 27 ▸ Using *How about* and *What about*. (Chart 5-12)

Choose the appropriate response for each conversation.

1. A: We aren't taking a vacation this summer. What about you?

 B: _____. Jim can't leave his job right now.

 a. We're staying home too.
 b. No, we didn't.
 c. Oh? Where are you going this year?

2. A: I really don't like our history professor. How about you?

 B: _____.

 a. I don't feel well today.
 b. What's the matter with her? I like her a lot.
 c. Yes, I will.

3. A: I'm voting for the new, young candidate. How about you?

 B: Not me. _____ .

 a. Where are you going?

 b. I think I will.

 c. I like the older guy, the one with experience.

4. A: I love sailing and being on the water. How about you?

 B: _____ .

 a. I like it too.

 b. Yes, I have.

 c. Yes, I did.

5. A: You don't eat meat, sir? What about fish? We have an excellent salmon tonight.

 B: _____ .

 a. No, thank you. I don't take sugar with my coffee.

 b. Okay, I'll have that.

 c. Yes, I am.

6. A: I thought the concert was great. How about you?

 B: _____ .

 a. The book was excellent.

 b. I like music.

 c. Me too.

PRACTICE 28 ▸ Review of questions. (Charts 5-1 → 5-12)
Make questions using the words in *italics*.

1. *be, dry, the clothes, will*

 A: When _____*will the clothes be dry*_____ ?

 B: In about an hour.

2. *did, do, you*

 A: What _____ on Saturday afternoon?

 B: I went to a baseball game.

3. *book, download, did, you*

 A: Which _____ ?

 B: A novel by Jorge Amado.

4. *did, it, long, take*

 A: How _____ to clean your apartment before your
 parents visited?

 B: Four hours.

5. *bread, do, like, you*

 A: What kind of _____ ?

 B: I don't like bread. I never eat it.

6. *are, calling, me, you*

A: Why _____ so late at night?

B: Sorry! I accidentally hit your number.

7. *are, meeting, you*

A: Who _____ at the restaurant?

B: Maria and her sister.

8. *is, you, taking*

A: Who _____ to the airport?

B: Eric.

9. *are, leaving, you*

A: How come _____ so early?

B: I'm really very tired.

PRACTICE 29 ▸ Review of questions. (Charts 5-1 → 5-12)

Complete the conversations by writing questions for the given answers. Use the information in parentheses to form the questions.

1. A: _____ *What is Jack doing* _____ now?

B: He's playing tennis. (Jack is playing tennis.)

2. A: _____ with?

B: Anna. (He is playing tennis with Anna.)

3. A: _____?

B: Serving the ball. (Anna is serving the ball.)

4. A: _____ in the air?

B: A tennis ball. (She is throwing a tennis ball in the air.)

5. A: _____?

B: Rackets. (Anna and Jack are holding rackets.)

6. A: _____ between them?

B: A net. (A net is between them.)

7. A: _____?

B: On a tennis court. (They are on a tennis court.)

8. A: _____?

B: For an hour and a half. (They have been playing for an hour and a half.)

9. A: _____ right now?

B: Jack. (Jack is winning right now.)

10. A: _____ the last game?

B: Anna. (Anna won the last game.)

PRACTICE 30 ▸ Tag questions. (Chart 5-13)
Complete the tag questions with the correct verbs.

1. Simple present

 a. You work at the university, _____ *don't* _____ you?

 b. Claire teaches at Midwood High School, _____ she?

 c. Bob and Mike sell real estate, _____ they?

 d. Kevin has a van, _____ he?

 e. You're in Professor Rossiter's class, _____ you?

 f. Your mother likes green tea, _____ she?

 g. Jill and Andrew don't have any kids yet, _____ they?

 h. Bryan isn't a lawyer, _____ he?

 i. I'm not wrong, _____ I?

2. Simple past

 a. Jennifer went to Mexico, _____ she?

 b. You spoke to Paul about this, _____ you?

 c. That was a good idea, _____ it?

 d. The police officer didn't give you a ticket, _____ he?

 e. John and Mary had a fight, _____ they?

3. Present progressive, *be going to,* and past progressive

 a. You're coming tomorrow, _____ you?

 b. Jim isn't working at the bank, _____ he?

 c. It's probably going to snow tomorrow, _____ it?

 d. Susie was sleeping in class, _____ she?

 e. The printer was working, _____ it?

 f. They weren't leaving, _____ they?

4. Present perfect

 a. The weather has been nice this spring, _____ it?

 b. We've had a lot of work this semester, _____ we?

 c. You haven't told the truth, _____ you?

 d. Shirley has gone home already, _____ she?

 e. Natalie hasn't left yet, _____ she?

 f. I have never met you before, _____ I?

PRACTICE 31 ▸ Tag questions. (Chart 5-13)
Add tag questions. Write the expected responses.

1. A: You've already seen that movie, _____ *haven't you* _____?

 B: _____ *Yes, I have* _____.

2. A: John hasn't called, _____?

 B: _____.

3. A: You talked to Mike last night, _____?

 B: _____.

4. A: You usually bring your lunch to school, _____?

 B: _____.

5. A: Rita and Philip have been married for five years, _____?

 B: _____.

6. A: Kathy has already finished her work, _____?

 B: _____.

7. A: This isn't a hard exercise, _____?

 B: _____.

8. A: Tony Wah lives in Los Angeles, _____?

 B: _____.

9. A: Tomorrow isn't a holiday, _____?

 B: _____.

10. A: This isn't your book, _____?

 B: _____.

11. A: Jack and Elizabeth were in class yesterday, _____?

 B: _____.

12. A: Maria won't be here for dinner tonight, _____?

 B: _____.

PRACTICE 32 ▸ Forming questions. (Chapter 5 Review)
Make questions using the information in parentheses.

1. A: _When are you going to buy a new bike?_

 B: Next week. (I'm going to buy a new bike next week.)

2. A: _How are you going to pay for it?_

 B: With my credit card. (I'm going to pay for it with my credit card.)

3. A: _____ your old bike?

 B: Ten years. (I have had my old bike for ten years.)

4. A: _____ your bike?

 B: Four or five times a week. (I ride my bike four or five times a week.)

5. A: _____ to work?

 B: I usually ride my bike. (I usually get to work by riding my bike.)

6. A: _____ your bike to work today?

 B: No. Today I got a ride. (I didn't ride my bike to work today.)

7. A: _____ you a ride?

 B: Paul did. (Paul gave me a ride.)

8. A: _____ your bike over the weekend?

 B: Yes, I did. (I rode my bike over the weekend.)

9. A: _____ over the weekend?

 B: Twenty-five miles. (I rode my bike twenty-five miles over the weekend.)

10. A: _____ a comfortable seat?

 B: Yes, it does. (My bike has a comfortable seat.)

11. A: _____?

 B: A mountain bike. (I have a mountain bike.)

12. A: _____ his new bike?

 B: Two weeks ago. (Jackson got his new bike two weeks ago.)

13. A: _____ Jason's new bike?

 B: Ollie. (Ollie broke Jackson's new bike.)

14. A: _____?

 B: He ran it into a brick wall. (He broke it by running it into a brick wall.)

15. A: _____?

 B: No, he didn't. (Ollie didn't get hurt.)

16. A: _____?

 B: No, it didn't. Only one wheel fell off. (The bike didn't have a lot of damage.)

17. A: _____?

 B: The front wheel. (The front wheel fell off, not the back wheel.)

18. A: _____?

 B: No, he hasn't. (Jackson hasn't fixed the bike yet.)

PRACTICE 33 ▸ Check your knowledge. (Chapter 5 Review)
Correct the errors.

Who

1. ~~Whom~~ saw the car accident?

2. How about ask Julie and Tim to come for dinner Friday night?

3. What time class begins today?

4. Where people go to get a driver's license in this city?

5. How long it takes to get to the beach from here?

6. She is working late tonight, doesn't she?

7. Oh, good! You found your keys. Where did you found them?

8. How much tall your father?

9. Who you talked to about registration for next term?

10. How come are you here so early today?

PRACTICE 34 ▸ Crossword puzzle. (Chapter 5)
Complete the crossword puzzle. Use the clues to find the correct words.

Across

3. I need someone to translate this letter from Chinese. _____ speaks Chinese?

4. _____ hand do you write with, your right or your left?

6. _____ you at home last night? I called, but no one answered.

7. _____ Florida have any mountains?

8. I need to buy some flour. What _____ do the stores open?

Down

1. _____ far is the main road from here?

2. How long does it _____ to go downtown on the bus?

3. _____ are you going now? To your yoga lesson?

4. _____ are you going to return? This afternoon or tonight?

5. _____ Rome the capital of Italy?

6. _____ happened over there? I see several police cars.

6 Nouns and Pronouns

PRACTICE 1 ▸ Forms of nouns. (Chart 6-1)
Read the paragraph. Circle the singular nouns. <u>Underline</u> the plural nouns.

> **Sharks**
> A shark is a fish. Sharks live in oceans all over the world. Some
> types are very large. The largest shark is the size of a bus. It has
> 3,000 teeth, in five rows in its mouth. When one tooth falls out,
> a new tooth grows in quickly. Some sharks are dangerous, and
> people try to avoid them.

PRACTICE 2 ▸ Forms of nouns. (Chart 6-1)
Write the plural form of the noun under each heading.

apple	child	lamp	river
bed	city	man	shelf
carrot	country	mouse	table
cat	fox	ocean	tomato
cherry	lake	peach	tiger

Living things that breathe	Furniture	Places on a map	Fruits and vegetables

PRACTICE 3 ▸ Forms of nouns. (Chart 6-1)
Write the correct singular or plural form of the given words.

1. one house two _____*houses*_____

2. a _____*door*_____ two doors

3. one box a lot of _____

4. one _____ three shelves

5. a copy two _____

6. a family several _____

7. a _____ two women

8. one child three _____

9. one fish several _____

10. a _____ a lot of flies

11. a dish two _____

12. a glass many _____

13. one _____ two dollars

14. one euro ten _____

15. a _____ several roofs

16. one life many _____

17. a photo a few _____

PRACTICE 4 ▸ Forms of nouns. (Chart 6-1)

Underline each noun. Write the correct plural if necessary. Do not change any other words.

1. <u>Airplane</u>ˢ have <u>wing</u>ˢ.

2. Some baby are born with a few tooth.

3. Child like to play on swing.

4. A child is playing on our swing now.

5. I eat a lot of potato, bean, pea, and tomato.

6. I had a sandwich for lunch.

7. Some animal live in zoo.

8. Human have two foot.

9. The government in my town introduced new fees.

10. Government collect tax.

PRACTICE 5 ▸ Subjects, verbs, and objects. (Chart 6-3)

Write "S" over the subject and "V" over the verb. If there is an object, write "O" over it.

1. Caroline dropped a dish.
 (S over Caroline, V over dropped, O over dish)

2. The dish fell.

3. The noise woke her baby.

4. The baby cried.

5. Caroline rocked her baby.

6. The phone rang.

7. A man came to the door.

8. The dog barked loudly.

9. Caroline answered the door.

PRACTICE 6 ▸ Subjects, verbs, and objects. (Chart 6-3)

Write the words in the lists in the correct order. Capitalize the first word in each sentence. Write a Ø if there is no object.

1. moved John

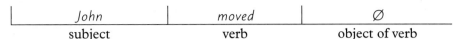

John	moved	Ø
subject	verb	object of verb

2. a new job he got

subject	verb	object of verb

3. a package arrived yesterday

subject	verb	object of verb

4. delivered the mail carrier the package

subject	verb	object of verb

5. my mother the package sent

subject	verb	object of verb

6. boarded the airplane the passengers

subject	verb	object of verb

7. left the gate the plane

subject	verb	object of verb

8. left the plane late

subject	verb	object of verb

PRACTICE 7 ▸ Subjects, verbs, and objects. (Chart 6-3)

Decide whether the word in bold is a noun or a verb. Write "N" for noun and "V" for verb above the word.

1. Andy hurt his **hand**.
 N above **hand**

2. Students **hand** in homework assignments to their teachers.
 V above **hand**

3. Ed has a loud **laugh**.

4. People always **laugh** at Ben's jokes.

5. I usually **wash** my car on Saturday.

6. Maria put a big **wash** in the washing machine.

7. The Northeast got a lot of **snow** last night.

8. It's going to **snow** tomorrow.

9. The **text** is too small for me to read.

10. I **text** several friends every day.

11. Please **sign** your name on the form.

12. The **sign** says *No left turn*.

PRACTICE 8 ▸ Objects of prepositions. (Chart 6-4)
Describe the picture. Choose the correct completions.

1. The bird is in / on the cage.

2. The bird is standing in / on the bar.

3. The cage is in / on the table.

4. The cat is beside / under the table.

5. The light is above / below the cat and the bird.

6. The bird and the cat are above / below the light.

7. The plant is behind / below the cage.

8. The cat is on / next to the door of the cage.

9. The cat wants to go into / out the cage.

10. Maybe the bird will fly at / out of the cage.

PRACTICE 9 ▸ Objects of prepositions. (Chart 6-4)
Choose the correct answers.

1. The earth revolves _____.

2. The new office building is _____.

3. If you want an education, go _____.

4. A submarine travels _____.

5. If you are sick, stay _____.

6. The plane flew _____.

a. to college

b. over the mountain

c. below the surface of the water

d. around the sun

e. between Fifth Avenue and Sixth Avenue

f. in bed

a submarine

PRACTICE 10 ▸ Prepositions. (Chart 6-4)
Complete the sentences with the correct words from the boxes.

| in | into | near | of | on | to |

1. A mosquito flew _____*in / into*_____ the room from the patio. It didn't bother me because

I had put insect repellent _____ my face and arms.

2. My headphones are _____ the top drawer _____ my desk.

3. My home is not _____ my office. It takes me more than an hour to drive

_____ my office every morning. That's a long drive.

above	below	from	of	on	through

4. The equator is an imaginary line that divides

the earth in half. The Northern Hemisphere is

_____ the equator, and the Southern

Hemisphere is _____ the equator.

5. Europe is north _____ the equator.

6. Ecuador is a country in South America. It is called Ecuador—the Spanish word for equator—

because the equator runs _____ the middle of it. When you look at a map,

you see that Ecuador is _____ the equator.

7. Antarctica is very far south. It's far _____ the equator.

PRACTICE 11 ▸ Objects of prepositions. (Chart 6-4)

Part I. Read the passage. Circle the prepositions and underline the nouns that are objects of the
prepositions.

A Hurricane in Jamaica

(1) We had a hurricane (in) Jamaica. Dark clouds appeared in the sky. Big waves rolled over
the beaches. A strong wind blew through the trees. The rain fell hard on our roof. The water
came under the door and into the house.

(2) After the storm, we walked around the neighborhood. Across the street, a tree was on
the ground. Another tree was leaning against the house. Some electrical wires were hanging near
the house too.

(3) During the hurricane, the sun was behind the clouds. Afterwards, it appeared again.
We were happy and grateful because we were standing beneath the hot Jamaican sun again.

Part II. Each statement is incorrect. Make true statements by correcting the prepositional phrases.

1. Dark clouds appeared through the trees.

 _____*Dark clouds appeared in the sky.*_____

2. The water came in through the open window.

3. After the storm, the people walked outside the neighborhood.

4. The tree had fallen down on my house.

5. The sun had been in the clouds.

6. The neighbors felt happy and grateful when they were standing in the rain.

Complete the sentences with *in*, *at*, or *on*.

The Jacksons got married...

1. _____*in*_____ the summer.
2. _____ June.
3. _____ June 17th.
4. _____ Saturday.
5. _____ 12:00 P.M.
6. _____ noon.
7. _____ 2017.
8. _____ Saturday afternoon.

Their baby was born...

9. _____ midnight.
10. _____ 12:00 A.M.
11. _____ the morning.
12. _____ April 12th.
13. _____ 2019.
14. _____ April.
15. _____ Wednesday.
16. _____ the spring.

Complete the sentences with *in*, *at*, or *on*.

1. Jan is a nurse on the night shift. She works in the hospital _____ night. She
 sleeps _____ the morning. She does her errands _____ the
 afternoon. She works _____ weekends. She has her days off _____
 Wednesdays and Thursdays.

2. Melissa is a new doctor at the hospital. She began work there _____ July 1st.
 _____ the present time, she is working in cardiology.* She is going to attend a
 lecture on cardiology _____ noon tomorrow. She is going to take an exam for
 cardiologists** _____ the summer. _____ the future, she wants to
 be a cardiologist.

Complete the sentences. Use all the words in *italics* in the correct word order.

1. *to the airport, tomorrow morning*

 I'll take you _____.

2. *last month, a new job*

 Harry got _____.

3. *in January, in the mountains, skis*

 Our family always _____.

4. *at the coffee shop, in the morning, has breakfast*

 Gladys usually _____.

*cardiology = the medical study of the heart
**cardiologist = a doctor who treats heart diseases

5. *last Sunday, jogged, in the park*

 We _____.

6. *bought, in the suburbs, last year, a house*

 The Green family _____.

PRACTICE 15 ▸ Word order: place and time. (Chart 6-6)
Complete each sentence by putting the phrases in the correct order.

1. The police officer stopped _____.

 _____1_____ the driver

 _____2_____ at a busy intersection

 _____3_____ at midnight

2. My friends rented _____.

 _____ on the lake

 _____ last summer

 _____ a sailboat

3. The kids caught _____.

 _____ in the river

 _____ several fish

 _____ last weekend

4. We ate _____.

 _____ at noon

 _____ our lunch

 _____ in the park

5. I bought _____.

 _____ a cup of coffee

 _____ at the corner store

 _____ after work yesterday.

PRACTICE 16 ▸ Subject-verb agreement. (Chart 6-7)
Complete the sentences with *is* or *are*.

1. These books _____*are*_____ from the library.

2. The books from the library _____ past due.

3. Everyone _____ here.

4. Everybody _____ on time for class.

5. All the teachers _____ here.

6. Every teacher at this school _____ patient.

7. Some people _____ wise.

8. There _____ a good movie at the Sunset Theater this weekend.

9. There _____ some good movies in town over the weekend.

10. The mall and the movie theater _____ open late tonight.

11. The rules of this game _____ easy.

12. This information about taxes _____ helpful.

PRACTICE 17 ▸ Subject-verb agreement. (Chart 6-7)
Choose the correct completions.

1. Classes at Central College (begin)/ begins next month.
2. When do / does new students register for class?
3. Every student need / needs to bring identification to registration.
4. Is / Are there an orientation for new students?
5. There is / are several classes to choose from.
6. Is / Are there any biology classes with Dr. Kennedy this semester?
7. Dr. Kennedy doesn't / don't teach biology.
8. She teaches / teach chemistry.
9. Everybody always enjoys / enjoy Dr. Kennedy's lectures.
10. The books for that class is / are available online.

PRACTICE 18 ▸ Adjectives. (Chart 6-8)
Underline each adjective. Draw an arrow to the noun it describes.

1. Paul has a loud voice.
2. Sugar is sweet.
3. The students took an easy test.
4. Air is free.
5. We ate some delicious food at a Mexican restaurant.
6. The child was sick.
7. The sick child got into his warm bed and sipped hot tea with honey and lemon in it.

PRACTICE 19 ▸ Adjectives. (Chart 6-8)
Complete each phrase with an adjective that has the opposite meaning.

1. new cars _____old_____ cars
2. a young man an _____ man
3. a good day a _____ day
4. hard exercises _____ exercises
5. a soft pillow a _____ pillow
6. a _____ street a wide street
7. _____ plates dirty plates
8. _____ cups full cups
9. dangerous cities _____ cities
10. a dark color a _____ color
11. a heavy box a _____ box
12. a _____ place a private place
13. my left foot my _____ foot
14. the wrong answer the _____ answer
15. a _____ walk a short walk

PRACTICE 20 ▸ Using nouns as adjectives. (Chart 6-9)

Use the information in *italics* to complete the sentences. Each completion should have a noun that is used as an adjective in front of another noun.

1. *Numbers on pages* are _____*page numbers*_____.

2. *Money that is made of paper* is _____.

3. *Buildings with apartments* are _____.

4. *Gardens with roses* are _____.

5. *Chains for keys* are _____.

6. *Students at universities* are _____.

7. *Walls made of bricks* are _____.

8. *Cartons that hold eggs* are _____.

9. *Views of mountains* are _____.

10. *Lights that control traffic* are _____.

11. *Pies that are made with apples* are _____.

12. *Bridges made from steel* are _____.

PRACTICE 21 ▸ Using nouns as adjectives. (Chart 6-9)

Choose the correct answers.

1. A: What kind of tree is that?

 B: It's a _____. It produces peaches in the summer.

 a. peaches tree b. peach tree c. tree peaches

2. A: So, you grew up on a farm. What kind of farm?

 B: A _____. We had chickens on the farm.

 a. farm chickens b. chickens farm c. chicken farm

3. A: We have a special dessert tonight. It's a cake made with carrots from the chef's own garden.

 B: Sounds good! I'll have the _____.

 a. carrot cake b. carrots cake c. cake carrots

4. A: What is a good present to get for your son? He likes to play games on the computer, right?

 B: Right. He loves _____.

 a. computers games b. computer games c. game computers

5. A: Are you going to travel in Canada by train?

 B: Yes, we are. We like _____.

 a. trip trains b. train trips c. trains trips

6. A: Look at that unusual building. Is it a new hotel?

 B: No. It's _____. A lot of big companies have their offices there.

 a. an office building b. an offices building c. a building office

7. A: The kids are folding paper to make airplanes.

 B: I used to make _____ when I was a kid too.

 a. paper airplanes b. airplane paper c. airplane papers

8. A: Why are people waiting in line at those trucks?

 B: Those are _____. They sell pizza, hot dogs, tacos, and all different kinds of food.

 a. truck foods b. food trucks c. food truck

PRACTICE 22 ▸ Review: adjectives. (Charts 6-8 and 6-9)

Part I. This passage is adapted from a blog by astronaut Sandra Magnus. She wrote it from space in 2008.

Read the passage. Underline the adjectives. Circle the nouns as adjectives.

The Night Sky

 The night sky below is not completely dark. The cloud cover over the earth reflects the city lights. There are lights above us too—white lights, red lights, and orange lights. They are all around us in space. They are everywhere. They sparkle.* You are swimming in a sea of beautiful lights. These bright lights in space are stars. They are large, like our sun, and they are very far from us. But from here, each star seems so tiny. You feel that space is enormous.**

Part II. Answer the questions according to the information in the passage. Circle "T" if the statement is true and "F" if the statement is false.

1. Astronauts can see the earth's night sky from space.	T	F
2. The writer sees lights of different colors.	T	F
3. These lights are stars.	T	F
4. Each star looks small, but it is not really small.	T	F
5. The writer feels that space is tiny.	T	F

PRACTICE 23 ▸ Review: nouns. (Charts 6-1 → 6-9)

These sentences have mistakes in the use of nouns. Find each noun. Decide if the noun should be plural and add the correct plural form as necessary. Do not change any other words in the sentences.

1. The mountain^s ⌃ in Chile are beautiful.

2. Cat hunt mouse.

3. Mosquito are small insect.

4. Everyone has eyelash.

5. Do you listen to any podcasts when you take plane trip?

6. Forest sometimes have fire. Forest fire endanger wild animal.

7. Sharp kitchen knife can be dangerous.

8. I couldn't get concert tickets for Friday. The ticket were all sold out.

9. There are approximately 250,000 different kind of flower in the world.

10. I applied to several foreign university because I want to study in a different country.

*sparkle = shine in bright flashes
**enormous = very big in size or in amount

11. Ted lives with three other university student.

12. In the past one hundred year, our daily life have changed in many way. We no longer need to use oil lamp or candle in our house, raise our own chicken, or build daily fire for cooking.

PRACTICE 24 ▸ Personal pronouns: subjects and objects. (Chart 6-10)
Underline the personal pronouns. Then write each pronoun and the noun it refers to.

1. Dr. Gupta is a math professor. Students like her very much. She makes them laugh. They enjoy Dr. Gupta's classes because they are fun.

 a. _____her_____ → _____Dr. Gupta_____

 b. _____ → _____

 c. _____ → _____

 d. _____ → _____

 e. _____ → _____

2. Dr. Reynolds is a dentist. Not many patients like him. He is not patient or gentle with them, but he is the only dentist in town, so many people go to him.

 a. _____ → _____

 b. _____ → _____

 c. _____ → _____

 d. _____ → _____

 e. _____ → _____

3. Beth says: "My hometown is a wonderful place. It's a small town. I know all the people there, and they know me. They are friendly. If you visit, they will welcome you."

 a. _____ → _____

 b. _____ → _____

 c. _____ → _____

 d. _____ → _____

 e. _____ → _____

 f. _____ → _____

 g. _____ → _____

 h. _____ → _____

PRACTICE 25 ▸ Personal pronouns: subjects and objects. (Chart 6-10)
Decide if the underlined word is a subject or object pronoun. Write "S" for subject and "O" for object above the underlined word.

1. Jackie just texted me.
 O

2. She's going to be late.
 S

3. Jia and Ning are arriving tomorrow. They'll be here around noon.

4. Their parents will be happy to see them.

5. The doctor canceled the appointment. He has had an emergency.

6. If you need to speak to the doctor, call him tomorrow morning.

7. Bob and I had dinner last night.

8. <u>We</u> went to a restaurant on the lake.

9. George invited <u>us</u> to his wedding.

10. <u>It</u>'s going to be in June.

11. Your mother called and left a message. Call <u>her</u> right away.

12. Please answer <u>me</u> as soon as possible.

13. <u>You</u> live in the dorms, right?

14. See <u>you</u> tomorrow!

PRACTICE 26 ▸ Personal pronouns: subjects and objects. (Chart 6-10)
Check (✓) all the pronouns that can complete each sentence.

1. Mark called _____ last night.

 ☐ he ☐ her

 ☐ I ☐ him

 ☐ me ☐ she

 ☐ them ☐ they

 ☐ us ☐ we

 ☐ you

2. _____ called Mark last night.

 ☐ He ☐ Her

 ☐ Him ☐ I

 ☐ Me ☐ She

 ☐ Them ☐ They

 ☐ Us ☐ We

 ☐ You

3. Sharon saw _____ on the plane.

 ☐ he and I ☐ her and I

 ☐ him and me ☐ him and I

 ☐ you and me ☐ you and I

 ☐ she and I ☐ she and me

 ☐ her and me ☐ them and I

 ☐ they and me ☐ them and us

4. _____ saw Sharon on the plane.

 ☐ He and I ☐ Her and I

 ☐ Him and me ☐ Him and I

 ☐ You and me ☐ You and I

 ☐ She and I ☐ She and me

 ☐ Her and me ☐ Them and I

 ☐ Me and them ☐ They and us

PRACTICE 27 ▸ Personal pronouns. (Chart 6-10)

Choose the correct completions.

1. Will you take I / me to the airport?

2. Will you take Jennifer and I / me to the airport?

3. Jennifer and I / me will be ready at 7:00 A.M.

4. Did you see Sabrina? She / Her was waiting in your office to talk to you.

5. I saw Laila a few minutes ago. I passed Sara, and she / her was talking to she / her in the hallway.

6. Nick used to work in his father's store, but his father and he / him had a serious disagreement. I think his father fired he / him.

7. Prof. Molina called we / us. He wants to see we / us in his office tomorrow morning.

8. Take these documents and destroy they / them. They / Them contain personal and financial information.

PRACTICE 28 ▸ Possessive nouns. (Chart 6-11)

Choose the correct answers.

1. I have one cousin. My _____ name is Paul.

 a. cousin's b. cousins'

2. I have two cousins. My _____ names are Paul and Kevin.

 a. cousin's b. cousins'

3. I have three sons. My _____ names are Ryan, Jim, and Scott.

 a. son's b. sons'

4. I have a son. My _____ name is Ryan.

 a. son's b. sons'

5. I have a puppy. My _____ name is Rover.

 a. puppy's b. puppies'

6. I have two puppies. My _____ names are Rover and Rex.

 a. puppie's b. puppies'

7. I have one child. My _____ name is Anna.

 a. child's b. childs'

8. I have two children. My _____ names are Anna and Keith.

 a. children's b. childrens'

9. The winner of the dance contest was the judges' choice but not the _____ choice.

 a. people's b. peoples'

10. Excuse me. Where is the _____ restroom?

 a. men's b. mens'

Write the possessive form of the *italicized* noun in the second sentence.

1. The book belongs to my *friend*. It's my ____friend's____ book.

2. These books belong to my *friends*. They are my ____friends'____ books.

3. The car belongs to my *parents*. It's my _____ car.

4. The car belongs to my *mother*. It's my _____ car.

5. This phone belongs to *Carl*. It's _____ phone.

6. The keys belong to *Carl*. They're _____ keys.

7. The toys belong to the *baby*. They are the _____ toys.

8. The toy belongs to the *baby*. It's the _____ toy.

9. The toys belong to the *babies*. They are the _____ toys.

10. This jacket belongs to *Sanjay*. It's _____ jacket.

11. The shoes belong to *Nate*. They are _____ shoes.

12. The shirt belongs to *James*. It's _____ shirt.

PRACTICE 30 ▸ Possessive nouns. (Chart 6-11)
Write the correct possessive form if necessary.

1. I met Dan sister yesterday.
 Dan's

2. I met Dan and his sister yesterday. (No change.)

3. I know Jack roommates.

4. I know Jack well. He's a good friend of mine.

5. I have one roommate. My roommate desk is always messy.

6. You have two roommates. Your roommates desks are always neat.

7. Jo Ann and Betty are sisters.

8. Jo Ann is Betty sister. My sister name is Sonya.

9. My name is Richard. I have two sisters. My sisters names are Jo Ann and Betty.

10. I read a book about the changes in women roles and men roles in modern society.

PRACTICE 31 ▸ Using whose. (Chart 6-12)
Complete the conversations with **Whose** or **Who's**.

1. A: I have an extra ticket to see Maddie Lane in concert tonight. Do you want to go?

 B: Maddie Lane? _____ that?

 A: She's a famous singer. A lot of our friends are going to the concert.

 B: _____ going?

 A: Lola, Jaden, Sofia, Juan, Kate, and I are going. We're taking two cars. You can ride with us.

 B: Okay. That sounds fun. _____ driving?

 A: Jaden and Sofia are driving.

B: _____ car are you riding in?

A: I'm riding in Sofia's car.

2. A: _____ book is that?

B: It's Indira's.

A: _____ that?

B: She's my classmate. We're taking a wonderful history class.

A: Really? I don't like my history class. _____ your teacher?

B: Prof. Kamm. _____ class are you in?

A: I'm in Prof. Kamm's morning class.

B: Oh! Well, his afternoon class is great. Maybe he's not a morning person!

PRACTICE 32 ▸ Using *whose*. (Chart 6-12)
Make questions with **Who** or **Whose**.

1. A: _____*Whose house is that?*_____

 B: Evan's. (That's Evan's house.)

2. A: _____*Who's living in that house?*_____

 B: Evan. (Evan is living in that house.)

3. A: _____

 B: Pedro's. (I borrowed Pedro's umbrella.)

4. A: _____

 B: Maya's. (I used Maya's book.)

5. A: _____

 B: Nick's. (Nick's book is on the table.)

6. A: _____

 B: Nick. (Nick is on the phone.)

7. A: _____

 B: Hannah Smith. (That's Hannah Smith.) She's a student in my class.

8. A: _____

 B: Hannah's. (That's Hannah's.) This one is mine.

PRACTICE 33 ▸ Possessive pronouns vs. possessive adjectives. (Chart 6-13)
Complete the sentences with possessive pronouns or possessive adjectives that refer to the words in *italics*.

1. A: Can I borrow your grammar book?

 B: Why? *You* have _____*your*_____ own* book. *You* have _____*yours*_____, and I have mine.

2. A: Kim wants to borrow your grammar book.

 B: Why? *She* has _____ own book. *She* has _____, and I have mine.

*__Own__ frequently follows a possessive adjective: e.g., *my own, your own, their own*. The word **own** emphasizes that nobody else possesses the exact same thing(s); ownership belongs **only** to me (*my own book*), to you (*your own book*), to them (*their own books*), to us (*our own books*), etc.

3. A: Jake wants to borrow your grammar book.

 B: Why? *He* has _____ own book. *He* has _____, and I have mine.

4. A: Jake and I want to borrow your grammar book.

 B: Why? *You* have _____ own books. *You* have _____, and I have mine.

5. A: Jake and Kim want to borrow our grammar books.

 B: Why? *They* have _____ own books. *We* have _____ own books. *They* have

 _____, and *we* have _____.

PRACTICE 34 ▶ Possessive pronouns vs. possessive adjectives. (Chart 6-13)
Choose the correct completions.

1. *Mrs. Lee* asked her / hers kids to clean up the kitchen.

2. I don't need to borrow your bicycle. *My sister* lent me her / hers.

3. *Ted and I* are roommates. Our / Ours apartment is small.

4. *Brian and Louie* have a bigger apartment. In fact, their / theirs is huge.

5. *You* can find your / yours keys in the top drawer of the desk.

6. The keys in the drawer belong to you. *I* have my / mine in my / mine pocket. *You* should look in the drawer for your / yours.

7. *Tom and Paul* talked about their / theirs experiences in the wilderness areas of Canada. I've had a lot of interesting experiences in the wilderness, but nothing to compare with their / theirs.

8. *I* know Eric well. He is a good friend of my / mine. *You* know him too, don't you? Isn't he a friend of you / yours too?

9. *Nadia* forgot her / hers umbrella at home. *I* have an two umbrellas in my / mine car, so she can borrow one of my / mine.

10. Did *you* remember to bring your / yours umbrella today? Where is your /yours?

PRACTICE 35 ▶ Reflexive pronouns. (Chart 6-14)
Complete the sentences with reflexive pronouns that refer to the words in *italics*.

1. *I* enjoyed _____*myself*_____ at Disney World.

2. *We* all enjoyed _____ there.

3. *Uncle Joe* enjoyed _____.

4. *Aunt Elsa* enjoyed _____.

5. *Jessica and Paul* enjoyed _____.

6. Hi, Emily! Did *you* enjoy _____?

7. Hi, Emily and Dan! Did *you* enjoy _____?

8. *Paul* takes a lot of pictures of _____. He took a funny selfie with Mickey Mouse.

9. *Jessica* was proud of _____ for riding a roller coaster at Disney World. She is usually scared to ride roller coasters.

10. In its advertising, *Disney World* calls _____ "the happiest place in the world."

PRACTICE 36 ▶ Reflexive pronouns. (Chart 6-14)

Complete each sentence with an appropriate expression from the box. Be sure to use the correct reflexive pronoun.

be proud of	✓cut	help	take care of	teach
blame	enjoy	introduce	talk to	work for

1. Ouch! I just ____ *cut myself* ____ with a knife.

2. I got 100% on all my math tests! I studied really hard. I feel so good! I _____.

3. John often _____. People think there is more than one person in the room, but there isn't. It's only John.

4. When I was young, I _____ to ride a bike. Then I taught the other kids in the neighborhood.

5. Sheri _____ for the accident, but it wasn't her fault. The other car didn't stop at the stop sign and crashed into hers.

6. Please have more! There's lots of pizza in the oven. All of you, _____ to more pizza.

7. Adam seldom gets sick because he eats healthy food and exercises regularly. He

 _____.

8. They went to a party last night. Let's ask them if they _____.

9. My father never worked for anyone. He always owned his own company. He

 _____ throughout his entire adult life.

10. At the beginning of each term, my students _____ to the whole class.

PRACTICE 37 ▶ Review: pronouns and possessive adjectives. (Charts 6-10 → 6-14)

Choose the correct completions.

1. Alan invited I / me to go to dinner with he / him.

2. You and Sam should be proud of yourself / yourselves. The two of you did a good job.

3. The room was almost empty. The only furniture was one table. The table stood by it / itself in one corner.

4. The bird returned to its / it's* nest to feed its / it's baby bird.

5. Nick has his tennis racket, and Ann has her / hers / her's*.

6. Where's Eric? I have some good news for Joe and he / him / his / himself.

7. Don't listen to Greg. You need to think for yourself / yourselves, Jane.
 It's you / your / your's* life.

8. We all have us / our / ours own ideas about how to live our / ours / our's* lives.

*REMINDER: Apostrophes are NOT used with possessive pronouns. Note that *its* = possessive adjective; *it's* = *it is*. Also note that *her's, your's,* and *our's* are NOT POSSIBLE in grammatically correct English.

9. You have your beliefs, and we have our / ours.

10. People usually enjoy themselves / theirselves* at family parties.

11. History repeats himself / herself / itself.

12. David didn't need my help. He finished the work by him / himself / hisself.

13. Is someone visiting us? Who's / Whose car is that in our driveway?

14. Don't forget your keys. Their / They're / There over their / they're / there on the table.

PRACTICE 38 ▶ Review: pronouns and possessive adjectives. (Charts 6-10 → 6-14)
Complete each passage with words from the box. You may use a word more than once. Capitalize words as necessary.

he	him	himself	his

(1) Tom is wearing a bandage on _____*his*_____ arm. _____*He*_____ hurt
 1 2

_____*himself*_____ while _____ was repairing the roof. I'll help
 3 4

_____ with the roof later.
 5

her	I	mine	she
hers	it	our	we

(2) I have a sister. _____ name is Katherine, but we call _____
 1 2

Kate. _____ and I share a room. _____ room is pretty small.
 3 4

_____ have only one desk. _____ has five drawers. Kate puts
 5 6

_____ things in the two drawers on the right. I keep _____ in the two
 7 8

drawers on the left. Kate doesn't open my two drawers, and I don't open _____.
 9

She and _____ share the middle drawer.
 10

he	his	their	them	they
her	my	theirs	themselves	

(3) Mr. Ramirez is the manager of our office. _____ has a corner office with
 1

_____ name on the door. Ms. Lake is _____ assistant.
 2 3

_____ office is next to Mr. Ramirez's office. _____ often work
 4 5

together on projects by _____, but I work with _____ sometimes.
 6 7

They never come to _____ office to meet. I always go to _____.
 8 9

I take an elevator to get to _____ offices, or I walk up a long flight of stairs.
 10

*NOTE: *Themself* and *theirselves* are not really words—they are NOT POSSIBLE in grammatically correct English. Only ***themselves*** is the correct reflexive pronoun form.

Write **another** or **the other** under each picture.

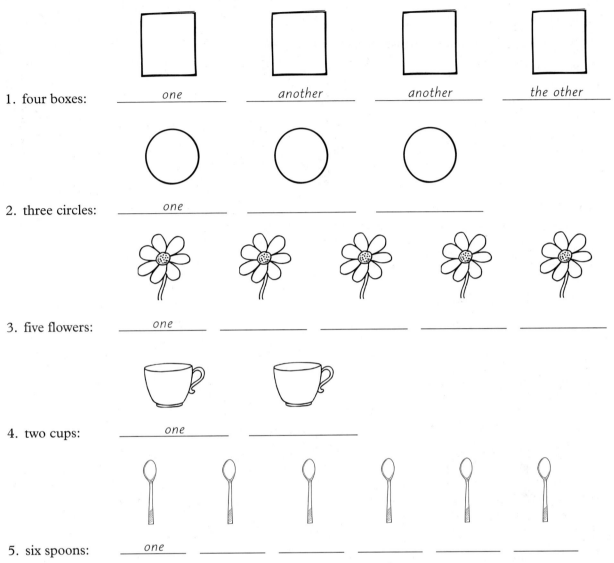

1. four boxes: *one* *another* *another* *the other*

2. three circles: *one*

3. five flowers: *one*

4. two cups: *one*

5. six spoons: *one*

PRACTICE 40 ▶ Singular forms of *other: another* vs. *the other.* (Chart 6-15)
Complete the sentences with **another** or the **other**.

1. There are two girls in Picture A. One is Ann. _____ is Sara.

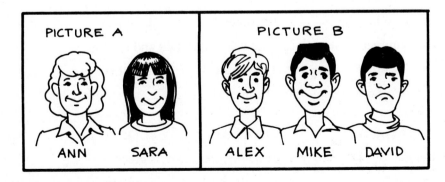

2. There are three boys in Picture B. One is Alex. _____ one is Mike.

3. In Picture B, Alex and Mike are smiling. _____ boy looks sad.

4. There are three boys in Picture B. All three have common first names. One is named Alex.

 a. _____ is named David.

 b. The name of _____ one is Mike.

5. There are many common English names for boys. Alex is one.

 a. Mike is _____.

 b. David is _____.

 c. John is _____ common name.

 d. Joe is _____.

 e. What is _____ common English name for a boy?

PRACTICE 41 ▸ Plural forms of other: other(s) vs. the other(s). (Chart 6-16)
Complete the sentences with **the other**, **the others**, **other**, or **others**.

1. There are four common nicknames for "Robert." One is "Bob." Another is "Bobby."
 _____The others_____ are "Robbie" and "Rob."

2. There are five English vowels. One is "a." Another is "e." _____ are "i," "o," and "u."

3. There are many consonants in English. The letters "b" and "c" are consonants.
 _____ are "d," "f," and "g."

4. Some people are tall, and _____ are short. Some people are neither tall nor short.

5. Some people are tall, and _____ people are short.

6. Some animals are huge. _____ are tiny.

7. Some animals are huge. _____ animals are tiny.

8. Of the twenty students in the class, eighteen passed the exam. _____ failed.

9. Out of the twenty students in the class, only two failed the exam. _____ students passed.

PRACTICE 42 ▸ Summary: forms of other. (Charts 6-15 → 6-17)
Choose the correct answers.

1. Gold is one kind of metal. Silver is _____.

 a. another b. the other c. the others d. others e. other

2. Summer is one season. Spring is _____.

 a. another b. the other c. the others d. others e. other

3. There are four seasons. Summer is one. _____ are winter, fall, and spring.

 a. Another b. The other c. The others d. Others e. Other

4. What's your favorite season? Some people like spring the best. _____ think fall is the nicest season.

 a. Another b. The other c. The others d. Others e. Other

5. This cat's eyes are different colors. One eye is gray, and _____ is green.

 a. another b. the other c. the others d. others e. other

6. There are two reasons not to buy that piece of furniture. One is that it's expensive. _____ is that it's not well made.

 a. Another b. The other c. The others d. Others e. Other

7. Alex failed his English exam, but his teacher is going to give him _____ chance to pass it.

 a. another b. the other c. the others d. others e. other

8. Some people drink tea in the morning. _____ have coffee. I prefer fruit juice.

 a. Another b. The other c. The others d. Others e. Other

9. There are five digits in the number 20,000. One digit is a 2. _____ digits are all zeroes.

 a. Another b. The other c. The others d. Others e. Other

PRACTICE 43 ▸ Nouns and pronouns. (Chapter 6 Review)

Choose the correct completions.

1. The people at the market is / are friendly.

2. How many potato / potatoes should I cook for dinner tonight?

3. I wanted to be alone, so I worked myself / by myself .

4. The twins were born in / on December 25th on / at midnight.

5. On the small island, there are seven vacation / vacations houses.

6. The bus driver waited for we / us at the bus stop.

7. Can you tell a good book by its / it's title?

8. This is our / ours dessert, and that is your / yours.

9. Jack has so much confidence. He really believes in him / himself.

10. These bananas are okay, but the other / the others were better.

PRACTICE 44 ▸ Check your knowledge. (Chapter 6 Review)

Correct the errors.

1. Look at those beautifuls mountains!

2. Three woman in our class play on the womens' soccer team at our college.

3. There are two horse, several sheeps, and a cow in the farmers field.

4. The owner of the store is busy in the moment.

5. The teacher met her's students at the park after school.

6. Everyone want peace in the world.

7. I grew up in a city very large.

8. This apple tastes sour. There are more, so let's try the other one.

9. Some tree lose their leaf in the winter.

10. I am going to wear my shirt blue to the party.

11. People may hurt theirselves if they use this machine.

12. Our neighbors invited my friend and I to visit they.

13. My husband boss works for twelve hour every days.

14. The students couldn't find they're books.

15. I always read magazines articles while I'm in the waiting room at my dentists office.

PRACTICE 45 ▶ Word search puzzle.
Circle the plural forms of these words in the puzzle: *man, woman, child, tooth, fly, foot, fox,* *wolf, monkey*. The words may be horizontal, vertical, or diagonal. The first letter of each word is highlighted in green.

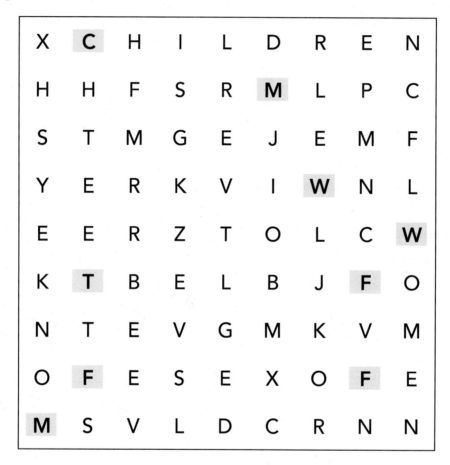

PRACTICE 1 ▸ Introduction to modal auxiliaries. (Chart 7-1)

Add the word **to** where necessary. Write Ø if **to** is not necessary.

1. Mr. Alvarez spilled ketchup on his shirt. He must _____Ø_____ change clothes before he goes to work.

2. Mr. Alvarez has _____to_____ change his shirt before he goes to the office.

3. Tom and I may _____ play soccer after work tomorrow.

4. Would you _____ speak more slowly, please?

5. The students have _____ take a test next Friday.

6. I'm not able _____ attend the meeting tomorrow.

7. Could you please _____ pass the salt and pepper? Thanks.

8. We have a bad phone connection. I can't _____ hear you very well. Are you able _____ hear me?

9. I stayed up past midnight last night. I couldn't _____ stay awake in class this morning.

10. I have _____ go to bed early tonight.

PRACTICE 2 ▸ Expressing ability: *can, could, be able to* (Chart 7-2)

Complete each sentence with the correct word in parentheses. Note the words in **bold**.

1. (*giraffe, zebra*) A _____zebra_____ **can't stretch** its neck to reach the tops of trees.

2. (*bee, cat*) A single _____ **can kill** a thousand mice in a year.

3. (*Rabbits, Elephants*) _____ **can break** small trees under their huge feet.

4. (*Monkeys, Chickens*) _____ **aren't able to climb** trees.

5. (*dogs, camels*) Did you know that _____ **can survive** 17 days without any water at all?

6. (*duck, sheep*) A _____ **can't lay** eggs.

7. (*cow, bull*) One _____ **is able to produce** as much as 8,500 lbs. (3,860 kgs) of milk in a year.

8. (*horse, cat*) A person **can sit** on a _____ without hurting it.

9. (*donkey, snake*) A _____ **is able to carry** heavy loads on its back.

10. (*squirrel, polar bear*) A _____ **can stay** high up in the trees for weeks and jump from branch to branch.

11. (*people, ants*) Most _____ **are able to lift** objects that are ten times heavier than their own bodies.

12. (*birds, humans*) Before airplanes, _____ **couldn't fly** from one place to another.

PRACTICE 3 ▸ Expressing ability. (Chart 7-2)

Part I. Completes the sentences with *can, can't, could,* or *couldn't*.

1. Patricia _____*could*_____ play the piano when she was only six years old because she took a lot of lessons.

2. Thanks for emailing the report, but something is wrong with the attachment. I'm trying, but I _____ open it.

3. Michael used to be a great swimmer in high school. He _____ swim like a fish!

4. Kenzo _____ ski before he lived in Canada, but now he's a very good skier.

5. _____ you speak French? I need some help with my French homework.

Part II. Rewrite the verbs in Part I. Use *be able to*.

1. Patricia ___*was able to play*___ the piano when she was only six years old because she took a lot of lessons.

2. Thanks for emailing the report, but something is wrong with the attachment. I _____ it.

3. Michael used to be a great swimmer. He _____ like a fish!

4. _____ French? I need some help with my French homework.

5. Kenzo _____ before he moved to Canada. Now he's a very good skier.

PRACTICE 4 ▸ Expressing possibility and permission. (Chart 7-3)

Decide if the meaning of the modal verb is *possibility* or *permission*.

		Meaning	
1. Both of my grandparents are retired. They like to travel. They may travel overseas next summer.		(possibility)	permission
2. They may take their two grandchildren with them.		possibility	permission
3. A: Yes, Jackson, you may play outdoors until dinner. B: Okay. Thanks, Mom!		possibility	permission
4. A: What's wrong with the dog's foot? B: He may have an infection.		possibility	permission
5. The dog has an infected foot. He might need to go to the vet.		possibility	permission
6. A: I'm sorry, sir, but passengers can't leave their plane seats when the "Fasten seat belt sign" is on. B: Oh, okay. I'm sorry.		possibility	permission
7. It may be hot and humid all weekend.		possibility	permission
8. If you finish the test early, you may leave.		possibility	permission
9. I might not stay up to watch the end of the game on TV. I'm very sleepy.		possibility	permission
10. A: Excuse me. Can I ask you a personal question? B: Hmmm … I don't know. I really don't like personal questions.		possibility	permission

PRACTICE 5 ▶ Expressing possibility. (Chart 7-3)

Rewrite each sentence using the words in parentheses.

1. Maybe I will take a nap. (*might*) ___I might take a nap.___

2. She might be sick. (*maybe*) ___Maybe she is sick.___

3. There may be time later. (*maybe*) _____

4. Maybe our team will win. (*may*) _____

5. You may be right. (*might*) _____

6. Maybe we'll hear soon. (*may*) _____

7. It might rain. (*may*) _____

8. Maybe it will snow. (*might*) _____

9. She might come tomorrow. (*maybe*) _____

10. She might be at home right now. (*maybe*) _____

PRACTICE 6 ▶ Expressing ability and possibility. (Charts 7-2 and 7-3)

Choose the correct answers.

1. A: Are you running in the big race tomorrow, Alan?

 B: No, I'm not. I _____ run. I broke my foot on Saturday, and now it's in a cast.
 - a. can
 - b. can't
 - c. may
 - d. may not

2. A: Where's Tracy? I've been looking for her all morning.

 B: I haven't seen her. She _____ be sick.
 - a. can
 - b. can't
 - c. might
 - d. might not

3. A: I heard that Jessica has gotten a scholarship to Duke University!

 B: It's not definite yet, but she _____ get one. The admissions office says that it's possible and they will let us know next month.
 - a. can
 - b. can't
 - c. might
 - d. might not

4. A: Larry has been in New York for a couple of months. Is he going to stay there or return home?

 B: It depends. If he _____ find a job there soon, he'll stay. If not, he'll come home.
 - a. can
 - b. can't
 - c. may
 - d. may not

5. A: Is Jodie a doctor now?

 B: Not yet, but almost. She finished medical school last month, but she hasn't taken her exams yet. She _____ be a doctor until she passes them.
 - a. can
 - b. can't
 - c. might
 - d. might not

6. A: When are you going to sell your old car?

 B: As soon as I _____ find someone to buy it!
 - a. can
 - b. can't
 - c. may
 - d. may not

PRACTICE 7 ▸ Meanings of *could*. (Charts 7-2 and 7-4)

Choose the expression that has the same meaning as the verb in *italics*.

1. A: How long will it take you to paint two small rooms?

 B: I'm not sure. If I have help, I *could finish* by Thursday.

 a. was able to finish b. might finish

2. I think I'll take my umbrella. It *could rain* today.

 a. was able to rain b. might rain

3. My niece *could read* by the time she was four years old.

 a. was able to read b. might read

4. You *could see* that the little boy was unhappy because of the sad expression in his eyes.

 a. were able to see b. might see

5. Sara is in excellent shape. I think she *could win* the 10-kilometer race on Saturday.

 a. was able to win b. might win

6. John *couldn't drive* for a month because of a broken ankle, but now it's healed.

 a. wasn't able to drive b. might not drive

7. Jane *could arrive* before dinner, but I don't really expect her until nine or later.

 a. was able to arrive b. might arrive

8. Simon was in an accident, but he *couldn't remember* how he had hurt himself.

 a. wasn't able to remember b. might not remember

PRACTICE 8 ▸ Polite requests: *May I, Could I, Can I*. (Chart 7-5)

Complete the conversations. Write the letter of the question that matches each answer.

> a. Can I borrow the book when you finish it?
>
> b. Could I pick you up at 6:30 instead of 6:00?
>
> c. Could we watch the comedy instead of the war movie?
>
> d. May I ask you a question?
>
> e. May I have some more potatoes, please?
>
> f. May I help you?

1. A: _____

 B: Yes. They're delicious, aren't they?

2. A: _____

 B: Yes. What would you like to know?

3. A: _____

 B: Thanks. I want to buy this.

4. A: _____

 B: That's a little late.

5. A: _____

 B: Sure. I'm in the mood for something funny.

6. A: _____

 B: Yes. I'll probably finish it tonight.

PRACTICE 9 ▸ Polite requests. (Charts 7-5 and 7-6)

Complete each part of the conversation with the correct *italicized* word. More than one word may be correct.

(1) *may, would*

 A: Hello, Tracy Johnson's office. _____ I help you?

 <small>1</small>

 B: Yes, please. I'd like to speak to Ms. Johnson.

 A: I'm sorry. She's in a meeting. _____ you leave your name and number?

 <small>2</small>

 I'll ask her to call you back.

 B: Yes. It's 555-7981.

 A: _____ I tell her what this is about?

 <small>3</small>

 B: Well, I have some good news for her. _____ you please tell her that?

 <small>4</small>

(2) *will, could*

 A: Of course.

 B: And _____ you please tell her that this is important?

 <small>5</small>

 A: All right, I certainly will. _____ I ask you just one more thing?

 <small>6</small>

 B: Yes?

 A: _____ you please leave me your name? You forgot to tell me that.

 <small>7</small>

PRACTICE 10 ▸ Polite requests. (Charts 7-5 and 7-6)

Check (✓) all the modal auxiliaries that correctly complete each question.

1. It's cold in here. _____ you please close the door?

 _____ May ✓ Could ✓ Can ✓ Would

2. Oh, I forgot my wallet. _____ I borrow ten dollars from you until tomorrow?

 _____ Could _____ May _____ Will _____ Can

3. I can't lift this box by myself. _____ you help me carry it?

 _____ Would _____ Could _____ May _____ Will

4. Hello. _____ I help you find something in the store?

 _____ Can _____ Would _____ May _____ Could

5. The store closes in ten minutes. _____ you please bring all your purchases to the counter?

 _____ Will _____ May _____ Can _____ Could

Complete the sentences. Use **should** or **shouldn't** and the expressions in the box.

always be on time for an appointment	drive the speed limit
attend all classes	give too much homework
be cruel to animals	quit
✓ drive a long distance	throw trash on the ground

1. If you are tired, _____ *you shouldn't drive a long distance* _____.

2. Cigarette smoking is dangerous to your health. You _____.

3. A good driver _____.

4. A teacher _____.

5. A student _____.

6. Animals have feelings. You _____.

7. It is important to be punctual. You _____.

8. Littering is against the law. You _____.

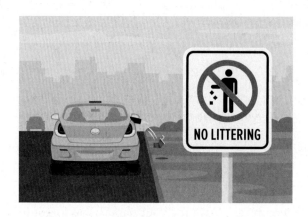

Write the letter of the word or phrase that correctly completes each sentence.

a. ask her again	f. read the instructions first
b. eat it	g. stay on my diet
c. find a new girlfriend	h. study
d. go to the game	i. wash it in cold water
e. try to use it yet	j. wash it in hot water

1. A: Should I wash this sweater in hot water to get the spot out?

 B: No. You shouldn't _____. The sweater will shrink if you wash it in hot water.
 You should _____.

2. A: This is my new 3D printer, but I can't figure out how to use it.

 B: That looks really expensive. You shouldn't _____. You should _____.

3. A: You like this chocolate cake, don't you?

 B: I love it, but I shouldn't _____. I'm trying to lose weight. I should _____.

4. A: Are you going to study for the exam tonight?

 B: I should _____, but I'm not going to. I'm going to the basketball game.

 A: How come?

 B: Well, I shouldn't _____, but I really want to see it. Our team might win the championship tonight!

5. A: I have asked Sophie to marry me five times. She always says "No." What should I do? Should I ask her again?

 B: No, of course not! You shouldn't _____. You should _____.

PRACTICE 13 ▸ Expressing advice. (Charts 7-7 and 7-8)
Choose the correct answers.

1. Danny doesn't feel well. He _____ see a doctor.

 (a.) should b. ought c. had

2. Danny doesn't feel well. He _____ better see a doctor.

 a. should b. ought c. had

3. Danny doesn't feel well. He _____ to see a doctor.

 a. should b. ought c. had

4. It's very warm in here. We _____ open some windows.

 a. should b. ought c. had

5. It's really cold in here. We _____ to close some windows.

 a. should b. ought c. had

6. There's a police car behind us. You _____ better slow down!

 a. should b. ought c. had

7. People who use public parks _____ clean up after themselves.

 a. should b. ought c. had

8. I have no money left in my bank account. I _____ better stop charging things on my credit card.

 a. should b. ought c. had

9. It's going to be a formal dinner and dance. You _____ to change clothes.

 a. should b. ought c. had

10. This library book is overdue. I _____ better return it today.

 a. should b. ought c. had

PRACTICE 14 ▸ Expressing necessity. (Chart 7-9)
Read the passage. Complete each sentence with an appropriate word from the box.

have	has	had	must

 I'm applying to colleges now. I would like to go to Stellar University, but they probably won't

accept me. First, students _____ to have excellent grades to go there, and my
 1

grades are only average. Second, a student _____ be in the top 10 percent of
 2

the class, and I am not. I am in the top 30 percent. Third, everybody _____
3
to take a difficult examination and do well on it. I am not good at examinations. I

_____ to take many examinations when I was younger, and I didn't do well on
4

any of them. On the other hand, I think they will accept me at State University. First, at this school, a

student doesn't _____ to have excellent grades, just good ones. Second, there
5

is no entrance examination. Instead, you just _____ to write a couple of good
6

essays, and I am good at writing. I _____ to write a lot of compositions last
7

year, and I always did well.

 You _____ got to be realistic when you choose your university. I think I
8

am very realistic, and I expect State University will be a good fit for me.

PRACTICE 15 ▸ Necessity: *must, have to, have got to.* (Chart 7-9)
Choose the correct completions.

1. Last week, John had to / must interview five people for the new management position.
2. Professor Drake had got to / had to cancel several lectures when she became ill.
3. Why did you have to / had to leave work early?
4. I must / had to take my daughter to the airport yesterday.
5. Where did John have to / had to go for medical help yesterday?
6. We had to / had got to contact a lawyer last week about a problem with our neighbors.
7. I have got to / had to leave now. I have to / had to pick up my kids. They're waiting at school.
8. You had to / must have a pencil with an eraser for the exam. Do not bring a pen.

PRACTICE 16 ▸ Necessity: *must, have to, have got to.* (Chart 7-9)
Write the past tense of the verbs in *italics*.

1. I *have to study* for my medical school exams.

 PAST: I _____had to study_____ for my medical school exams.

2. We *have to turn off* our water because of a leak.

 PAST: We _____ our water because of a leak.

3. *Do* you *have to work* over the holidays?

 PAST: _____ you _____ over the holidays?

4. Jerry *has got to see* the dentist twice this week.

 PAST: Jerry _____ the dentist twice last month.

5. Who *has got to be* in early for work this week?

 PAST: Who _____ in early for work last week?

6. The bank *must close* early today.

 PAST: The bank _____ early yesterday.

Check (✓) the sentence that best completes each conversation.

1. A: Ma'am, show me your driver's license, please.

 B: Of course, officer. But what did I do? Why did you pull me over?

 A: ☐ You didn't stop at the red light. You have to stop at red lights.

 ☐ You've got to be on time for work.

 ☐ You have to fill out this form.

2. A: Son, what happened? You didn't call to say that you were going to be late.

 B: I'm sorry. I forgot.

 A: ☐ You must get better grades.

 ☐ You have to clean up your room.

 ☐ You've got to be more responsible.

3. A: Nice shoes. But they're too big for you!

 B: Well, I ordered them from an internet site, but they sent the wrong ones instead.

 A: ☐ You must wear better shoes.

 ☐ You've got to walk a lot.

 ☐ You have to send them back and get the right ones.

4. A: May I help you?

 B: Yes. I'm here to apply for the assistant teacher's job.

 A: ☐ Okay. Everyone has to apply for a job.

 ☐ Okay. Everyone must fill out an application. Here it is.

 ☐ Okay. Everyone has got to pay attention.

5. A: Ms. Honeywell, Noah will be better in a few days.

 B: Should he take any medicine, doctor?

 A: ☐ No. He has got to play football tomorrow.

 ☐ No. He has to take this medicine three times a day.

 ☐ No. He just has to stay in bed for a couple of days and drink plenty of water.

Complete the sentences with *don't have to* or *must / must not*.

1. To fly from one country to another, you _____*must*_____ have a plane ticket and a passport.

2. To fly from one city to another in the same country, it's necessary to have a plane ticket, but you

 _____ have a passport.

3. You _____ print your boarding pass. You can use a mobile boarding pass on your phone instead.

4. Ethan, you are allergic to bees. There are a lot of bees in the flowers. You _____ play near them.

5. You _____ order fish in this seafood restaurant. You can have chicken or beef if you prefer.

6. Your fever is gone. You _____ take this medicine any more.

7. Susie, you _____ take this medicine. It's for adults, not children. It will make you sick.

8. If you see a sign that says "No Left Turn," you _____ turn left there.

9. When your phone rings, you _____ answer it. The caller can leave a message.

10. When you are in a theater, you _____ use your phone. You have to turn it off.

11. It's warm all the time in Hawaii, so you _____ wear heavy sweaters and jackets there.

12. The wedding is very formal. Everyone has to wear formal clothes. You _____ wear jeans or sandals.

13. You _____ apologize. It wasn't your fault.

14. We _____ pack for our trip right now. We aren't leaving until next week.

15. We _____ be late for the meeting tomorrow. Our manager expects everyone to be there a little early.

PRACTICE 19 ▶ Expressing necessity, lack of necessity, and prohibition.
(Charts 7-9 and 7-10)

Write the phrases in the correct columns.

cook every meal themselves	say "sir" or "madam" to others
drive without a license	stay in their homes in the evening
eat and drink in order to live	stop when they see a police car's lights behind them
✓fall asleep while driving	take other people's belongings
pay taxes	

People have to / must . . . (necessary)	People must not . . . (Don't!)	People don't have to . . . (not necessary)
	fall asleep while driving	

PRACTICE 20 ▸ Logical conclusions. (Chart 7-11)
Choose the correct answers.

Five Cousins at the Dinner Table

1. Isabel has eaten two potatoes and now she is asking for another one. _____
2. Rose is sitting at the table, but she isn't eating anything. She had a dish of ice cream just before dinner. _____
3. Emily is telling everyone about her trip to Costa Rica. She is leaving next week. _____
4. Jill just tasted some fish and made a funny face. _____
5. Natalie has fallen asleep at the dinner table! _____

a. She must not like it.
b. She must be very tired.
c. She must like them.
d. She must not be hungry.
e. She must be excited about it.

PRACTICE 21 ▸ Logical conclusion or necessity. (Charts 7-9 and 7-11)
Write "1" if *must* expresses a logical conclusion. Write "2" if *must* expresses necessity.

1 = logical conclusion

2 = necessity

1. _____2_____ You *must have* a passport to travel abroad.
2. _____1_____ You *must like* to read. You have such a large library.
3. _____ You *must take off* your shoes before entering this room.
4. _____ The dessert *must be* good. It's almost gone.
5. _____ You *must try* this dessert. It's wonderful.
6. _____ Travelers *must empty* their pockets before going through security.
7. _____ You *must pay* in advance if you want a front-row seat for the performance.
8. _____ Ellen *must* really *like* being at the beach. She goes there every vacation.

PRACTICE 22 ▸ Tag questions with modal auxiliaries. (Chart 7-12)
Complete the tag questions with the correct modal auxiliary.

1. You won't be upset if I don't go, _____ you?
2. George can help us, _____ he?
3. Mr. Cheng would like to come with us, _____ he?
4. You would rather stay home, _____ you?
5. Claire can't speak French, _____ she?
6. You don't have to work next weekend, _____ you?
7. Teachers shouldn't give too much homework, _____ they?
8. I'll see you tomorrow, _____ I?
9. You couldn't hear me, _____ you?
10. We should cross the street here, _____ we?
11. Ms. Scott has to take a driving course, _____ she?
12. If Grandma is expecting us at 6:00, we should leave here at 4:00, _____ we?

Pretend that someone says the following sentences to you. Which verbs give instructions? <u>Underline</u> the imperative verbs.

1. I'll be right back. <u>Wait</u> here.

2. <u>Don't wait</u> for Rebecca. She's not going to come.

3. Read pages 39 to 55 before class tomorrow.

4. What are you doing? Don't throw those papers in the trash. They're important.

5. Come in and have a seat. I'll be right with you.

6. Please turn off your phones before class begins.

7. Meet me at the coffee shop after class tomorrow. If your plans change, text me.

8. It's raining really hard. Here, take this umbrella, but don't forget to bring it back!

Complete the conversation with verbs from the boxes.

Six neighborhood friends have grown up together. They are very close. They meet for breakfast on Sundays and then try to do something active together during the day. Here's a conversation they had on one recent Sunday.

Part I. fly listen sail walk

JOHNNY: There's a strong wind today. Let's _____ our kites on the beach today.
 1

 BOBBY: No, the wind is perfect for sailing. Let's _____ on the lake today.
 2
 We could rent two boats for a few hours.

 GRACE: Why don't we _____ over to the park? It's a beautiful day, and we could
 3
 have a great time. There's a country music festival there today.

 DORA: Yes, let's go to the park and _____ to country music.
 4

Part II. go see shop

ALICE: I don't like country music very much. I'd rather go to the mall. Let's _____
 5
shopping. They're having a big holiday sale today.

TIMMY: Shopping is boring. I'll tell you what. Alice, why don't you _____ and the
 6
rest of us will do something else.

ALICE: Hmmm. Grace, do you want to drive over to the mall with me?

GRACE: No, I'd rather do something as a group. Okay, guys—let's _____. What
 7
can the rest of us enjoy as a group?

Part III. do, have, plan, tell

JOHNNY: I think we should go to the country music festival together. They have a lot of great

musicians. After that, let's _____ pizza at my house. We can order it from
 8
the Pizza Pan.

BOBBY: Okay. Let's _____ that today—go to the festival and end up at Johnny's.
 9
Then let's _____ a sailing day next week. Johnny, why don't you
 10
_____ your parents we're having a pizza dinner and invite them to join us too?
 11

PRACTICE 25 ▶ Stating preferences. (Chart 7-15)
Complete the sentences with ***prefer***, ***like(s)***, or ***would rather***.

1. I _____*prefer*_____ cold weather to hot weather.

2. A: What's your favorite fruit?

 B: I _____*like*_____ strawberries better than any other fruit.

3. Mary _____*would rather*_____ save money than enjoy herself.

4. A: Why isn't your brother going with us to the movie?

 B: He _____ stay home and read than go out on a Saturday night.

5. A: Does Peter _____ football to baseball?

 B: No. I think he _____ baseball better than football.

 A: Then why didn't he go to the game yesterday?

 B: Because he _____ watch sports on his computer than go to a ball park.

6. A: Do you want to go out to the Japanese restaurant for dinner?

 B: That would be okay, but honestly I _____ Chinese food to Japanese food.

 A: Really? I _____ Japanese food better than Chinese food.

 B: Why don't we go to the Italian restaurant? We both love Italian food.

Use the words in parentheses to make a new sentence with the same meaning.

1. Alex would rather swim than jog. (*prefer*)

 _____Alex prefers swimming to jogging._____

2. My son would rather eat fish than beef. (*like*)

3. Kim likes salad better than dessert. (*prefer*)

4. In general, Nicole would rather have coffee than tea. (*like*)

5. Bill prefers teaching history to working as a business executive. (*would rather*)

6. When Sam thinks about having a pet, he prefers dogs to cats. (*like*)

7. On a long trip, Susie would rather drive than ride in the back seat. (*prefer*)

8. I like studying in a noisy room better than studying in a quiet room. (*would rather*)

9. Alex likes soccer better than baseball. (*would rather*)

The words in green are modal auxiliaries. Read the passage, and then answer the question.

Doing Chores

Everyone in my family has to do chores
1
around the house. A chore is a special job that
one person must perform. The chore could
2 3
be to wash the dinner dishes, for example,
or it might be to sweep the porch. My
4
parents give chores to my brother Joe and me,
and we have to do these chores every day.
5

Sometimes if one of us is busy and can't do a chore, the other one may take care of it. For
6 7
example, last Friday it was Joe's turn to wash the dishes after dinner. But he said he couldn't wash
8
them at that time because he had to hurry to school for a basketball game. Joe asked me, "Will
9
you do the dishes for me, please? I promise to do them for you tomorrow when it's your turn.
I've got to be on time for the game at school." I agreed to do Joe's chore and washed the dishes
10
after dinner.

But the next night, Joe "forgot" that we had traded days. When I reminded him to wash the
dishes, he said, "Who, me? It's not my turn."

In the future, we should put our agreements in writing. That ought to solve any problems if
11 12
anyone says, "It's not my turn."

What is the meaning of these modal auxiliaries from the passage? Circle the word or words closest in
meaning to the modal.

Modal Auxiliary		Meaning		
(1) Everyone **has to** do …	*must*	*should*	*is able to*	*might*
(2) … one person **must** perform …	*has to*	*should*	*is able to*	*might*
(3) The chore **could** be to wash …	*must*	*should*	*is able to*	*might*
(4) … it **might** be to sweep …	*must*	*should*	*is able to*	*could*
(5) … we **have to** do these chores …	*must*	*should*	*are able to*	*might*
(6) … and **can't** do a chore …	*must not*	*shouldn't*	*isn't able to*	*might not*
(7) … the other one **may** …	*must*	*should*	*is able to*	*might*
(8) But he said he **couldn't** …	*must not*	*shouldn't*	*wasn't able to*	*may not*
(9) **Will** you do the dishes …	*Must you*	*Should you*	*Are you able to*	*Would you*
(10) **I've got to** be on time …	*must*	*should*	*am able to*	*may*
(11) … we **should** put our …	*must*	*ought to*	*are able to*	*may*
(12) That **ought to** solve …	*must*	*should*	*is able to*	*may*

Correct the errors.

1. Before I left on my trip last month, I ~~must~~ *had to* get a passport.

2. Could you to bring us more coffee, please?

3. Ben can driving, but he prefers take the bus.

4. A few of our classmates can't to come to the school picnic.

5. May you take our picture, please?

6. Why aren't you wearing a jacket? You must to be really cold!

7. Jim would rather has Fridays off in the summer than a long vacation.

8. You must stopping at intersections with stop signs.

9. Take your warm clothes with you. It will maybe snow.

10. It's such a gorgeous day. Why we don't go to a park or the beach?

PRACTICE 29 ▸ Crossword puzzle. (Chapter 7)

Complete the puzzle with modal auxiliaries. Use the clues to find the correct words.

Across

2. If you want to be a lawyer, you _____ to graduate from law school.

3. I _____ go with you. I don't know yet. If I finish my homework, I'll go with you.

5. _____ don't you join us for lunch today?

6. I'd _____ go fishing than go sailing.

7. You haven't eaten all day. You _____ be very hungry!

8. When I was a kid, I _____ jump high into the air. Now I can't.

Down

1. Uh oh! You had _____ slow down! I see a police officer on his motorcycle over there.

3. _____ I come in? I'd like to talk to you.

4. I _____ study tonight, but I'm not going to. I'm going to stream a movie.

Appendix 1

Phrasal Verbs

Complete the examples in the chart.

Group A: Phrasal Verbs (separable)		
Verb	**Definition**	**Example**
figure out	find the solution to a problem	I *figured* ___out___ the answer.
hand in	give homework, papers, etc., to a teacher	We *handed* _____ our homework.
hand out	give something to this person, then that person, etc.	The teacher *handed* _____ the test papers to the class.
look up	look for information in a dictionary, phone book, online, etc.	I *looked* _____ the store hours online.
make up	invent (a story)	Kids like to *make* _____ stories.
pick up	lift	Tom *picked* _____ the baby.
put down	stop holding or carrying	I *put* _____ the heavy packages.
put off	postpone	We *put* _____ our trip until next summer.
put on	place clothes on one's body	I *put* _____ my coat before I left.
take off	remove clothes from one's body	I *took* _____ my coat when I arrived.
throw away } **throw out** }	put in the trash, discard	I *threw* _____ my old notebooks. I *threw* _____ my old notebooks.
turn off	stop a machine or a light	I *turned* _____ the lights and went to bed.
turn on	start a machine or a light	I *turned* _____ the light and read a book.
wake up	stop sleeping	I *woke* _____ at six.
write down	write a note on a piece of paper	I *wrote* his phone number _____.

PRACTICE 2 ▸ Group A.
Complete the sentences with particles from the box.

away	down	in	off	on	out	up

1. Jackson is all wet. I told him to take _____ his clothes and put _____ some dry ones.

2. Lilly made _____ a story. She didn't tell the truth.

3. Alice used her phone to look _____ a word. Then she wrote _____ the definition.

4. Sometimes I postpone doing my homework. I put it _____ till the last minute, but I never hand _____ assignments late.

5. My arms hurt, so I put the baby _____ for a minute. But he started crying right away, so I picked him _____ again.

6. My roommate is messy. He never picks _____ his clothes.

7. I wanted to wake _____ at 7:00, but I didn't get up until 7:30. When the alarm rang, I turned it _____ and went back to sleep.

8. We don't need these receipts anymore. We can throw them _____.

9. When I got my physics test today, I realized that I couldn't figure _____ any of the answers. Our teacher had made a mistake and handed _____ the wrong test!

PRACTICE 3 ▸ Group A.
Choose all the correct completions for each sentence.

1. Akiko turned off (her phone,) the butter. (the stove.)

2. I took off my coat. my homework. my wedding ring.

3. Jonas put on his shoes. a pencil. the dishes.

4. Benjamin made up a story. a fairy tale. an excuse.

5. Susanna threw out some air. some rotten food. an old shirt.

6. Antonio put off a doctor's appointment. a meeting. a trip.

7. Max figured out a puzzle. a math problem. difficult.

8. Kyong handed in some candy. a report. some late homework.

9. The secretary wrote down a message. a pencil. a phone number.

10. The mail carrier put down a box. the mail truck. a sack of mail.

11. Mustafa turned off the light. the computer. the car engine.

PRACTICE 4 ▸ Group B.

Complete the examples for the chart.

Group B: Phrasal Verbs (nonseparable)		
Verb	**Definition**	**Example**
call on	ask (someone) to speak in class	The teacher *called* _____ Ali.
come from	originate	Where did these bananas *come* _____?
get over	recover from an illness or a shock	Sue *got* _____ her cold quickly.
get off	leave ⎫ a bus/airplane/train/subway	I *got* _____ the bus at First Street.
get on	enter ⎭	I *got* _____ the bus at Fifth Street.
get in/into.	enter ⎫ a car, a taxi	I *got* _____ the taxi at the airport.
get out of	leave ⎭	I *got* _____ the taxi at the hotel.
look into.	investigate	The police are *looking* _____ the crime.
run into	meet by chance	I *ran* _____ Peter at the store.

PRACTICE 5 ▸ Group B.

Complete the sentences with particles from the list.

from	in	into	off	on	out of	over

1. When I raised my hand in class, the teacher called _____ me.

2. Josh feels okay today. He got _____ his cold.

3. Last week I flew from Chicago to Miami. I got _____ the plane in Chicago. I got _____ the plane in Miami.

4. Elena took a taxi to the airport. She got _____ the taxi in front of her apartment building. She got _____ the taxi at the airport.

5. I take the bus to school every day. I get _____ the bus at the corner of First Street and Sunset Boulevard. I get _____ the bus just a block away from the classroom building.

6. The receptionist at the power company didn't know why my bill was so high, but she said she would look _____ it.

7. I ran _____ Pierre at the mall. He's married and has ten kids!

8. I ordered some new furniture. It came _____ India.

PRACTICE 6 ▸ Group B.

Complete each sentence in Column A with the correct phrase from Column B.

Example: Annette speaks both French and English because she comes . . .

> *Annette speaks both French and English because she comes from Quebec.*

Column A	Column B
1. Annette speaks both French and English because she comes	a. into your request for medical records.
2. When Sylvia lost her job, it took her several weeks to get	✓b. from Quebec.

3. Our office will need several days to look	c. over the shock.
4. When a plane lands, the first-class passengers get	d. into a taxi and went to the airport.
5. While I was walking in the mall, I ran	e. on unprepared students.
6. When he left the hotel, David got	f. into several friends from high school.
7. Mrs. Riley, our math teacher, often calls	g. off first.

PRACTICE 7 ▸ Group C.

Complete the examples for the chart.

Group C: Phrasal Verbs (separable)		
Verb	**Definition**	**Example**
ask out.	ask (someone) to go on a date	Tom *asked* Emily _____. They went to a movie.
call back	return a telephone call	I'll *call* you _____ tomorrow.
call off	cancel	We *called* _____ the picnic because of the rain.
call up	make a telephone call	I *called* _____ my friend in New York.
give back	return something to someone	I borrowed Lee's pen, then I *gave* it _____.
hang up	hang on a hanger or a hook	I *hung* my coat _____ in the closet.
pay back	return borrowed money to someone	Thanks for the loan. I'll *pay* you _____ soon.
put away	put something in its usual or proper place	I *put* the clean dishes _____.
put back	return something to its original place	I *put* my books _____ into my bag.
put out.	extinguish (stop) a fire, a cigarette	We *put* _____ the campfire before we left.
shut off	stop a machine or light, turn off	I *shut* _____ the copy machine before I left the office.
try on.	put on clothing to see if it fits	I *tried* _____ several pairs of shoes.
turn down	decrease the volume	Chris *turned* _____ the music. It was too loud.
turn up	increase the volume	Michael *turned* _____ the music. He likes loud music.

PRACTICE 8 ▸ Group C.

Complete the sentences with particles from the box.

away	back	down	off	on	out	up

1. You still owe me the money I lent you. When are you going to pay me _____?

2. Turn _____ the music! It's too loud! I can't hear myself think.

3. Debra put _____ the fire in the oven with a fire extinguisher.

4. I'll wash and dry the dishes, and you can put them _____ in the cabinet.

5. Before you buy shoes, you should try them _____ to see if they fit.

6. I can't hear the news. Could you please turn _____ the TV?

7. You can borrow my stapler, but please give it _____ to me before you leave the office.

8. I didn't hear anyone on the other end of the phone, so I hung _____.

9. You can look at these books, but please put them _____ on the shelf when you're finished.

10. Bob hasn't paid his electric bill for months, so the electric company shut his power _____.

11. A: I hear that Tom asked you _____ for next Saturday night.

 B: Yes, he did. He called me _____ a couple of hours ago and invited me to a soccer game.

 A: The game has been called _____ because it's raining. Didn't you hear about it?

 B: No, I didn't. I'd better call Tom _____ and ask him what he wants to do instead.

PRACTICE 9 ▸ Phrasal verbs: separable. (Groups A, B, C)

Complete the sentences with a given particle where possible. If not possible, write "X."

1. *out*	a. Paulo asked ___*out*___ one of his classmates.
	b. Paulo asked one of his classmates ___*out*___.
2. *on*	a. The teacher called ___*on*___ Ted for the answer.
	b. The teacher called Ted ___*X*___ for the answer.
3. *into*	a. The police are looking _____ the crime, but they need help from the public to solve it.
	b. The police are looking the crime _____, but they need help from the public to solve it.
4. *into*	a. Khalifa ran his cousin _____ at the store.
	b. Khalifa ran _____ his cousin at the store.
5. *up*	a. Claire turned _____ the ringer on her phone.
	b. Claire turned the ringer on her phone _____.
6. *away*	a. Dr. Benson threw _____ a valuable coin by mistake.
	b. Dr. Benson threw a valuable coin _____ by mistake.
7. *down*	a. Yumi's baby cries whenever she puts him _____.
	b. Yumi's baby cries whenever she puts _____ him.
8. *up*	a. Would you please wake _____ me in one hour?
	b. Would you please wake me _____ in one hour?

9. *away*	a. You can leave the dishes. I'll put them _____ later.
	b. You can leave the dishes. I'll put _____ them later.
10. *up*	a. When Joan feels lonely, she calls _____ a friend and talks for a while.
	b. When Joan feels lonely, she calls a friend _____ and talks for a while.
11. *off*	a. The hill was so steep that I had to get _____ my bicycle and walk.
	b. The hill was so steep that I had to get my bicycle _____ and walk.
12. *from*	a. This fruit is very fresh. It came _____ my garden.
	b. This fruit is very fresh. It came my garden _____ .

PRACTICE 10 ▸ Group D.

Complete the examples.

Group D: Phrasal Verbs (separable)		
Verb	**Definition**	**Example**
cross out	draw a line through	I *crossed* _____ the misspelled word.
fill in	complete by writing in a blank space	We *fill* _____ the blanks in grammar exercises.
fill out	write information on a form	I *filled* _____ a job application.
fill up	fill completely with gas, water, coffee, etc.	We *filled* _____ the gas tank.
find out	discover information	I *found* _____ where he lives.
have on	wear	She *has* a blue blouse _____ .
look over	examine carefully	*Look* _____ your paper for errors before you hand it in.
point out	call attention to	The teacher *pointed* _____ a misspelling.
print out	create a paper copy	Would you like me to *print* _____ your receipt, or should I email you a copy?
tear down	destroy a building	They *tore* _____ the old house and built a new one.
tear out (of)	remove (paper) by tearing	I *tore* a sheet of paper _____ _____ my notebook.
tear up	tear into small pieces	I *tore* _____ the documents with my credit card information.
turn around **turn back**	change to the opposite direction	After a mile, we *turned* _____ / _____ .
turn over	turn the top side to the bottom	I *turned* the paper _____ and wrote on the back.

PRACTICE 11 ▸ Group D.

Complete the sentences with particles from the box.

around	back	down	in	of	out	over	up

1. You're going to burn those pancakes! You need to turn them __over__ and cook the other side.

2. When the teacher finds a mistake in our writing, she points it _____ so we can correct it.

3. When I write words in this practice, I am filling _____ the blanks.

4. When I discover new information, I find something _____.

5. When I finish writing my essay, I will print it _____.

6. When buildings are old and dangerous, we tear them _____.

7. When I turn and go in the opposite direction, I turn _____.

8. When I remove a piece of paper from a spiral notebook, I tear the paper _____ my notebook.

9. When I write something that I don't want anybody else to see, I tear the paper into tiny pieces. I tear _____ the paper.

10. When I write information on an application form, I fill the form _____.

11. When I make a mistake in something I write, I erase the mistake if I'm using a pencil. If I'm using a pen, I cross the mistake _____ by drawing a line through it.

12. When my juice glass is empty, I fill it _____ again if I'm still thirsty.

13. When I check my homework carefully before I give it to the teacher, I look it _____.

PRACTICE 12 ▸ Groups A, B, C, D

Complete the sentences with the particles in *italics*. The particles may be used more than once or not at all.

1. *out, away, back, down, off, on*

 Sofie . . .

 a. put __off__ her vacation because she was sick.

 b. put _____ her boots to go out in the rain.

 c. put the phone _____ when she saw a spider crawling toward her.

 d. put her things _____ in her suitcase after the customs officer checked them.

 e. put _____ the stovetop fire with a small fire extinguisher.

 f. put _____ all the groceries she bought before she started dinner.

2. *out, in, up*

 James . . .

 a. handed _____ his financial report before the due date.

 b. handed _____ thank-you gifts to his staff for their hard work.

3. *into, off, on, up, over, out of*

 Leah . . .

 a. got _____ the flu in three days and felt wonderful.

 b. got _____ the bus and walked home.

 c. got _____ the bus and sat down behind the driver.

 d. got _____ a taxi and buckled her seatbelt.

 e. paid the driver and got _____ the taxi.

4. *in, down, up, out*

 a. This book has a few pages missing. The baby tore them _____.

 b. Before I throw my credit card receipts away, I tear them _____. I don't want anyone to read them.

 c. The building across the street will be torn _____ to make room for a parking garage.

5. *over, into, up*

 a. The neighbors asked the sheriff to look _____ a crime in their neighborhood.

 b. The sheriff looked _____ a suspect's address on the computer.

 c. The sheriff took the suspect's ID, looked it _____ slowly, and decided it was fake.

6. *off, down, up, back*

 a. I called Chloe _____ several times but got no answer. I'm a little worried.

 b. The meeting was called _____ because the chairperson was sick.

 c. Jack called and left a message. I'll call him _____ after dinner.

7. *over, up, in, off, back*

 a. I'm trying to do homework, but your music is very loud. It's hard to concentrate. Please turn it _____.

 b. It's cold, and I'm tired. Let's turn _____ and go home.

 c. Could I turn _____ the TV? I can't hear it very well.

 d. Joe, the meat needs to be cooked on the other side. Would you turn it _____, please?

8. *in, out, up*

 a. I forgot to fill _____ a couple of blanks on the test. I hope I passed.

 b. Can I take this application home and fill it _____? I don't have much time now.

 c. Jack carries a thermos bottle to work. He fills _____ his cup when he gets thirsty.

 d. Gas is expensive. It costs a lot to fill _____ my tank.

Complete the examples for the chart.

Group E: Phrasal Verbs (separable)		
Verb	**Definition**	**Example**
blow out	extinguish (a match, a candle)	He *blew* the candles _____ .
bring back	return	She *brought* my books _____ to me.
bring up	(1) raise (children)	The Lees *brought* _____ six children.
	(2) mention, start to talk about	He *brought* the news _____ in conversation.
cheer up	make happier	The good news *cheered* me _____ .
clean up	make neat and clean	I *cleaned* _____ my apartment.
give away	donate, get rid of by giving	I didn't sell my old bike. I *gave* it _____ .
help out	assist (someone)	Could you please *help* me _____ ?
lay off	stop employment	The company *laid* _____ 100 workers.
leave on	(1) not turn off (a light, a machine)	Please *leave* the light _____ . I can't see.
	(2) not take off (clothing)	I *left* my coat _____ during class.
take back	return	She *took* a book _____ to the library.
take out	invite out and pay for	He *took* Mary _____ . They went to a movie.
talk over	discuss	We *talked* the problem _____ .
think over	consider	I *thought* the problem _____ .
work out	solve	We *worked* the problem _____ .

Complete the sentences with particles from the box.

| away | back | off | on | out | over | up |

1. It's pretty chilly in here. You might want to leave your jacket _____ .

2. My father speaks with an Australian accent. He was brought _____ in Australia.

3. The Smiths have marriage problems, but they are trying to work them _____ . They talk them _____ as soon as they occur.

4. Isabel blew _____ the candles on her birthday cake.

5. My roommate gives _____ his old clothes to homeless people. He tries to help them _____ as often as possible.

6. I took my parents _____ to a restaurant for their anniversary. Then I cleaned _____ their house the next day for them.

7. These are bad economic times. Businesses are laying _____ hundreds of workers.

8. The store's return policy is that you can bring clothes _____ within two weeks if you have a receipt.

9. I'm meeting with my supervisor later today. I'm going to bring _____ the idea of a raise.

10. I won't be home until midnight, so please leave some lights _____ .

11. When I'm sad, my friends try to cheer me _____ .

12. Are you sure you want to change jobs? Do you want to think it _____ some more?

13. I hate to bring this problem _____, but we need to talk about it.

14. I can't sell this old table. I guess I'll give it _____. Someone will be able to use it.

15. My parents usually help me _____ when I'm having trouble paying my bills.

16. You can borrow my tools, but when you finish, be sure to put them _____.

PRACTICE 15 ▸ Group F.

Complete the examples for the chart.

Group F: Phrasal Verbs (intransitive)		
Verb	**Definition**	**Example**
break down	stop functioning properly	My car *broke* _____ on the highway.
break out	happen suddenly	War *broke* _____ between the two countries.
break up	separate, end a relationship	Ann and Tom *broke* _____.
come in	enter a room or building	May I *come* _____?
dress up	put on nice clothes	People usually *dress* _____ for weddings.
eat out	eat outside of one's home	Would you like to *eat* _____ tonight?
fall down	fall to the ground	I *fell* _____ and hurt myself.
get up	get out of bed in the morning	What time did you *get* _____ this morning?
give up	quit doing something or quit trying	I can't do it. I *give* _____.
go on	continue	Let's not stop. Let's *go* _____.
go out	not stay home	Jane *went* _____ with her friends last night.
hang up	end a telephone conversation	When we finished talking, I *hung* _____.
move in (to)	start living in a new home	Some people *moved* _____ next door to me.
move out (of)	stop living at a place	My roommate is *moving* _____.
show up	come, appear	Jack *showed* _____ late for the meeting.
sit back	put one's back against a chair back	*Sit* _____ and relax. I'll get you a drink.
sit down	go from standing to sitting	Please *sit* _____.
speak up	(1) speak louder I can't hear you. (2) express one's opinion without fear	You'll have to *speak* _____.
stand up	go from sitting to standing	I *stood* _____ and walked to the door.
start over	begin again	I lost count, so I *started* _____.
stay up	not go to bed	I *stayed* _____ late last night.
take off	ascend in an airplane	The plane *took* _____ 30 minutes late.

Complete the sentences with particles from the box.

back	down	in	off	on	out	over	up

1. The plane shook a little when it took _____. It made me nervous.

2. I'm afraid we can't hear you in the back of the room. Could you please speak _____?

3. My chemistry teacher is so confusing. I can't understand a thing! I think I'll just drop the class and start _____ with a new teacher next term.

4. I was late to work. The bus broke _____, and we had to wait for another.

5. Mrs. Taylor is in the hospital again. She fell _____ and broke her hip.

6. Jim and Sarah aren't getting married. They had a fight and broke _____ last night.

7. Julian's at the doctor's office. He broke _____ in a rash last night, and he doesn't know what it is.

8. I'm very nervous when I fly. I can't just sit _____ and relax.

9. Sometimes when I stand _____ too fast, I get dizzy.

10. Someone keeps calling and hanging _____. It's very annoying.

11. Sorry, I didn't mean to interrupt you. Please go _____.

12. A: Professor Wilson, do you have a minute?

 B: Sure. Come _____ and sit _____.

Complete the sentences with particles from the box.

into	of	out	up

1. *Leo is lazy and irresponsible. He . . .*

 a. broke __*up*__ with his girlfriend because she didn't want to wash his clothes.

 b. stayed _____ all night and didn't come home until morning.

 c. showed _____ late for class without his homework.

 d. goes _____ with friends to parties on school nights.

 e. eats _____ at restaurants every day because he doesn't like to cook.

 f. moved _____ _____ his apartment without telling the manager.

2. *Amy is careful and responsible. She . . .*

 a. goes to bed very early. She never stays _____ past 9:00.

 b. gets _____ at 5:00 every morning.

 c. speaks _____ in class when no one will answer.

 d. dresses _____ for school.

 e. moved _____ an apartment close to her school.

 f. never gives _____ when she gets frustrated.

PRACTICE 18 ▸ Group G.

Complete the examples for the chart.

Group G: Phrasal Verbs (three-word)		
Verb	**Definition**	**Example**
drop in (on)	visit without calling first or without an invitation	We *dropped* _____ _____ my aunt.
drop out (of)	stop attending (school)	Beth *dropped* _____ _____ graduate school.
get along (with)	have a good relationship with	I *get* _____ well _____ my roommate.
get back (from)	return from (a trip)	When did you *get* _____ _____ Hawaii?
get through (with)	finish	I *got* _____ _____ my work before noon.
grow up (in)	become an adult	Anika *grew* _____ _____ Sweden.
look out (for)	be careful	*Look* _____ _____ that car!
run out (of)	finish the supply of (something)	We *ran* _____ _____ gas.
sign up (for)	put one's own name on a list	Did you *sign* _____ _____ the school trip?
watch out (for)	be careful	*Watch* _____ _____ that car!

PRACTICE 19 ▸ Group G.

Complete the phrasal verbs.

1. Look _____! There's a car coming! Look _____ _____ the truck too!

2. I grew up in New Zealand. Where did you grow _____?

3. If you want to be in the class, you have to sign _____ _____ it first.

4. I couldn't finish the examination. I ran _____ _____ time.

5. Joe is really tired. He just got _____ _____ a 10-day mountain climbing trip.

6. Jack dropped _____ _____ school last week. His parents are upset.

7. Watch _____ _____ the truck! It has a loose wheel.

8. Joanne got _____ _____ her work early, so she's leaving for vacation today.

9. My neighbor likes to drop _____ _____ us during dinner. I think she's lonely.

10. A: I want to move to another dorm room.

 B: Why?

 A: I don't get _____ _____ my roommate. She's messy and plays loud music when I'm trying to study.

PRACTICE 20 ▶ Group G.

Complete each sentence with the correct word from the box.

assignment	✓dance class	Mexico	paint
rocks	snakes	the hospital	their neighbors

1. Martin signed up for a ___dance class___. It starts next week.

2. The Hansens get along well with _____. They even take vacations together.

3. I can't finish the living room walls because I've run out of _____.

4. The highway sign said to watch out for _____. They roll down the hills and sometimes hit cars.

5. As soon as I get through with this _____, we can go to lunch. I have just one more problem to figure out.

6. Naomi speaks Spanish because she grew up in _____.

7. Let's go check on Hannah. She just got back from _____.

8. Look out for _____ on the path. They're not poisonous, but they might startle you.

PRACTICE 21 ▶ Group H.

Complete the examples.

Group H: Phrasal Verbs (three-word)		
Verb	**Definition**	**Example**
come along (with)	accompany	Do you want to *come* _____ _____ us?
come over (to)	visit the speaker's place	Some friends are *coming* _____ tonight.
cut out (of)	remove	I *cut* sugar _____ _____ my diet.
find out (about)	discover information about	When did you *find* _____ _____ the problem?
get together (with)	join, meet	Let's *get* _____ after work today.
go back (to)	return to a place	I *went* _____ _____ work after my illness.
go over (to)	(1) approach	I *went* _____ _____ the window.
	(2) visit another's home	Let's *go* _____ _____ Jim's tonight.
hang around (with)		John likes to *hang* _____ the coffee shop.
hang out (with)	spend time relaxing	Kids like to *hang* _____ _____ each other.
keep away (from)	not give to	*Keep* sharp knives _____ _____ children.
set out (for)	begin a trip	We *set* _____ _____ the mountain at sunrise.
sit around (with)	sit and do nothing	Don't *sit* _____ all day. Do something!

Complete each sentence with two particles.

1. Before we consider buying a home in this area, we'd like to find ____*out*____ more ___*about*___ the schools.

2. The mountain climbers set _____ _____ the summit at dawn and reached it by lunchtime.

3. When my grandma was 65, she decided to go _____ _____ school and get a college degree.

4. Teenagers like to hang _____ _____ friends after school.

5. Susie needs to keep _____ _____ the dog. She's allergic to the fur.

6. I'm going shopping. Do you want to come _____ _____ me?

7. I invited my class to come _____ _____ our beach house on Saturday.

8. I'm too busy these days. I need to cut something _____ _____ my schedule.

9. A: Did you go _____ _____ Brian's last night?

 B: No, he wasn't home, so I just sat _____ my apartment _____ my cat.

Complete the sentences with particles that will give the same meanings as the <u>underlined</u> words.

1. I'd like to <u>get information</u> about the company. I want to find ____*out*____ ___*about*___ it before I apply for a job there.

2. The two brothers <u>began their</u> fishing <u>trip</u> to the lake before sunrise. They set _____ early because they wanted to be the first ones there.

3. What time is the supervisor <u>returning</u>? I'd like to talk to him when he gets _____.

4. Mark won't be home for dinner. He plans to <u>join</u> his co-workers for a party. They only get _____ once a year, so Mark is looking forward to it.

5. The dog was growling when the dog catcher <u>approached</u> him. The dog catcher went _____ _____ him very carefully.

Appendix 2
Preposition Combinations

PRACTICE 1 ▶ Group A.*
Test yourself and practice the preposition combinations. Follow these steps:

(1) Cover the ANSWERS column with a piece of paper.

(2) Complete the SENTENCES.

(3) Then remove the paper and check your answers.

(4) Then cover both the ANSWERS and the SENTENCES to complete your own REFERENCE LIST.

(5) Again check your answers.

Preposition Combinations: Group A		
Answers	**Sentences**	**Reference List**
from	He was absent __*from*__ work.	**be absent** __*from*__ s.t.**
of	I'm afraid __*of*__ rats.	**be afraid** __*of*__ s.t./s.o.**
about	I'm angry __*about*__ it.	**be angry** _____ s.t.
at / with	I'm angry _____ you.	**be angry** _____ s.o.
about	I'm curious _____ many things.	**be curious** _____ s.t./s.o.
to	This is equal _____ that.	**be equal** _____ s.t./s.o.
with	I'm familiar _____ that book.	**be familiar** _____ s.t./s.o.
of	The room is full _____ people.	**be full** _____ (*people/things*)
for	I'm happy _____ you.	**be happy** _____ s.o.
about	I'm happy _____ your good luck	**be happy** _____ s.t.
to	He's kind _____ people and animals.	**be kind** _____ s.o.
to	She's always nice _____ me.	**be nice** _____ s.o.
to	Are you polite _____ strangers?	**be polite** _____ s.o.
for	I'm ready _____ my trip.	**be ready** _____ s.t.
for	She's thirsty _____ lemonade.	**be thirsty** _____ s.t.

**s.t. = "something"; s.o. = "someone"

Match each phrase in Column A with a phrase in Column B. Use each phrase only once.

Column A	Column B
1. Our dog is afraid ____ _b_ ____ .	a. about his team's win
2. The class is curious ____ .	✓b. of cats
3. Mr. White is angry ____ .	c. for a glass of water
4. Several nurses have been absent ____ .	d. for the start of school
5. After gardening all day, Hannah was thirsty ____ .	e. from work due to illness
6. The workers are angry ____ .	f. about the snake in the cage
7. The baseball coach was happy ____ .	g. to everyone
8. The kitchen cupboard is full ____ .	h. of canned foods
9. I'm not ready ____ .	i. about their low pay
10. It's important to be kind ____ .	j. at his dog for chewing his shoes

PRACTICE 3 ▶ Group A.

Complete the sentences with prepositions.

1. Mr. Porter is nice _____ everyone.

2. One inch is equal _____ 2.54 centimeters.

3. Joe has good manners. He's always polite _____ everyone.

4. I'm not familiar _____ that book. Who wrote it?

5. Anna got a good job that pays well. I'm very happy _____ her.

6. Anna is very happy _____ getting a new job.

7. My backpack is full _____ books.

8. The workers were angry _____ the decrease in their pay.

9. Half the students were absent _____ class yesterday. There is a flu virus going around.

10. I'm not familiar _____ that movie. Who is in it?

11. Kids ask a lot of questions. They are curious _____ everything.

12. William has been afraid _____ spiders since he was a kid.

PRACTICE 4 ▶ Group B.

The prepositions in the column on the left are the correct completions for the blanks. Follow the same steps you used for Group A on page 142.

	Preposition Combinations: Group B	
Answers	Sentences	Reference List
for	I admire you _____ your honesty.	**admire** s.o. _____ s.t.
for	He applied _____ a job.	**apply** _____ s.t.
with	I argued _____ my husband.	**argue** _____ s.o.

about / over	We argued _____ money.	**argue** _____ s.t.	
in	My parents believe _____ me.	**believe** _____ s.o./s.t.	
from	I borrowed a book _____ Oscar.	**borrow** s.t. _____ s.o.	
with	I discussed the problem _____ Jane.	**discuss** s.t. _____ s.o.	
with	Please help me _____ this.	**help** s.o. _____ s.t.	
to	I introduced Sam _____ Mackenzie.	**introduce** s.o. _____ s.o./s.t.	
at	I laughed _____ the joke.	**laugh** _____ s.o./s.t.	
for	I'm leaving _____ Rome next week.	**leave** _____ (*a place*)	
at	Don't stare _____ me.	**stare** _____ s.o./s.t.	

PRACTICE 5 ▸ Group B.

Complete the sentences with prepositions.

1. I borrowed this phone charger _____ Pedro.

2. Could you please help me _____ these heavy bags?

3. Emma, I'd like to introduce you _____ Andrew Kennedy.

4. You shouldn't stare _____ people. It's not polite.

5. Do you believe _____ ghosts?

6. Are you laughing _____ my mistake?

7. I admire my father _____ his honesty and intelligence.

8. I argued _____ Elena _____ politics.

9. I discussed my educational plans _____ my parents.

10. I applied _____ admission to the university.

11. We're leaving _____ Cairo next week.

PRACTICE 6 ▸ Groups A and B.

Complete the sentences with prepositions.

1. Daniel is always nice _____ everyone.

2. A: How long do you need to keep the Spanish book you borrowed _____ me?

 B: I'd like to keep it until I'm ready _____ the exam next week.

3. A: Why weren't you more polite _____ Alan's friend?

 B: Because he kept staring _____ me all evening. He made me nervous.

4. ⁵⁄₁₀ is equal _____ ½.

5. You did a lot of shopping. The refrigerator is full _____ food.

6. Where is the nearest coffee shop? I'm thirsty _____ an iced coffee.

7. I need to discuss my grade _____ my professor.

8. There's a new position for a project manager at my company. You should apply _____ it.

The prepositions in the column on the left are the correct completions for the blanks. Follow the same steps you used for Group A on page 142.

Answers	Sentences	Reference List
	Preposition Combinations: Group C	
of	I'm aware _____ the problem.	**be aware** _____ s.o./s.t.
for	Smoking is bad _____ you.	**be bad** _____ s.o./s.t.
to	The solution is clear _____ me.	**be clear** _____ s.o
about	Alex is crazy _____ football.	**be crazy** _____ s.t.
from	Jane is very different _____ me.	**be different** _____ s.o./s.t.
for	Venice is famous _____ its canals.	**be famous** _____ s.t.
to / with	She's friendly _____ everyone.	**be friendly** _____ s.o.
for	Fresh fruit is good _____ you.	**be good** _____ s.o.
for	I'm hungry _____ some chocolate.	**be hungry** _____ s.t.
in	I'm interested _____ art.	**be interested** _____ s.t.
about	I'm nervous _____ my test scores.	**be nervous** _____ s.t.
with	I'm patient _____ children.	**be patient** _____ s.o.
of	My parents are proud _____ me.	**be proud** _____ s.o./s.t.
for	Who's responsible _____ this?	**be responsible** _____ s.o./s.t.
about	I'm sad _____ losing my job.	**be sad** _____ s.t.
to	A lemon is similar _____ a lime.	**be similar** _____ s.o./s.t.
of / about	I'm sure _____ the facts.	**be sure** _____ s.t.

Complete the sentences with prepositions.

1. I don't understand that sentence. It isn't clear _____ me.

2. Mark Twain is famous _____ his novels about life on the Mississippi River.

3. Are you hungry _____ for lunch yet?

4. Our daughter graduated from college. We're very proud _____ her.

5. Sugar isn't good _____ you. It is bad _____ your teeth.

6. Who was responsible _____ the accident?

7. My coat is similar _____ yours but different _____ Ben's.

8. Some people aren't friendly _____ strangers.

9. My daughter is crazy _____ horses. She is very interested _____ them.

10. Sara knows what she's talking about. She's sure _____ her facts.

PRACTICE 9 ▸ Groups A and C.
Complete the sentences with prepositions.

1. Dr. Nelson, a heart specialist, is . . .

 a. proud _____ her work.

 b. famous _____ her medical expertise.

 c. sure _____ her skills.

 d. familiar _____ the latest techniques.

 e. patient _____ her patients.

 f. aware _____ the stresses of her job.

 g. interested _____ her patients' lives.

 h. kind _____ her patients' families.

2. Her patient, Ms. Green, is . . .

 a. sad _____ her illness.

 b. nervous _____ an upcoming surgery.

 c. aware _____ the risks of surgery.

 d. full _____ hope.

 e. curious _____ alternative medicine.

 f. ready _____ a quick recovery.

PRACTICE 10 ▸ Group D.
The prepositions in the column on the left are the correct completions for the blanks. Follow the same steps you used for Group A on page 142.

Preposition Combinations: Group D		
Answers	Sentences	Reference List
with	I agree _____ you.	**agree** _____ s.o.
about	I agree with you _____ that.	**agree with** s.o. _____ s.t.
in	We arrived _____ Toronto at six.	**arrive** _____ (*a city/country*)
at	We arrived _____ the hotel.	**arrive** _____ (*a building/room*)
about	We all complain _____ the weather.	**complain** _____ s.o./s.t.
of	A book consists _____ printed pages.	**consist** _____ s.t.
with	I disagree _____ you.	**disagree** _____ s.o.
about	I disagree with you _____ that.	**disagree with** s.o. _____ s.t.
from	She graduated _____ Reed College.	**graduate** _____ (*a place*)
to	Luke invited me _____ the game.	**invite** s.o. _____ s.t.
to	We listened _____ some music.	**listen** _____ s.o./s.t.
for	Jack paid _____ my dinner.	**pay** _____ s.t.
to	I talked _____ Annie on the phone.	**talk** _____ s.o.

about	We talked _____ her problem.	**talk** _____ s.t.
on	A salesman waited _____ a customer.	**wait** _____ s.o.
for	We waited _____ the bus.	**wait** _____ s.t.
about	Olivia complained to me _____ my dog.	**complain to** s.o. _____ s.t.

PRACTICE 11 ▸ Group D.
Complete the sentences with prepositions.

1. Zachary paid _____ his airplane ticket in cash.

2. Natalie graduated _____ high school two years ago.

3. I waited _____ the bus.

4. Jim is a waiter. He waits _____ customers at a restaurant.

5. I have a different opinion. I don't agree _____ you.

6. I arrived _____ this city last month.

7. I arrived _____ the airport around eight.

8. I listened _____ the news on TV last night.

9. The supervisor agreed _____ the employees' decision to work longer days and shorter weeks.

10. This practice consists _____ verbs that are followed by certain prepositions.

11. Adrian invited me _____ his party.

12. I complained _____ the building manager_____ the leaky faucet in the kitchen.

13. Megan disagreed _____ her father _____ the amount of her weekly allowance.

14. Did you talk _____ Professor Adams _____ your grades?

PRACTICE 12 ▸ Groups A, B, and D.
Complete the sentences with prepositions.

1. Everyone is talking _____ the explosion in the high school chemistry lab.

2. Carlos was absent _____ class six times last term.

3. Fruit consists mostly _____ water.

4. Our children are very polite _____ adults.

5. Three centimeters is equal _____ approximately one and a half inches.

6. I borrowed some clothes _____ my best friend.

7. Are you familiar _____ ancient Greek history?

8. I discussed my problem _____ my uncle.

9. I admire you _____ your ability to laugh _____ yourself when you make a silly mistake.

10. A: Are you two arguing _____ each other _____ money again?

 B: Yeah, listen _____ this.

 A: Shhh. I don't want to hear any of this. Stop complaining _____ me _____ your finances. I don't agree with either of you.

The prepositions in the column on the left are the correct completions for the blanks. Follow the same steps you used for Group A on page 142.

Preposition Combinations: Group E		
Answers	Sentences	Reference List
about	She asked me _____ my trip.	**ask** s.o. _____ s.t. (inquire)
for	She asked me _____ my advice.	**ask** s.o. _____ s.t. (request)
to	This book belongs _____ me.	**belong** _____ s.o.
about / of	I dreamed _____ going to Paris.	**dream** _____ s.o./s.t.
about	Do you know anything _____ jazz?	**know** _____ s.t.
at	I'm looking _____ this page.	**look** _____ s.o./s.t.
for	I'm looking _____ my lost keys.	**look** _____ s.o./s.t. (search)
like	Anna looks _____ her sister.	**look** _____ s.o. (resemble)
to	I'm looking forward _____ vacation.	**look forward** _____ s.t.
to	Your opinion doesn't matter _____ me.	**matter** _____ s.o.
with	Something is the matter _____ the cat.	**be the matter** _____ s.o./s.t.
for	I'm searching _____ my lost keys.	**search** _____ s.o./s.t.
from	She separated the boys _____ the girls.	**separate** (*this*) _____ (*that*)
about / of	I warned them _____ the danger.	**warn** s.o. _____ s.t.

Complete the sentences with prepositions.

1. What's the matter _____ Charlie? Is he hurt?

2. We can go out for dinner, or we can eat at home. It doesn't matter _____ me.

3. To make this recipe, you have to separate the egg whites _____ the yolks.

4. I don't know anything _____ astrology.

5. I'm looking forward _____ my vacation next month.

6. Isabel dreamed _____ dancing last night.

7. Right now I'm doing homework. I'm looking _____ my book.

8. Jim can't find his book. He's looking _____ it.

9. Jim is searching _____ his book.

10. I asked the waitress _____ another cup of coffee.

11. I asked Rebecca _____ her trip to Japan.

12. Does this pen belong _____ you?

13. The city was warned _____ the hurricane in advance.

14. Do you think Jon looks _____ his father or his mother?

15. Magda is always looking _____ her keys. She seems pretty disorganized.

16. Look _____ those clouds. It's going to rain.

Make sentences by matching each phrase in Column A with a phrase in Column B. Use each phrase only once.

Column A	Column B
1. The police are searching _____ .	a. about monsters and dragons
2. The baby keeps looking _____ .	b. to their 20th wedding anniversary
3. Once again, Julie is looking _____ .	c. for her glasses. She always misplaces them
4. In this picture, Paula looks _____ .	d. about the schools in this area
5. The Browns are looking forward _____ .	e. about high winds on the bridge
6. Before you do the wash, you need to separate the darks _____ .	f. with this car. It's making strange noises
7. Sometimes Joey is afraid to sleep. He often dreams _____ .	g. for the suspect
8. Something's the matter _____ .	h. from the whites
9. The sign on the highway warned drivers _____ .	i. at the TV screen. It has bright colors
10. We're planning to move here. Do you know much _____ ?	j. like her mother. The resemblance is very strong

The prepositions in the column on the left are the correct completions for the blanks. Follow the same steps you used for Group A on page 142.

Preposition Combinations: Group F		
Answers	**Sentences**	**Reference List**
to	I apologized _____ my friend.	**apologize** _____ s.o.
for	I apologized _____ my behavior.	**apologize** _____ s.t.
of	I don't approve _____ Scott's behavior.	**approve** _____ s.t.
to / with	I compared this book _____ that book.	**compare** (*this*) _____ (*that*)*
on	I depend _____ my family.	**depend** _____ s.o./s.t.
of / from	He died _____ heart disease.	**die** _____ s.t.
from	The teacher excused me _____ class.	**excuse** s.o. _____ s.t.
for	I excused him _____ his mistake.	**excuse** s.o. _____ s.t. (forgive)
for	I forgave him _____ his mistake.	**forgive** s.o. _____ s.t.
of	I got rid _____ my old clothes.	**get rid** _____ s.o./s.t.
to	What happened _____ your car?	**happen** _____ s.o./s.t.
on	I insist _____ the truth.	**insist** _____ s.t.
from	I protected my eyes _____ the sun.	**protect** s.o./s.t. _____ s.o./s.t.
on	I am relying _____ you to help me.	**rely** _____ s.o./s.t.
of	Mr. Lee took care _____ the problem.	**take care** _____ s.o./s.t.
for	Thank you _____ your help.	**thank** s.o. _____ s.t.

*Also possible: *I compared this and that.* (*And* is not a preposition. A parallel structure with *and* may follow *compare*.)

PRACTICE 17 ▸ Group F.

Complete the sentences with prepositions.

1. I apologized _____ Ann _____ stepping on her toe.

2. I thanked Sam _____ helping me fix my car.

3. My grandfather doesn't approve _____ gambling.

4. Please forgive me _____ forgetting your birthday.

5. My friend insisted _____ taking me to the airport.

6. Please excuse me _____ being late.

7. Children depend _____ their parents for love and support.

8. In my composition, I compared this city _____ my hometown.

9. Umbrellas protect people _____ rain.

10. We're relying _____ Jason to help us move into our new apartment.

11. We had mice in the house, so we set some traps to get rid _____ them.

12. Who is taking care _____ the children while you are gone?

13. What happened _____ your finger? Did you cut it?

14. My manager excused me _____ the meeting when I became ill.

15. What did Mr. Hill die _____?

PRACTICE 18 ▸ Group F.

Write "C" beside the correct sentences. Write "I" beside those that are incorrect. In some cases, both may be correct.

1. a. ___C___ I need to be excused from class tomorrow.

 b. ___C___ My professor excused me for being late.

2. a. ___C___ Do you approve of your government's international policies?

 b. ___I___ Do you approve on the new seatbelt law?

3. a. _____ I apologized for the car accident.

 b. _____ I apologized to Mary's parents.

4. a. _____ Why did you get rid over your truck? It was in great condition.

 b. _____ I got rid of several boxes of old magazines.

5. a. _____ Pierre died of a heart attack.

 b. _____ Pierre's father also died from heart problems.

6. a. _____ It's not a good idea to compare one student to another.

 b. _____ I wish my parents wouldn't compare me with my brother.

7. a. _____ We can rely on Lesley to keep a secret.

 b. _____ There are several people whom my elderly parents rely in for assistance.

8. a. _____ You can relax. I took care about your problem.

 b. _____ The nurses take wonderful care of their patients at Valley Hospital.

The prepositions in the column on the left are the correct completions for the blanks. Follow the same steps you used for Group A on page 142.

Answers	Sentences	Reference List
to	I'm accustomed _____ hot weather.	**be accustomed** _____ s.t.
to	I added a name _____ my address book.	**add** (*this*) _____ (*that*)
on	I'm concentrating _____ the lecture.	**concentrate** _____ s.t.
into	I divided the cookie _____ two pieces.	**divide** (*this*) _____ (*that*)
from	They escaped _____ prison.	**escape** _____ (*a place*)
about	I heard _____ the prison escape.	**hear** _____ s.o./s.t.
from	I heard about it _____ my cousin.	**hear about** s.t. _____ s.o.
from	The escapees hid _____ the police.	**hide** (s.t.) _____ s.o.
for	We're hoping _____ good weather.	**hope** _____ s.t.
by	I multiplied 8 _____ 2.	**multiply** (*this*) _____ (*that*)
to / with	I spoke _____ the teacher.	**speak** _____ s.o.
about	We spoke to Dr. Carter _____ my problem.	**speak to/with** _____ s.t.
about	I told the teacher _____ my problem.	**tell** s.o. _____ s.t.
from	I subtracted 7 _____ 16.	**subtract** (*this*) _____ (*that*)
about	I wonder _____ lots of curious things.	**wonder** _____ s.t.

Complete the sentences with prepositions.

1. Shhh. I'm trying to concentrate _____ this math problem.

2. How did the bird escape _____ its cage?

3. Did you tell your parents _____ the dent in their new car?

4. We're hoping _____ good weather tomorrow so we can go sailing.

5. Did you hear _____ the earthquake in Turkey?

6. I heard _____ my sister last week. She sent me an email.

7. I spoke _____ Dr. Rice _____ my problem.

8. I'm not accustomed _____ cold weather.

9. When you divide 6 _____ 2, the answer is 3.

10. When you subtract 1 _____ 6, the answer is 5.

11. When you multiply 6 _____ 3, the answer is 18.★

12. When you add 6 _____ 4, the answer is 10.★★

13. George wondered _____ his team's chances of winning the tennis tournament.

14. Zoe hid her journal _____ her younger sister.

★Also possible: multiply 6 times 3
★★Also possible: add 6 and 4; add 6 plus 4

Complete the sentences with prepositions.

1. My father insisted _____ knowing the truth.

2. I was wondering _____ your birthday. What do you want to do?

3. What's the matter _____ you today?

4. She hid the secret _____ everyone.

5. We separated the younger kids _____ the teenagers.

6. I apologized _____ my manager _____ my mistake.

7. We got rid _____ the insects in our apartment.

8. Who does this book belong _____?

9. Does it matter _____ you what time I call this evening?

10. We're looking forward _____ your visit.

11. Fresh vegetables are good _____ you.

12. Parents protect their children _____ harm.

13. Shhh. I'm trying to concentrate _____ my work.

14. I rely _____ my friends for their help.

15. I don't approve _____ Bob's lifestyle.

16. The official warned us _____ the danger of traveling alone in the countryside.

Index

Answer Key

CHAPTER 1: PRESENT TIME

PRACTICE 1, p. 1

1. am sitting
2. sit
3. do
4. am doing
5. am looking
6. am choosing
7. isn't doing
8. is checking
9. checks
10. posts
11. posts
12. is looking

PRACTICE 2, p. 1

2. speak
3. speaks
4. speak
5. speaks
7. do not / don't speak
8. does not / doesn't speak
9. do not / don't speak
10. does not / doesn't speak
12. Do … speak
13. Does … speak
14. Do … speak
15. Does … speak

PRACTICE 3, p. 2

2. manages
3. collect
4. programs
5. run
6. cooks
7. coach
8. drives
9. write

PRACTICE 4, p. 2

2. doesn't come / comes
3. doesn't snow / snows
4. don't grow / grow
5. doesn't follow / follows
6. don't bark / bark
7. doesn't revolve / revolves
8. don't turn / turn

PRACTICE 5, p. 3

1. do
2. Ø
3. does
4. Ø
5. do
6. Ø
7. Ø, does
8. Ø
9. Ø
10. do
11. Do

PRACTICE 6, p. 3

2. are speaking
3. is speaking
4. are speaking
5. is speaking
7. are not / aren't speaking
8. is not / isn't speaking
9. are not / aren't speaking
10. is not / isn't speaking
12. Is … speaking
13. Are … speaking
14. Are … speaking
15. Is … speaking

PRACTICE 7, p. 4

1. are waiting
2. arrives
3. is playing
4. is sleeping
5. works
6. falls
7. are watching
8. are laughing
9. makes
10. posts
11. is filing
12. are listening
13. is drawing
14. is walking
15. are putting
16. getting

PRACTICE 8, p. 4

Group 1
2. a
3. b

Group 2
1. c
2. b
3. a

Group 3
1. b
2. a
3. c

Group 4
1. b
2. a
3. c

PRACTICE 9, p. 5

3. Is she
4. Is she
5. Does she
6. Is she
7. Is she
8. Does she
9. Does she
10. Does she
11. Is she

PRACTICE 10, p. 5

3. Do you
4. Are you
5. Do you
6. Do you
7. Are you
8. Are you
9. Do you
10. Are you

PRACTICE 11, p. 5

2. a
3. a
4. c
5. a
6. c
7. b
8. a
9. b
10. b

PRACTICE 12, p. 6

3. plural noun
4. singular verb
5. singular verb
6. plural noun
7. plural noun
8. singular verb
9. singular verb
10. plural noun

PRACTICE 13, p. 6

3. kangaroo<u>s</u>
4. taste<u>s</u> come<u>s</u>
5. Apple<u>s</u> contain∅
6. bake<u>s</u> cut<u>s</u> put<u>s</u> pie∅
7. mechanic∅ repair<u>s</u>
8. work<u>s</u> restaurant∅ serve<u>s</u> customer<u>s</u>
9. go∅ restaurant<u>s</u>

PRACTICE 14, p. 7

1. eats
2. teaches
3. studies
4. does
5. pays
6. has
7. watches
8. goes
9. rides
10. flies

PRACTICE 15, p. 7

3. catches
4. he transfers
5. He arrives
6. He stays
7. he leaves
8. He attends
9. He usually studies
10. tries
11. he goes
12. He has

PRACTICE 16, p. 8

3. Does she <u>ever</u> bring her lunch to work?
4. Luke <u>always</u> stays home in the evening.
5. He is <u>generally</u> at his desk in the evening.
6. He doesn't <u>usually</u> go out.
7. But he doesn't <u>always</u> study in the evening.
8. He <u>sometimes</u> watches a little TV.
9. He <u>rarely</u> stays awake past midnight.
10. He is <u>almost never</u> awake past midnight.
11. Does he <u>occasionally</u> go out at night?
12. Is he <u>always</u> home at night?

PRACTICE 17, p. 8

2. often / frequently skips
3. usually / often / frequently visits
4. is usually / often / frequently / almost always
5. rarely / seldom / hardly ever goes
6. usually / often / frequently / almost always cleans
7. sometimes / occasionally does
8. is never

PRACTICE 18, p. 9

Part I
Circle: *form, have, call, are, occur, travel, cause, like, is coming*
Underline: usually, often, never
Part II
1. T
2. F
3. F
4. F
5. T
6. F
7. F
8. T

PRACTICE 19, p. 9

2. a
3. b
4. b
5. a
6. a
7. b
8. a
9. b
10. a

PRACTICE 20, p. 10

3. drive
4. 'm/am playing
5. prefer
6. need
7. understand
8. belong
9. 's/is raining, is shining

PRACTICE 21, p. 10

2. needs
3. is enjoying
4. are always
5. are eating
6. are drinking
7. reading
8. is working
9. is feeding
10. are playing
11. knows
12. love
13. has
14. play
15. is smiling
16. relaxing
17. usually takes
18. is

PRACTICE 22, p. 11

3. Do you
 I do, I don't
4. Does
 she does, she doesn't
5. Are
 they are, they aren't/they're not
6. Do they
 they do, they don't
7. Is
 he is, he isn't/he's not
8. Are you
 I'm not, I am
9. Is
 it is, it isn't / it's not
10. Do
 we do / we don't

PRACTICE 23, p. 11

2. ~~has~~ have
3. is always
4. ~~goes~~ go
5. come<u>s</u>
6. is starting
7. ~~no~~ doesn't or isn't working
8. ~~Is Catherine has~~ Does Catherine have
9. ~~are loving~~ love
10. ~~do~~ does
11. sometimes asks
12. ~~Does~~ Do
13. mix<u>es</u>
14. ~~frys~~ fr<u>i</u>es
15. ~~studing~~ stud<u>y</u>ing

PRACTICE 24, p. 12

help
need
am
'm making
do
Do you speak
do
don't
need
need

want
don't
often choose
classes
I don't
think
need
usually advise
does
have

PRACTICE 25, p. 13

Across
1. does
2. fly
4. beginning
6. costs

Down
1. drive
2. flies
3. begin
5. is

CHAPTER 2: PAST TIME

PRACTICE 1, p. 14

2. Did Ben walk home? Ben didn't walk home.
3. Did Hana work all day? Hana didn't work all day.
4. Did Dad plant roses? Dad didn't plant roses.
5. Did Mom like the game? Mom didn't like the game.
6. Did Kim cook dinner? Kim didn't cook dinner.
7. Did Nate play tennis? Nate didn't play tennis.
8. Did they arrive late? They didn't arrive late.
9. Did Sam invite Ava? Sam didn't invite Ava.
10. Did we finish our work? We didn't finish our work.

PRACTICE 2, p. 14

2. Did you work?
 You didn't work.
3. She works every day .
 Does she work?
4. Did she work?
 She didn't work.
5. They work every day.
 They don't work.
6. Did they work?
 They didn't work.
7. He works every day.
 Does he work?
8. Did he work?
 He didn't work.

PRACTICE 3, p. 15

2. We watched a lot of movies.
3. The kids played soccer.
4. Sarah lived in Canada.
5. Amy listened to loud music.
6. Alex didn't work.
7. I didn't walk to school.
8. Did you travel often?
9. Did your teacher help you with your homework?
10. Did Ben play the piano?

PRACTICE 4, p. 15

1. Did
2. Did
3. Was
4. Was
5. Did
6. Were
7. Did
8. Did
9. Did
10. Were
11. Was
12. Did

PRACTICE 5, p. 16

3. Was she sad
4. Did they eat
5. Were they hungry
6. Did you go
7. Did she understand
8. Did he forget

PRACTICE 6, p. 16

2. Did / did
3. Was / wasn't
4. Did / did
5. Was / was
6. Was / was
7. Did / didn't
8. Did / did
9. Were / were
10. Did / did

PRACTICE 7, p. 17

2. Were you
 I wasn't
3. Did you practice
 I did
4. Was the test
 it wasn't
5. Did you make
 I didn't
6. Was the car
 it was
7. Did you put
 I did
8. Did you go
 I didn't

PRACTICE 8, p. 18

Part I
brought
fought
thought
taught
found

Part II
swam
drank
sang
rang

Part III
blew
drew
flew
grew
knew
threw

Part IV
wrote
froze
rode
sold
stole

Part V
hit
hurt
read
shut
cost
put
quit

Part VI
paid
said

PRACTICE 9, p. 18

[Circle the following words in the puzzle: bring, buy, go, grow, say, take]

PRACTICE 10, p. 18

2. brought
3. came
4. did
5. took
6. forgot
7. knew
8. wrote
9. drove
10. saw

PRACTICE 11, p. 19

2. lost
3. bought
4. found
5. ate
6. read
7. heard
8. left
9. got
10. spoke

PRACTICE 12, p. 19

3. had
4. missed
5. overslept
6. Did you set
7. I did
8. set
9. didn't work
10. weren't
11. saw
12. took
13. cost
14. got
15. left
16. Did you call
17. I didn't
18. didn't have
19. forgot
20. didn't lose

PRACTICE 13, p. 20

-e:
racing, raced

two consonants:
Double? No
working, worked
starting, started

two vowels + on consonant:
Double? No
shouting, shouted
waiting, waited

one vowel + one consonant:
One syllable verbs:
Double? Yes
patting, patted
shopping, shopped

2-syllable verbs, stress on 1st syllable:
Double? No
listening, listened
happening, happened

2-syllable verbs, stress on 2nd syllable:
Double? Yes
occurring, occurred
referring, referred

-y:
Double? No
playing, played
replying, replied
studying, studied

ie:
Double? No
dying, died
tying, tied

PRACTICE 14, p. 21
Double the consonants:
hitting
beginning
cutting
winning

Drop the *-e:*
coming
hoping
taking
writing

Just add *-ing:*
learning
listening
raining
staying

PRACTICE 15, p. 21

3. biting, bite
4. sitting, sit
5. writing, write
6. fighting, fight
7. waiting, wait
8. getting, get
9. starting, start
10. permitting, permit
11. lifting, lift
12. eating, eat
13. tasting, taste
14. cutting, cut
15. meeting, meet
16. visiting, visit

PRACTICE 16, p. 22

2. picked
3. arrive
4. crying
5. walk, walking
6. played, playing
7. practiced
8. referring
9. studied, studying
10. hopped
11. hoped, hoping
12. planned, planning
13. smile, smiled
14. helped, helping
15. listened, listening

PRACTICE 17, p. 22
Part I
2. are reporting
3. are running
4. are competing
5. are racing
6. is starting
7. are getting
8. are trying
9. are speeding
10. is raining
11. aren't stopping

Part II
2. shouted
3. enjoyed
4. raced
5. surprised
6. passed
7. finished
8. admitted
9. slowed
10. continued
11. achieved
12. crossed
13. struggled
14. treated
15. dropped
16. managed

PRACTICE 18, p. 23
2. aren't, are
3. wasn't, was
4. didn't come, came
5. doesn't come, comes
6. didn't sleep, slept
7. isn't, is
8. didn't disappear, disappeared
9. don't make, make

PRACTICE 19, p. 24
3. are playing, played
4. drink, am drinking
5. teaches, taught
6. swims, is swimming
7. are sleeping, slept
8. reads, read
9. try, are trying
10. are eating, ate

PRACTICE 20, p. 24
2. were … doing
3. were playing
4. was studying
5. Was … raining
6. Was … working
7. wasn't feeling
8. wasn't listening

PRACTICE 21, p. 25
2. was ringing
3. was watching
4. were talking
5. were playing, were reading, were sitting, looking

PRACTICE 22, p. 25
3. hurt, was playing
4. was hiking, found
5. saw, was hiking
6. picked up, hiking
7. tripped, fell, was dancing
8. was dancing, met
9. was dancing, got

2. c
3. b
4. a
5. g
6. h
7. f
8. e

PRACTICE 24, p. 26

2. was washing, dropped, broke
3. saw, was eating, talking, joined
4. was singing, didn't hear
5. Did your lights go out, was taking, found, ate, went, slept

PRACTICE 25, p. 27

2. 1, 2 they left the building, they stood outside in the rain
3. 2, 1 the music began, everyone started to dance
4. 2, 1 They danced until the music ended
5. 2, 1 When the soccer player scored a goal, the fans cheered
6. 2, 1 Everyone left the stadium as soon as the game was over
7. 1, 2 Before Mateo went to bed, he finished his homework
8. 1, 2 He had some coffee when he woke up

PRACTICE 26, p. 27

2. used to be a secretary
3. used to play tennis
4. used to have fresh eggs
5. used to crawl under his bed, put his hands over his ears
6. used to go to the beach
7. used to wear jeans
8. didn't use to like/never used to like
9. didn't use to be allergic/never used to be allergic

PRACTICE 27, p. 28

Part I
Circle: know, are, have
Underline: was, made, was working, placed, was walking, stared, wondered, was looked, took, had, weighed, was

Part II
1. F
2. T
3. F
4. F

PRACTICE 28, p. 29

2. ~~are~~
3. ~~was understand~~ understood
4. ~~was~~ were
5. ~~hear~~ heard, ~~knew~~ know
6. ~~go~~ went
7. ~~drove~~ drive, ~~am~~ was
8. ~~no used~~ didn't use
9. ~~Did~~ Was
10. ~~Were ... seeing~~ Did ... see, ~~stopped~~ stop
11. ~~living~~ live
12. ~~maked~~ made
13. ~~was breaking~~ broke, ~~hoped~~ hopped
14. ~~used~~ use, ~~move~~ moved
15. ~~miss~~ missed, ~~get~~ got

PRACTICE 29, p. 29

2. was playing
3. rang
4. was boiling
5. turned
6. answered
7. opened
8. saw
9. was holding
10. asked
11. screamed
12. fell
13. hurt
14. slammed
15. ran
16. heard
17. waiting
18. opened
19. took
20. thanked
21. signed

PRACTICE 30, p. 30

1. a
2. b
3. b
4. a
5. c
6. c
7. b
8. b
9. c
10. b
11. a
12. a
13. c
14. c
15. b

CHAPTER 3: FUTURE TIME

PRACTICE 1, p. 31

6. will finish
7. will design
10. is going to live
12. 'll be

PRACTICE 2, p. 31

2. is going to leave
3. isn't going to leave
4. Are ... going to leave
5. is going to be
6. are going to be
7. am not going to be
8. Is ... going to be
9. is going to rain
10. isn't going to snow
11. Is ... going to rain

PRACTICE 3, p. 32

are going to leave	will leave
is going to leave	will leave
are going to leave	will leave
are going to leave	will leave
are not going to leave	will not leave
is not going to leave	will not leave
am not going to leave	will not leave

PRACTICE 4, p. 32

The Smiths **will** celebrate their 50th wedding anniversary on December 1st of this year. Their children are planning a party for them at a local hotel. Their family and friends **will** join them for the celebration.

Mr. and Mrs. Smith have three children and five grandchildren. The Smiths know that two of their children **will** be at the party, but the third child, their youngest daughter, is far away in Africa, where she is doing medical research. They believe she **will** be in Africa at the time of the party.

The Smiths don't know it, but their youngest daughter **will** come home. She is planning to surprise them. It **will** be a wonderful surprise for them! They **will** be very happy to see her. The whole family **will** enjoy being together for this special occasion.

2. Will Mr. Jones give
 Is Mr. Jones going to give
3. Will Jacob quit
 Is Jacob going to quit
4. Will Mr. and Mrs. Kono adopt
 Are Mr. and Mrs. Kono going to adopt
5. Will the Johnsons move
 Are the Johnsons going to move
6. Will Dr. Johnson retire
 Is Dr. Johnson going to retire

PRACTICE 6, p. 33

2. Will we have
3. we will have
4. Will the test be
5. will not be
6. Will I pass
7. You will pass
8. will not pass

PRACTICE 7, p. 33

2. a. eats
 b. ate
 c. is going to eat
 d. will eat
3. a. doesn't arrive
 b. didn't arrive
 c. isn't going to arrive
 d. will not arrive
4. a. Do … eat
 b. Did … eat
 c. Are … going to eat
 d. Will … eat
5. a. don't eat
 b. didn't eat
 c. am not going to eat
 d. will not eat

PRACTICE 8, p. 34

1. 'll enjoy … 'll begin … 'll teach
2. 'll be … 'll call
3. 'll start … 'll ride … 'll drive

PRACTICE 9, p. 35

2. A: Will Paul have / Is Paul going to have
 B: he will / is OR he won't / isn't
3. A: Will Jane graduate / Is Jane going to graduate
 B: she will / is OR she won't / isn't
4. A: Will her parents be / Are her parents going to be
 B: they will / are OR they won't / aren't
5. A: Will you answer / Are you going to answer
 B: I will / am OR I won't / I'm not
6. A: Will Jill / Is Jill going to text
 B: she will / is OR she won't / isn't

PRACTICE 10, p. 35

1. a
2. a
3. c
4. b
5. a
6. a
7. c
8. a
9. c
10. b
11. b

PRACTICE 11, p. 36

Part I
2. 'm going to stream
3. 're going to move
4. 'm going to get

Part II
2. 'll ask
3. 'll clean
4. 'll pay

PRACTICE 12, p. 37

2. 'll
3. 'm going to
4. 'll
5. 'm going to, 'll

PRACTICE 13, p. 37

1. will
2. are going to
3. will
4. are going to
5. am going to
6. am going to
7. will

PRACTICE 14, p. 38

Part I
3. he'll probably go
4. he probably won't finish
5. they'll probably have

Part II
7. I'm probably not going to be
8. they probably aren't going to come
9. she probably isn't going to ride
10. it is probably going to be

PRACTICE 15, p. 39

2. About 50% Certain
3. About 50% Certain
4. About 90% Certain
5. About 50% Certain
6. 100% Certain
7. 100% Certain
8. About 90% Certain
9. About 50% Certain
10. About 90% Certain
11. About 50% Certain
12. About 90% Certain

PRACTICE 16, p. 39

2. are probably not going to invite
3. may have … Maybe … will have
4. may rent
5. will probably decide
6. may not be … may be
7. will go
8. probably won't go

PRACTICE 17, p. 40

Underlined clauses:
1. Before Bill met Maggie
2. until he met Maggie.
3. When he met Maggie
4. after he met her
5. After they dated for a year
6. As soon as Bill gets a better job
7. before they buy a house
8. when they have enough money
9. After they get married
10. until they die

PRACTICE 18, p. 40

2. I'm not going to go … until I finish
3. Before Layla watches … she will finish
4. Jim is going to read … after he gets
5. When I call … I'll ask
6. Ms. Torres will stay … until she finishes
7. As soon as I get … I'm going to take

2. If it is hot tomorrow,
3. if he has enough time
4. If I don't exercise at the gym tomorrow,
5. if I get a raise soon
6. If Gina doesn't study for her test,
7. if I have enough money
8. If I don't study tonight,

PRACTICE 20, p. 41

Sam and I are going to leave on a road trip tomorrow. We'll pack our suitcases and put everything in the car before we **go** to bed tonight. We'll leave tomorrow morning at dawn, as soon as the sun **comes** up. We'll drive for a couple of hours on the interstate highway while we **talk** and **listen** to our favorite music. When we **see** a nice rest area, we'll stop for coffee. After we **walk** around the rest area a little bit, we'll get back in the car and drive a little longer. We'll stay on that highway until we **come** to Highway 44. Then we'll turn off and drive on scenic country roads. If Sam **gets** tired, I'll drive. Then when I **drive,** he'll probably take a little nap. We'll keep going until it **gets** dark.

PRACTICE 21, p. 42

1. e	5. b
2. g	6. c
3. a	7. d
4. f	

PRACTICE 22, p. 42

2. Before my friends come over, I'm going to clean up my apartment. OR
 I'm going to clean up my apartment before my friends come over.
3. When the storm is over, I'm going to do some errands. OR
 I'm going to do some errands when the storm is over.
4. If you don't update your skills, you will have trouble finding a job. OR
 You will have trouble finding a job if you don't update your skills.
5. As soon as Joe finishes his report, he is going to meet us at the coffee shop. OR
 Joe is going to meet us at the coffee shop as soon as he finishes his report.
6. After Lesley washes and dries the dishes, she will put them away. OR
 Lesley will put away the dishes after she washes and dries them.
7. If they don't leave at seven, they won't get to the theater on time. OR
 They won't get to the theater on time if they don't leave at seven.

PRACTICE 23, p. 43

5. 'll	13. will run
6. put	14. get
7. 'll go	15. 'll pour
8. turn on	16. read
9. am waiting	17. will come
10. take	18. 'll talk
11. will start	19. 'll have
12. barks	20. 'll make

21. say	27. will ring
22. 'll finish	28. 'll talk
23. 'll go	29. 'll go
24. is	30. make
25. has	31. will be
26. 'll work	

PRACTICE 24, p. 44

2. They're going to travel … They're traveling
3. We're going to get … We're getting
4. He's going to start … He's starting
5. She's going to go … She's going
6. My neighbors are going to build … My neighbors are building

PRACTICE 25, p. 44

2. is leaving	6. are coming
3. is giving	7. am meeting
4. are having	8. am graduating
5. is … taking	

PRACTICE 26, p. 45

1. b	5. b
2. a	6. a
3. a	7. b
4. b	8. a

PRACTICE 27, p. 45

1. a	6. a, b
2. a, b	7. a
3. a, b	8. a
4. a, b	9. a
5. a	10. a, b

PRACTICE 28, p. 46

2. opens
3. arrives / gets in
4. begins / starts
5. A: do … close
 B: closes
6. open … starts / begins … arrive … ends / finishes
7. A: does … depart / leave
 B: leaves / departs
 B: does … arrive (get in)

PRACTICE 29, p. 47

1. d	5. b
2. f	6. c
3. a	7. g
4. h	8. e

PRACTICE 30, p. 47

2. set
3. doing
4. go
5. fell
6. is writing … is waiting
7. takes … gets
8. go … tell
9. am taking … forgetting
10. will discover … (will) apologize

PRACTICE 31, p. 47

1. My friends **will** join us after work.
2. Maybe the party **will end** / **is going to end** soon. OR The party **may end** soon.
3. On Friday, our school **will close** / **is going to close** early so teachers can go to a workshop.
4. It **will rain** / **is going to rain** tomorrow.
5. Our company is going to **sell** computer equipment to schools.
6. Give grandpa a hug. He's about to **leave.**
7. Mr. Scott is going to retire and **move** to a warmer climate.
8. If your soccer team **wins** the championship tomorrow, we'll have a big celebration for you.
9. I bought this cloth because I'**m going to** / **am going to** make some curtains for my bedroom.
10. I moving to London when I **finish** my education here.
11. Are you going **to go** to the meeting? OR Are you **going to** the meeting?
12. I opened the door and **walked** to the front of the room.
13. When **are** you going to move into your new apartment?
14. Maybe I **will** celebrate my 30th birthday with my friends at a restaurant. OR **I may** celebrate …

PRACTICE 32, p. 48

2. need
3. go
4. am going to finish
5. send
6. stayed
7. was reading
8. heard
9. went
10. didn't see
11. went
12. found
13. made
14. is watching
15. always watches
16. is
17. is going to mow
18. am making
19. is cooking
20. was
21. used to make
22. got
23. are going to go / are going
24. are
25. are going to see
26. bought
28. leave
29. usually stay
30. are
31. are not going to stay
32. tried
33. was
34. may stay
35. will stay
36. plays
37. skips
38. isn't doing
39. doesn't study
40. go
41. will / is going to fail
42. saw
43. ran
44. caught
45. knocked
46. called
47. was waiting / waited
48. got
49. understood
50. put
51. took
52. ended
53. woke

PRACTICE 33, p. 50

Across:
3. rains
7. arrive
8. Maybe

Down:
1. probably
2. will
4. starts
5. going
6. begin
8. may

CHAPTER 4: PRESENT PERFECT AND PAST PERFECT

PRACTICE 1, p. 51

2. stopped
3. put
4. known
5. been
6. wanted
7. said
8. had
9. gone
10. taken

PRACTICE 2, p. 51

I.

Simple form	Simple past	Past participle
hurt	hurt	hurt
put	put	put
quit	quit	quit
upset	upset	upset
cut	cut	cut
shut	shut	shut
let	let	let
set	set	set

II.

Simple form	Simple past	Past participle
ring	rang	rung
drink	drank	drunk
swim	swam	swum
sing	sang	sung
sink	sank	sunk

III.

Simple Form	Simple Past	Past Participle
win	won	won
feed	fed	fed
weep	wept	wept
stand	stood	stood
keep	kept	kept
sit	sat	sat
stick	stuck	stuck
meet	met	met
have	had	had
find	found	found
buy	bought	bought
catch	caught	caught
fight	fought	fought
teach	taught	taught
pay	paid	paid
bring	brought	brought
think	thought	thought

PRACTICE 3, p. 52

2. A: Have you ever gone
 B: haven't … have never gone
3. A: Have you ever been
 B: haven't … have never been
4. A: Has she ever shown
 B: hasn't … has never shown
5. A: Have I ever told
 B: haven't … have never told
6. A: Have they ever tried
 B: haven't … have never tried

PRACTICE 4, p. 53

2. A: Have you ever talked
 B: have … have talked OR haven't … have never talked
3. A: Has Erica ever rented
 B: has … has rented OR hasn't … has never rented
4. A: Have you ever seen
 B: have … have seen OR haven't … have never seen
5. A: Has Joe ever caught
 B: has … has caught OR hasn't … has never caught
6. A: Have you ever had
 B: have … have had OR haven't … have never had
7. A: Have I ever met
 B: have … have met OR haven't … have never met
8. A: Have the boys ever been
 B: have … have been OR haven't … have never been

PRACTICE 5, p. 54

1. b
2. a
3. b
4. a
5. b
6. b
7. a
8. a

PRACTICE 6, p. 54

2. has already learned the alphabet
3. has already corrected our tests
4. hasn't returned the tests yet
5. hasn't cooked dinner yet
6. has already cooked

PRACTICE 7, p. 55

2. haven't met all my neighbors yet
3. has just returned
4. has traveled
5. has already changed
6. has already had
7. hasn't invited me yet
8. have recently retired
9. haven't talked
10. have already had

PRACTICE 8, p. 55

1. has taught
2. has sold
3. has loved
4. have had
5. have known
6. have played
7. have gotten
8. have gone
9. have been
10. has been

PRACTICE 9, p. 56

3. since
4. for
5. for
6. since
7. since
8. since
9. since
10. for

PRACTICE 10, p. 56

2. I have known my teacher **since** September.
3. Sam has wanted a dog **for** two years.
4. Sara has needed a new car **since** last year / **for** a year.
5. Our professor has been sick **for** a week / **since** last week.
6. My parents have lived in Canada **since** December.
7. I have known Dr. Brown **since** 2009.
8. Tom has worked at a fast-food restaurant **for** three weeks.

PRACTICE 11, p. 57

2. have you made
3. Have you always enjoyed
4. have
5. have you traveled
6. have been
7. Have you ever wanted
8. have never wished
9. Have you ever thought
10. haven't
11. haven't met

PRACTICE 12, p. 57

2. has drunk
3. has … begun
4. has won
5. have met
6. have … found
7. have … paid
8. have bought

PRACTICE 13, p. 58

5. C
6. F
7. F
8. F
9. C
10. C
11. F
12. F
13. C
14. F

PRACTICE 14, p. 58

Check:
1. a, c, d, e, g, h
2. c, e, f, i

PRACTICE 15, p. 58

2. k, e
3. a, g
4. j, d
5. l, f
6. b, h

PRACTICE 16, p. 59

(1) started, was, had, has become, has been
(2) has led, has made, took, went, have gone, hasn't ended

PRACTICE 17, p. 59

2. has been playing … two hours
3. has been working … 7:00 this morning
4. has been driving … six hours
5. has been writing … three years
6. have been arguing … Jim brought home a stray cat
7. has been raining … two days
8. has been losing … her birthday

PRACTICE 18, p. 60

1. F
2. F
3. T
4. F
5. T
6. F

PRACTICE 19, p. 60

2. b
3. a
4. b
5. a
6. a
7. b
8. a

PRACTICE 20, p. 61

2. is shopping ... has been shopping ... has bought
3. is sitting ... has already drunk ... has been waiting
4. have been fishing ... haven't caught
5. aren't doing ... have been playing
6. are taking ... have been driving ... have driven

PRACTICE 21, p. 61

2. is
3. Have you ever worked
4. have worked / 've worked
5. had
6. did you work
7. have worked / 've worked
8. have never had
9. did you like
10. did not like / didn't like
11. was
12. are you working
13. do not have / don't have
14. have not had / haven't had
15. quit
16. Are you looking
17. am going to go / 'm going
18. is looking
19. will do / 'll do
20. have never looked / 've never looked
21. will be / is
22. do not know / don't know
23. will find / 'll find
24. go

PRACTICE 22, p. 62

2. <u>2</u> I opened the door.
 <u>1</u> Someone knocked on the door.
3. <u>1</u> Her boyfriend called.
 <u>2</u> My sister was happy.
4. <u>1</u> He saw me putting on my coat.
 <u>2</u> Our dog stood at the front door.
5. <u>2</u> Ken laughed at my joke.
 <u>1</u> Ken heard the joke many times.
6. <u>2</u> Don opened his car door with a wire hanger.
 <u>1</u> Don lost his keys.
7. <u>2</u> My plants died.
 <u>1</u> I forgot to water the plants.
8. <u>2</u> Kelly didn't go to the movie with us.
 <u>1</u> She saw the movie with her sister.

PRACTICE 23, p. 63

1. c		6. a	
2. j		7. h	
3. g		8. e	
4. b		9. f	
5. i		10. d	

PRACTICE 24, p. 63

(1) Alan Green got married for the first time at age 49. His new life is very different because he has had to change many old habits. For example, before his marriage, he <u>had always watched</u> TV during dinner, but his wife likes to talk at dinnertime, so now the TV is off.

(2) Until he got married, he <u>had always listened</u> to jazz. He <u>had never liked</u> any other kind of music. But his wife likes pop, rock, and hip-hop music. Now Alan listens to all different kinds of music.

(3) When he was a bachelor, Alan was a slob. He <u>had always left</u> his dirty socks on the floor. Now he picks them up and puts them in the laundry basket. He <u>had never put</u> the cap back on the toothpaste, but now he does. He <u>had always left</u> his dirty dishes in the sink for days. Now he washes his dishes right away.

(4) Alan <u>had never shared</u> the TV remote control with anyone before he got married. He still likes to have control of the TV remote, but he doesn't say anything when his wife uses it.

2. had always listened
3. had never liked
4. had always left
5. had never put
6. had never shared

PRACTICE 25, p. 64

1. c
2. f
3. e
4. d
5. b
6. a

PRACTICE 26, p. 64

1. Did you enjoy ... enjoyed
2. Did you see ... was ... hadn't seen
3. haven't seen ... is ... haven't seen
4. Did you get ... got ... had already begun
5. had already gone
6. have painted ... have you painted

PRACTICE 27, p. 64

2. Anna **has** been a soccer fan **for** a long time.
3. Since I **was** a child, I have liked to solve puzzles.
4. Have you ever **wanted** to travel around the world?
5. The family **has been** at the hospital since they **heard** about the accident.
6. My sister is only 30 years old, but her hair has **begun** to turn gray.
7. Jake has been working as a volunteer at the children's hospital **for** several years.
8. Steve has worn his black suit only once since he **bought** it.
9. My cousin **has been** studying for medical school exams since last month.
10. I **haven't gotten** my test results from the doctor yet. I'll find out soon.
11. Our meeting **had** already ended when Michelle got here.

PRACTICE 28, p. 65

1. been
2. taken
3. known
4. broken
5. seen
6. gone
7. found
8. understood

CHAPTER 5: ASKING QUESTIONS

PRACTICE 1, p. 66

2. Does Tom like coffee?
3. Is Pietro watching a movie?
4. Are you having lunch with Raja?
5. Did Rafael walk to school?
6. Was Clarita taking a nap?
7. Will Ted come to the meeting?
8. Is Ingrid a good artist?
9. Were you at the wedding?

PRACTICE 2, p. 67

1. A: Is
 B: is
2. A: Is
 B: isn't
3. A: Does
 B: does
4. A: Do
 B: do
5. A: Have
 B: haven't
6. A: Did
 B: didn't
7. A: Are
 B: am
8. A: Will
 B: will
9. A: Do
 B: do
10. A: Did
 B: did
11. A: Is there
 B: there is

PRACTICE 3, p. 67

3. A: Is
 B: isn't
4. A: Do
 B: do
5. A: Do
 B: don't
6. A: Does
 B: does
7. A: Is
 B: is
8. A: Is
 B: isn't
9. A: Will
 B: won't

PRACTICE 4, p. 68

2. A: Does George
 B: he doesn't
3. A: Did Jane and Anna
 B: they did
4. A: Did Jane
 B: she didn't
5. A: Did George
 B: he did
6. A: Did Jane and Anna
 B: they didn't
7. A: Did George and John
 B: they did
8. A: Will Jane
 B: she will
9. A: Will George and Anna
 B: they will
10. A: Will John
 B: he won't

PRACTICE 5, p. 69

1. c
2. b
3. a
4. a
5. a
6. b
7. b

PRACTICE 6, p. 69

1. does he work
2. does he work
3. is Marta making
4. did she say
5. did Jean and Don visit
6. did they visit her

PRACTICE 7, p. 70

1. Does
2. Where
3. Is
4. When
5. Will
6. When
7. Are
8. Where
9. Is
10. Where
11. Did
12. When

PRACTICE 8, p. 70

	Question word	Helping verb	Subject	Main verb	Rest of sentence
1.	Ø	Did	you	hear	the news?
2.	When	did	you	hear	the news?
3.	Ø	Is	Eric	traveling	for work?
4.	Where	is	Eric	traveling?	
5.	Ø	Will	the class	end	soon?
6.	When	will	the class	end?	
7.	Ø	Did	the teacher	help	a student?
8.	Who(m)	did	the teacher	help?	
9.	Ø	Will	the chef	cook	a special dish tonight?
10.	What	will	the chef	cook	tonight?

PRACTICE 9, p. 71

1. Where did apple trees originate (b)
2. Where do apple trees grow (b)
3. Do they grow (a)
4. Do the trees produce apples (a)
5. When do they produce (b)
6. What do you find (b)
7. Will some of the seeds become (a)

PRACTICE 10, p. 71

1. d
2. e
3. c
4. b
5. f
6. a

PRACTICE 11, p. 72

1. a. you are going downtown
 b. are you going downtown
2. a. did Paul leave early for
 b. Paul left early
3. a. are your clothes on the floor
 b. are your clothes on the floor for
4. a. Mira needs money
 b. does Mira need money

PRACTICE 12, p. 73

2. When does Rachel start
3. Why did you miss
4. When are you leaving
5. When do you expect
6. Where did you eat lunch
7. What time did you eat
8. Why do you eat lunch
9. Where does the bullet train go
10. When will they build a bullet train
11. Where did you study
12. Why did you study

PRACTICE 13, p. 74

3. O Who(m) do you know …
4. S Who was on TV …
5. S What happened …
6. O What does Jason know
7. O Who(m) is Gilda calling
8. S Who answered the phone
9. O What did you say
10. S What is important

PRACTICE 14, p. 75

Part I	Part II
1. What	1. Who(m)
2. Who	2. Who(m)
3. Who	3. What
4. What	4. What
5. Who	5. What
6. What	6. What

PRACTICE 15, p. 76

1. Who knows Julio?
2. Who(m) does Julio know?
3. Who will help us?
4. Who(m) will you ask?
5. Who(m) is Eric talking to?
6. Who is knocking on the door?
7. What surprised them?
8. What did Jack say?
9. What did Emma talk about?
10. Who(m) did Reece talk about?

PRACTICE 16, p. 76

1. Who taught …
2. What did Robert see
3. Who got …
4. What are you making
5. Who(m) does that cell phone belong …
6. What is …

PRACTICE 17, p. 76

Answers will vary.

2. What does spacious mean
 It means big and roomy.
3. What does mild mean
 It means fairly warm, not cold
 (when you are talking about the weather)
4. What does hilarious mean
 It means very funny.
5. What does industrious mean
 It means hard-working.

PRACTICE 18, p. 77

1. What is Alex doing …
2. What did you do …
3. What do astronauts do …
4. What are you going to do …
5. What did Sara do …
6. What is Emily going to do …
7. What do you want to do …
8. What does Nick do …

PRACTICE 19, p. 77

1. Which
2. What
3. What
4. Which … which
5. What
6. which
7. What
8. What … which

PRACTICE 20, p. 78

1. What kind of music …
2. What kind of clothes …
3. What kind of Italian food …
4. What kind of books …
5. What kind of car …
6. What kind of government …
7. What kind of job …
8. What kind of person …

PRACTICE 21, p. 79

1. hot … hot
2. soon … soon
3. expensive … expensive
4. busy … busy
5. serious … serious
6. old … old
7. fresh … fresh
8. well … well

PRACTICE 22, p. 79

1. How often
2. How many times
3. How many times
4. How often
5. How often
6. How many times

PRACTICE 23, p. 80

2. How many blocks is it from the university to the
 science museum
 How far is it from the college to the museum
3. How many miles do you live from your office
 How far do you live from your office
4. How many kilometers is it from the earth to the moon
 How far is it from the earth to the moon

PRACTICE 24, p. 80

1. How far is it
 How many miles is it
 How long does it take
2. How high is Mount Everest
 How many meters is Mount Everest
 How long did it take …
 How many days did it take …
3. How long is …
 How many miles is …
 How many days does it take …

PRACTICE 25, p. 81
2. long
3. often
4. far
5. far
6. long
7. high
8. long
9. often
10. far
11. long
12. often

PRACTICE 26, p. 82
1. How do you spell your name
2. How do you like …
3. How do you say …
4. How do you pronounce …
5. How do you feel …

PRACTICE 27, p. 82
1. a
2. b
3. c
4. a
5. b
6. c

PRACTICE 28, p. 83
1. will the clothes be dry
2. did you do
3. book did you download
4. long did it take
5. bread do you like
6. are you calling me
7. are you meeting
8. is taking you
9. you are leaving

PRACTICE 29, p. 84
1. What is Jack doing …
2. Who(m) is he playing …
3. What is Anna doing
4. What is she throwing …
5. What are Anna and Jack holding
6. What is …
7. Where are they
8. How long have they been playing
9. Who is winning …
10. Who won …

PRACTICE 30, p. 85
1. a. don't
 b. doesn't
 c. don't
 d. doesn't
 e. aren't
 f. doesn't
 g. do
 h. is
 i. am
2. a. didn't
 b. didn't
 c. wasn't
 d. did
 e. didn't
3. a. aren't
 b. is
 c. isn't
 d. wasn't
 e. wasn't
 f. were
4. a. hasn't
 b. haven't
 c. have
 d. hasn't
 e. has
 f. have

PRACTICE 31, p. 85
1. A: haven't you
 B: Yes, I have
2. A: has he
 B: No, he hasn't
3. A: didn't you
 B: Yes, I did
4. A: don't you
 B: Yes, I do
5. A. haven't they
 B. Yes, they have
6. A. hasn't she
 B. Yes, she has
7. A. is it
 B. No, it isn't
8. A: doesn't he
 B: Yes, he does
9. A: is it
 B: No, it isn't
10. A: is it
 B: No, it isn't
11. A: weren't they
 B: Yes, they were
12. A: will she
 B: No, she won't

PRACTICE 32, p. 86
1. When are you going to buy
2. How are you going to pay
3. How long have you had
4. How often do you ride
5. How do you usually get
6. Did you ride
7. Who gave
8. Did you ride
9. How far did you ride
10. Does your bike have
11. What kind of bike do you have
12. When did Jason get
13. Who broke
14. How did he break it
15. Did Billy get hurt
16. Did the bike have a lot of damage
17. Which wheel fell off
18. Has Jason fixed the bike yet

PRACTICE 33, p. 87
1. **Who** saw the car accident?
2. How about **asking** Julie and Tim to come for dinner Friday night?
3. What time **does class begin** today?
4. Where **do** people go to get a driver's license in this city?
5. How long **does it take** to get to the beach from here?
6. She is working late tonight, **isn't** she?
7. **Whose** glasses are those?
8. **How tall is** your father?
9. Who **did you talk / have you talked** to about registration for next term?
10. How come **you are** here so early today?

PRACTICE 34, p. 88

CHAPTER 6: NOUNS AND PRONOUNS

PRACTICE 1, p. 89
Circle: fish, world, shark, bus, mouth, tooth, tooth
Underline: oceans, types, teeth, rows, sharks, people

PRACTICE 2, p. 89

Living things that breathe	Furniture	Places on a map	Fruits and Vegetables
children	beds	cities	apples
foxes	lamps	countries	cherries
men	shelves	lakes	carrots
mice	tables	oceans	peaches
cats		rivers	tomatoes
tigers			

PRACTICE 3, p. 89
3. boxes
4. shelf
5. copies
6. families
7. woman
8. children
9. fish
10. fly
11. dishes
12. glasses
13. dollar
14. euros
15. roof
16. lives
17. photos

PRACTICE 4, p. 90
Underlined nouns:
2. bab**ies** ... **teeth**
3. Child**ren** ... swing**s**
4. No change.
5. potato**es**, bean**s**, pea**s**, ... tomato**es**
6. No change.
7. animal**s** ... zoo**s**
8. Human**s** ... **feet**
9. No change.
10. Government**s** ... tax**es**

PRACTICE 5, p. 90
 S V
2. The dish fell.
 S V O
3. The noise woke her baby.
 S V
4. The baby cried.
 S V O
5. Caroline rocked her baby.
 S V
6. The phone rang.
 S V O
7. A man came to the door.

 S V
8. The dog barked loudly
 S V O
9. Caroline answered the door.

PRACTICE 6, p. 91

	subject	verb	object of verb
2.	He	got	a new job
3.	A package	arrived	Ø
4.	The mail carrier	delivered	the package
5.	My mother	sent	the package
6.	The passengers	boarded	the airplane
7.	The plane	left	the gate
8.	The plane	left	Ø

PRACTICE 7, p. 91
3. N
4. V
5. V
6. N
7. N
8. V
9. N
10. V
11. V
12. N

PRACTICE 8, p. 92
1. in
2. on
3. on
4. beside
5. above
6. below
7. behind
8. next to
9. into
10. out

PRACTICE 9, p. 92
1. d
2. e
3. a
4. c
5. f
6. b

PRACTICE 10, p. 92
1. in / into ... on
2. in ... of
3. near ... to
4. above ... below
5. of
6. through ... on
7. from

PRACTICE 11, p. 93
Part I
Circled words:
(1) in, in, over, through, on, under, into
(2) after, around, across, on, against, near
(3) behind, beneath

Underlined words:
(1) Jamaica, sky, beaches, trees, roof, door, house
(2) storm, neighborhood, street, ground, house, house
(3) clouds, sun

Part II

1. Dark clouds appeared in the sky.
2. The water came in under the door.
3. After the storm, the people walked around the neighborhood.
4. The tree had fallen on the ground / across the street.
5. The sun was behind the clouds.
6. The neighbors felt happy and grateful when they were standing beneath the hot Jamaican sun.

PRACTICE 12, p. 94

2. in	10. at
3. on	11. in
4. on	12. on
5. at	13. in
6. at	14. in
7. in	15. on
8. on	16. in
9. at	

PRACTICE 13, p. 94

1. at … in … in … on … on
2. on … At … at … in … In

PRACTICE 14, p. 94

1. to the airport tomorrow morning
2. a new job last month
3. skis in the mountains in January
4. has breakfast at the coffee shop in the morning
5. jogged in the park last Sunday
6. bought a house in the suburbs last year

PRACTICE 15, p. 95

2. 2 on the lake
 3 last summer
 1 a sailboat
3. 2 in the river
 1 several fish
 3 last weekend
4. 3 at noon
 1 our lunch
 2 in the park
5. 1 a cup of coffee
 2 at the corner store
 3 after work yesterday

PRACTICE 16, p. 95

2. are	8. is
3. is	9. are
4. is	10. are
5. are	11. are
6. is	12. is
7. are	

PRACTICE 17, p. 96

2. do	7. doesn't
3. needs	8. teaches
4. Is	9. enjoys
5. are	10. are
6. Are	

PRACTICE 18, p. 96

3. easy → test
4. free → air
5. delicious → food … Mexican → restaurant
6. sick → child
7. sick → child … warm → bed … hot → tea

PRACTICE 19, p. 96

2. old	9. safe
3. bad	10. light
4. easy	11. light
5. hard	12. public
6. narrow	13. right
7. clean	14. right
8. empty	15. long

PRACTICE 20, p. 97

2. paper money	8. egg cartons
3. apartment buildings	9. mountain views
4. rose gardens	10. traffic lights
5. key chains	11. apple pies
6. university students	12. steel bridges
7. brick walls	

PRACTICE 21, p. 97

1. b	5. b
2. c	6. a
3. a	7. a
4. b	8. b

PRACTICE 22, p. 98

Part I
Underline: white, red, orange, beautiful, bright, shining, large, far, tiny, enormous
Circle: night, cloud, city

Part II
1. T
2. T
3. T
4. T
5. F

PRACTICE 23, p. 98

2. **Cats** hunt **mice**
3. **Mosquitos/Mosquitoes** are small **insects**.
4. Everyone has **eyelashes**.
5. Do you listen to any podcasts when you take plane **trips**?
6. **Forests** sometimes have **fires**. Forest **fires** endanger wild **animals**.
7. Sharp kitchen **knives** can be dangerous.
8. I couldn't get **concert** tickets for Friday. The **tickets** were all sold out.
9. There are approximately 250,000 different **kinds** of **flowers** in the world.
10. I applied to several foreign **universities** because I want to study in a different **country**.
11. Ted lives with three other university **students**.
12. In the past one hundred **years**, our daily **lives** have changed in many **ways**. We no longer need to use oil **lamps** or **candles** in our **houses**, raise our own **chickens**, or build daily **fires** for cooking.

PRACTICE 24, p. 99

1. a. her → Dr. Gupta
 b. She → Dr. Gupta
 c. them → students
 d. They → students
 e. they → classes
2. a. him → Dr. Reynolds
 b. He → Dr. Reynolds
 c. them → patients
 d. he → Dr. Reynolds
 e. him → Dr. Reynolds
3. a. It → my hometown
 b. I → Beth
 c. They → the people
 d. me → Beth
 e. They → the people
 f. you → you (the reader of this passage)
 g. they → the people
 h. you → you (the reader of this passage)

PRACTICE 25, p. 99

3. S
4. O
5. S
6. O
7. S
8. S
9. O
10. S
11. O
12. O
13. S
14. O

PRACTICE 26, p. 100

1. me, them, us, you, her, him
2. He, You, I, She, They, We
3. him and me, you and me, her and me, them and us
4. He and I, She and I, You and I

PRACTICE 27, p. 101

1. me
2. me
3. I
4. She
5. she … her
6. he … him
7. us … us
8. them … They

PRACTICE 28, p. 101

1. a
2. b
3. b
4. a
5. a
6. b
7. a
8. b
9. a
10. a

PRACTICE 29, p. 102

3. parents'
4. mother's
5. Carl's
6. Carl's
7. baby's
8. baby's
9. babies'
10. Sanjay's
11. Nate's
12. James's / James'

PRACTICE 30, p. 102

3. I know **Jack's** roommates.
4. No change.
5. I have one roommate. My **roommate's** desk is always messy.
6. You have two roommates. Your **roommates'** desks are always neat.
7. No change.
8. Jo Ann is **Betty's** sister. My **sister's** name is Sonya.

9. My name is Richard. I have two sisters. My **sisters'** names are Jo Ann and Betty.
10. I read a book about the changes in **women's** roles and **men's** roles in modern society.

PRACTICE 31, p. 102

1. Who's, Who's, Who's, Whose
2. Whose, Who's, Who's, Whose

PRACTICE 32, p. 103

3. Whose umbrella did you borrow?
4. Whose book did you use?
5. Whose book is on the table?
6. Who's on the phone?
7. Who's that?
8. Whose is that?

PRACTICE 33, p. 103

2. her, hers
3. his, his
4. your, yours
5. their, our, theirs, ours

PRACTICE 34, p. 104

1. her
2. hers
3. Our
4. theirs
5. your
6. mine … my … yours
7. their … theirs
8. mine … yours

PRACTICE 35, p. 104

1. myself
2. ourselves
3. himself
4. herself
5. themselves
6. yourself
7. yourselves
8. itself

PRACTICE 36, p. 105

2. am proud of myself
3. talks to himself
4. taught myself
5. blamed herself
6. help yourselves
7. takes care of himself
8. enjoyed themselves
9. worked for himself
10. introduce themselves

PRACTICE 37, p. 105

2. yourselves
3. itself
4. its … its
5. hers
6. him
7. yourself … your
8. our … our
9. ours
10. themselves
11. itself
12. himself
13. Whose
14. They're … there

PRACTICE 38, p. 106

(1) 4. he
 5. him
(2) 1. Her
 2. her
 3. She
 4. Our
 5. We
 6. It
 7. her
 8. mine
 9. hers
 10. I
(3) 1. He
 2. his
 3. his
 4. Her
 5. They
 6. themselves
 7. them
 8. my
 9. theirs
 10. their

PRACTICE 39, p. 107

2. one … another … the other
3. one … the other
4. one … another … another … another … the other
5. one … another … another … another … another … the other

PRACTICE 40, p. 107

1. The other
2. Another
3. The other
4. a. Another
 b. the other
5. a. another
 b. another
 c. another
 d. another
 e. another

PRACTICE 41, p. 108

1. The others
2. The others
3. Others
4. others
5. other
6. Others
7. Other
8. The others
9. The other

PRACTICE 42, p. 108

1. a
2. a
3. c
4. d
5. b
6. b
7. a
8. d
9. b

PRACTICE 43, p. 109

1. are
2. potatoes
3. by myself
4. on … at
5. vacation
6. us
7. its
8. our … yours
9. himself
10. the others

PRACTICE 44, p. 109

1. Look at those **beautiful** mountains!
2. Three **women** in our class play on the **women's** soccer team at our college.
3. There are two **horses**, several **sheep**, and a cow in the **farmer's** field.
4. The owner of the store is busy **at** the moment.
5. The teacher met **her** students at the park after school.
6. Everyone **wants** peace in the world.
7. I grew up in a **very large city**.
8. This apple tastes sour. There are more, so let's try **another** one.
9. Some **trees** lose their **leaves** in the winter.
10. I am going to wear my **blue shirt** to the party.
11. People may hurt **themselves** if they use this machine.
12. Our neighbors invited my friend and **me** to visit **them**.
13. My **husband's** boss works for twelve **hours** every **day**.
14. The students couldn't find **their** books.
15. I always read **magazine** articles while I'm in the waiting room at my **dentist's** office.

PRACTICE 45, p. 110

Circle: men, women, children, teeth, flies, feet, foxes, wolves, monkeys

CHAPTER 7: MODAL AUXILIARIES

PRACTICE 1, p. 111

1. Ø
2. to
3. Ø
4. Ø
5. to
6. to
7. Ø
8. Ø….to … to
9. Ø
10. to

PRACTICE 2, p. 111

2. cat
3. Elephants
4. Chickens
5. camels
6. duck
7. cow
8. horse
9. donkey
10. squirrel
11. ants
12. humans

PRACTICE 3, p. 112

Part I
2. can't
3. could
4. couldn't
5. Can

Part II
2. 'm not able to open
3. was able to swim
4. Are you able to speak
5. wasn't able to ski

PRACTICE 4, p. 112

2. possibility
3. permission
4. possibility
5. possibility
6. permission
7. possibility
8. permission
9. possibility
10. permission

PRACTICE 5, p. 113

3. Maybe there will be time later.
4. Our team may win.
5. You might be right.
6. We may hear soon.
7. It may rain.
8. It might snow.
9. Maybe she will come tomorrow.
10. Maybe she is at home right now.

PRACTICE 6, p. 113

1. b
2. c
3. c
4. a
5. b
6. a

PRACTICE 7, p. 114

1. b
2. b
3. a
4. a
5. b
6. a
7. b
8. a

PRACTICE 8, p. 114

1. e
2. d
3. f
4. b
5. c
6. a

PRACTICE 9, p. 115

1. May
2. Would
3. May
4. Would
5. will / could
6. Could
7. Will / Could

PRACTICE 10, p. 115

2. Could, May, Can
3. Would, Could, Will
4. Can, May, Could
5. Will, Can, Could

PRACTICE 11, p. 116

2. should quit
3. should drive the speed limit
4. shouldn't give too much homework
5. should attend all classes
6. shouldn't be cruel to animals
7. should always be on time for an appointment
8. shouldn't throw trash on the ground

PRACTICE 12, p. 116

1. j … i
2. e … f
3. b … g
4. h … d
5. a … c

PRACTICE 13, p. 117

2. c
3. b
4. a
5. b
6. c
7. a
8. c
9. b
10. c

PRACTICE 14, p. 117

1. have
2. must
3. has
4. had
5. have
6. have
7. had
8. have

PRACTICE 15, p. 118

1. had to
2. had to
3. have to
4. had to
5. have to
6. had to
7. have got to … have to
8. must

PRACTICE 16, p. 118

2. had to turn off
3. Did … have to work
4. had to see
5. had to be
6. had to close

PRACTICE 17, p. 119

1. You didn't stop at the red light. You have to stop at red lights.
2. You've got to be more responsible.
3. You have to send them back and get the right ones.
4. Okay. Everyone must fill out an application. Here it is.
5. No. He just has to stay in bed for a couple of days and drink plenty of water.

PRACTICE 18, p. 119

2. don't have to
3. don't have to
4. must not
5. don't have to

6. don't have to
7. must not
8. must not
9. don't have to
10. must not
11. don't have to
12. must not

PRACTICE 19, p. 120

People have to / must
eat and drink in order to live
pay taxes
stop when they see a police car's lights behind them

People must not
fall asleep while driving
drive without a license
take other people's belongings

People don't have to
cook every meal themselves
say "sir" or "madam" to others
stay in their homes in the evening

PRACTICE 20, p. 121

1. c
2. d
3. e
4. a
5. b

PRACTICE 21, p. 121

3. 2
4. 1
5. 2
6. 2
7. 2
8. 1

PRACTICE 22, p. 121

1. will
2. can't
3. wouldn't
4. wouldn't
5. can
6. do
7. should
8. won't
9. could
10. shouldn't
11. doesn't
12. shouldn't

PRACTICE 23, p. 122

3. Read
4. Don't throw
5. Come in … have
6. turn off
7. Meet … text
8. take … don't forget

PRACTICE 24, p. 122

Part I
1. fly
2. sail
3. walk
4. listen

Part II
5. go
6. shop
7. see

Part III
8. have
9. do
10. plan
11. tell

PRACTICE 25, p. 123

4. would rather
5. A: prefer
 B: likes … would rather
6. B: prefer
 A: like

PRACTICE 26, p. 124

2. My son likes fish better than beef.
3. Kim prefers salad to dessert
4. In general, Nicole likes coffee better than tea.
5. Bill would rather teach history than work as a business executive.
6. When Sam thinks about having a pet, he likes dogs better than cats.
7. On a long trip, Susie prefers driving to riding in the back seat.
8. I would rather study in a noisy room than study in a quiet room.
9. Alex would rather play soccer than baseball.

PRACTICE 27, p. 125

2. has to
3. might
4. could
5. must
6. isn't able to
7. might
8. wasn't able to
9. Would you
10. must
11. ought to
12. should

PRACTICE 28, p. 126

2. Could **you bring** us more coffee, please?
3. Ben can **drive**, but he prefers **to take** the bus.
4. A few of our classmates can't **come** to the school picnic.
5. **Could / Would / Will / Can** you take our picture, please?
6. Why aren't you wearing a jacket? You **must be** really cold!
7. Jim would rather **have** Fridays off in the summer than a long vacation.
8. You must **stop** at intersections with stop signs.
9. Take your warm clothes with you. It **may** / **might** / snow. OR Maybe **it will** snow.
10. It's such a gorgeous day. Why **don't we** go to a park or the beach?

PRACTICE 29, p. 126

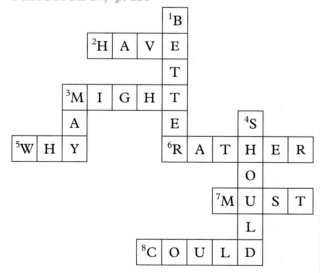

APPENDIX 1: PHRASAL VERBS

PRACTICE 1, p. 128

1. out
2. in
3. out
4. up
5. up
6. up
7. down
8. off
9. on
10. off
11. away
12. out
13. off
14. on
15. up
16. down

PRACTICE 2, p. 129

1. off, on
2. up
3. up, down
4. off
5. down, up
6. up
7. up, off
8. out
9. out, out

PRACTICE 3, p. 129

2. my coat, my wedding ring
3. his shoes
4. a story, a fairy tale, an excuse
5. some rotten food, an old shirt
6. a doctor's appointment, a meeting, a trip
7. a puzzle, a math problem
8. a report, some late homework
9. a message, a phone number
10. a box, a sack of mail
11. the light, the computer, the car engine

PRACTICE 4, p. 130

1. on
2. from
3. over
4. off
5. on
6. in/into
7. out of
8. into
9. into

PRACTICE 5, p. 130

1. on
2. over
3. off, on
4. in, out of
5. on, off
6. into
7. into
8. from

PRACTICE 6, p. 130

2. c
3. a
4. g
5. f
6. d
7. e

PRACTICE 7, p. 131

1. out
2. back
3. off
4. up
5. back
6. up
7. back
8. away
9. back
10. out
11. off
12. on
13. down
14. up

PRACTICE 8, p. 132

1. back
2. down
3. out
4. away
5. on
6. up

7. back
8. up
9. back

10. off
11. out, up, off, back

7. off
8. back
9. up
10. on
11. up

12. over
13. up
14. away
15. out
16. away/back

PRACTICE 9, p. 132

3a. into
3b. X
4a. X
4b. into
5a. up
5b. up
6a. away
6b. away
7a. down
7b. X

8a. X
8b. up
9a. away
9b. X
10a. up
10b. up
11a. off
11b. X
12a. from
12b. X

PRACTICE 15, p. 137

1. down
2. out
3. up
4. in
5. up
6. out
7. down
8. up
9. up
10. on
11. out

12. up
13. in
14. out
15. up
16. back
17. down
18. up
19. up
20. over
21. up
22. off

PRACTICE 10, p. 133

1. out
2. in
3. out
4. up
5. out
6. on
7. over

8. out
9. out
10. down
11. out of
12. up
13. around / back
14. over

PRACTICE 16, p. 138

1. off
2. up
3. over
4. down
5. down
6. up

7. out
8. down
9. up
10. up
11. on
12. in, down

PRACTICE 11, p. 134

2. out
3. in
4. out
5. out
6. down
7. around

8. out
9. up
10. out
11. out
12. up
13. over

PRACTICE 17, p. 138

1b. up
1c. up
1d. out
1e. out
1f. out of
2a. up

2b. up
2c. up
2d. up
2e. into
2f. up

PRACTICE 12, p. 134

1b. on
1c. down
1d. away
1e. out
1f. up
2a. in
2b. out
3a. over
3b. off
3c. on
3d. in
3e. out of
4a. out
4b. up
4c. down

5a. into
5b. up
5c. over
6a. up
6b. off
6c. back
7a. off
7b. back
7c. up
7d. over
8a. in
8b. out
8c. up
8d. up

PRACTICE 18, p. 139

1. in on
2. out of
3. along with
4. back from
5. through with

6. up in
7. out for
8. out of
9. up for
10. out for

PRACTICE 19, p. 139

1. out, out for
2. up
3. up for
4. out of
5. back from

6. out of
7. out for
8. through with
9. in on
10. along with

PRACTICE 13, p. 136

1. out
2. back
3. up
4. up
5. up
6. away
7. out

8. off
9. on
10. back
11. out
12. over
13. over
14. out

PRACTICE 20, p. 140

2. their neighbors
3. paint
4. rocks
5. assignment

6. Mexico
7. the hospital
8. snakes

PRACTICE 21, p. 140

1. along with
2. over
3. out of
4. out about
5. together
6. back to
7. over to

8. over to
9. around
10. out with
11. away from
12. out for
13. around

PRACTICE 14, p. 136

1. on
2. up
3. out, over

4. out
5. away, out
6. out, up

PRACTICE 22, p. 141

2. out for
3. back to
4. out with
5. away from
6. along with
7. out to
8. out of
9. over to, in, with

PRACTICE 23, p. 141

2. out
3. back
4. together
5. over to

APPENDIX 2: PREPOSITION COMBINATIONS

PRACTICE 2, p. 143

2. f
3. j
4. e
5. c
6. i
7. a
8. h
9. d
10. g

PRACTICE 3, p. 143

1. to
2. to
3. to
4. with
5. for
6. about
7. of
8. about
9. from
10. with
11. about
12. of

PRACTICE 5, p. 144

1. from
2. with
3. to
4. at
5. in
6. at
7. for
8. with, about
9. with
10. for
11. for

PRACTICE 6, p. 144

1. to
2. from, for
3. to, at
4. to
5. of
6. for
7. with
8. for

PRACTICE 8, p. 145

1. to
2. for
3. for
4. of
5. for, for
6. for
7. to, from
8. to
9. about, in
10. about

PRACTICE 9, p. 146

1a. of
1b. for
1c. of
1d. with
1e. with
1f. of
1g. in
1h. to
2a. about
2b. about
2c. of
2d. of
2e. about
2f. for

PRACTICE 11, p. 147

1. for
2. from
3. for
4. on
5. with
6. in
7. at
8. to

PRACTICE 12, p. 147

1. about
2. from
3. of
4. to
5. to
6. from
7. with
8. with
9. for, at
10. with, about, to, to, about

PRACTICE 14, p. 148

1. with
2. to
3. from
4. about
5. to
6. about/of
7. at
8. for
9. for
10. for
11. about
12. to
13. about
14. like
15. for
16. at

PRACTICE 15, p. 149

1. g
2. i
3. c
4. j
5. b
6. h
7. a
8. f
9. e
10. d

PRACTICE 17, p. 150

1. to, for
2. for
3. of
4. for
5. on
6. for
7. on
8. to
9. from
10. on
11. of
12. of
13. to
14. from
15. from

PRACTICE 18, p. 150

3a. C
3b. C
4a. I
4b. C
5a. C
5b. C
6a. C
6b. C
7a. C
7b. I
8a. I
8b. C

PRACTICE 20, p. 151

1. on
2. from
3. about
4. for
5. about
6. from
7. to, about
8. to
9. by
10. from
11. by
12. to
13. about
14. from

PRACTICE 21, p. 152

1. on
2. about
3. with
4. from
5. from
6. to, for
7. of
8. to
9. to
10. to
11. for
12. from
13. on
14. on
15. of
16. about

NOTES

NOTES